THE OCEAN SPEAKS

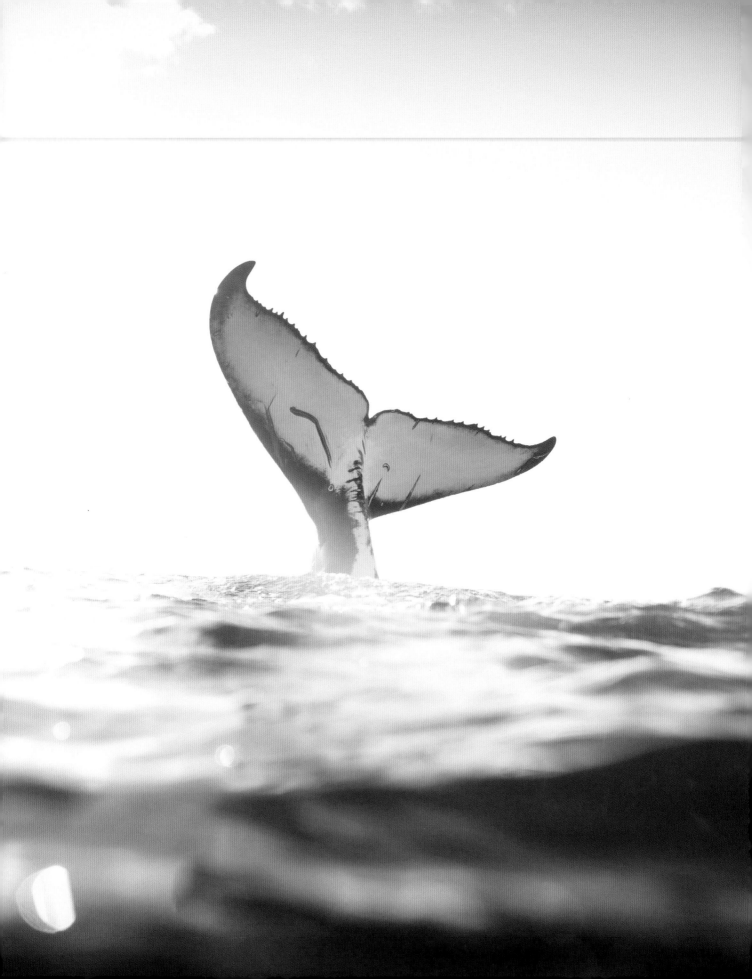

THE OCEAN SPEAKS

A photographic journey of discovery and hope

Curated by
MATT PORTEOUS & TAMSIN RAINE

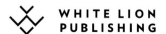

WHITE LION
PUBLISHING

Contents

The Pacific Ocean

The Polar Oceans

Foreword

Nicole Stott, 'Astronaut, aquanaut, artist'

We live on a planet!

I know. No kidding, right? But it's pretty impressive how the simple facts (things we likely know from a very early age, but for some reason don't actively carry forward with us in our day-to-day lives) are sometimes the most compelling.

I've been blessed to experience our planetary home from some extraordinary vantage points. From inner space – immersed in the ocean, as a crewmate on the Aquarius undersea habitat—to outer space, as a crewmate on the Space Shuttle and International Space Station. Witnessing the complexity of human survival in these extreme environments, I discovered three simple, yet life-changing lessons:

• We live on a planet. An overwhelmingly beautiful, colourful, crystal-clear planet.
• We are all Earthlings.
• The only border that matters is the veil-thin blue line of atmosphere that blankets and protects us all.

To survive, and thrive, here on Earth, we must bring the three simple lessons of 'planet, Earthlings and thin blue line' into our daily lives. We must appreciate the awe and wonder and ultimate significance of our planetary spaceship.

I think this is a very human response to seeing Earth from space, or to being immersed in its waters. It's a stunning presentation of our reality. It's not just about awareness, it's about the undeniable understanding of who and where we all are, together in space – the reality of the interconnectivity of everything and all the life with which we share our planet.

When we look at our planet from space we see all the colours we know Earth to be. And the colours we are most likely to see are blues – all shades of blue. Some shades I never remembered seeing before. The blues of the ocean – the signature blues of our water planet – set against the blackest black of outer space. We witness all of this in a heightened state. We see it with our eyes, feel it with our hearts and try to process it with our brains. At the same time, we're not hearing any of the familiar sounds we know from Earth. It's like we're experiencing all of this awesomeness with the mute button on. This is how that reality of 'planet, Earthlings and thin blue line' comes to life – through the silence and the feelings, and through all those blues. We are reminded not just of the beauty of our planet, but of the significance of the ocean itself and of all that lies above and below it. That blue is what distinguishes us and our place in the universe and all life as we know it. That blue is what we are in search of in every other place we are exploring in space. That blue equals life.

Our undersea and outer-space ships have been built as mechanical life-support systems, and mimic as far as possible what Earth does for us naturally. As a crew on such a craft, we know that our survival places depends on us staying acutely aware of the health and well-being of our atmosphere, our spaceship, and of all our

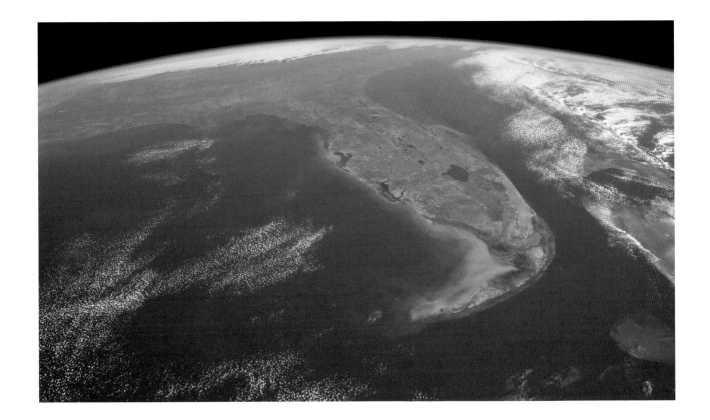

Florida, USA, as seen from the International Space Station. Image courtesy NASA.

crewmates. I believe that the peaceful and successful international cooperation that we've experienced in these extreme environments holds the key to the same kind of peaceful and successful cooperation for all of humanity.

Remember – we live on a planet! A blue planet in space. The perfect distance from the Sun. A planet that spins at a thousand miles per hour, shares a gravitational partnership with our Moon, and orbits the Sun at 67,000 miles per hour. All of this is what literally holds the life-giving blue of our oceans and that thin blue line of atmosphere in place to ensure our survival. And yet we just feel at home. So comfortable in our home that we sometimes forget about the special nature of this place and our role in protecting it. We tend to forget that our planet is our spaceship and how important it is to accept our role as its crew.

I'm thankful for this book, *The Ocean Speaks*, and for the explorers who have shared their stories from our planet's oceans and speak on their behalf, in a way that acknowledges the value of all the creatures – from the tiniest to the largest – that inhabit them. Each one of these storytellers has found a way to embrace their role as crewmates, not passengers, here on Spaceship Earth.

I'm honoured to have been asked to share some outer- and inner-space perspective on our ocean planet. I'm hopeful that you all will read this book. And I hope you will consider each of the stories as a call to action as crewmates in your own lives. We live on a planet! An ocean planet! By accepting our role as crewmates, not passengers, we have the power to create a future for all life on Earth that's as beautiful as it looks from space.

A Message of Hope

Endless, mysterious and profound, the oceans hold the secrets to life itself. But within their depths lies a hidden truth – the ocean, our most undervalued asset, is under threat. For the past seven years, we at Ocean Culture Life (OCL) have been driven by a single mission: to give a resounding voice to the ocean, uniting a diverse global community of passionate ocean enthusiasts, scientists, grassroots activists and researchers. Together with ocean enthusiasts from every corner of the world, we have embarked on a journey to share the ocean's untold stories, hoping to inspire change and safeguard its future.

Founded by passionate lovers of the ocean, OCL has tirelessly championed the cause of ocean conservation. We have joined hands with like-minded individuals worldwide who share our unwavering commitment to protect and preserve this vital ecosystem. At OCL, we believe that the ocean is not an entity separate from us but an integral part of our existence. It regulates our climate, sustains life on Earth, and inspires countless artists, scientists, adventurers and dreamers. Our community comprises experts in marine biology, environmental science and conservation, as well as skilled storytellers

BELOW: Installation of Reef Stars on a damaged reef ('Growing Hope', pp. 182–5).

OPPOSITE: An extremely curious humpback whale (*Megaptera novaeangliae*) meets a local guide ('A Whale Connection', pp. 170–3).

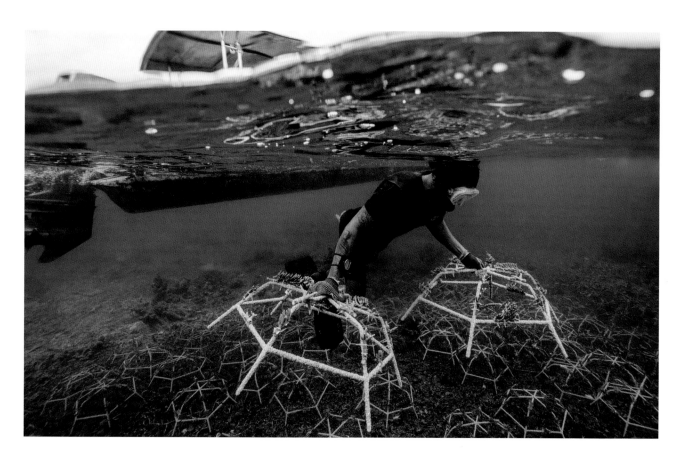

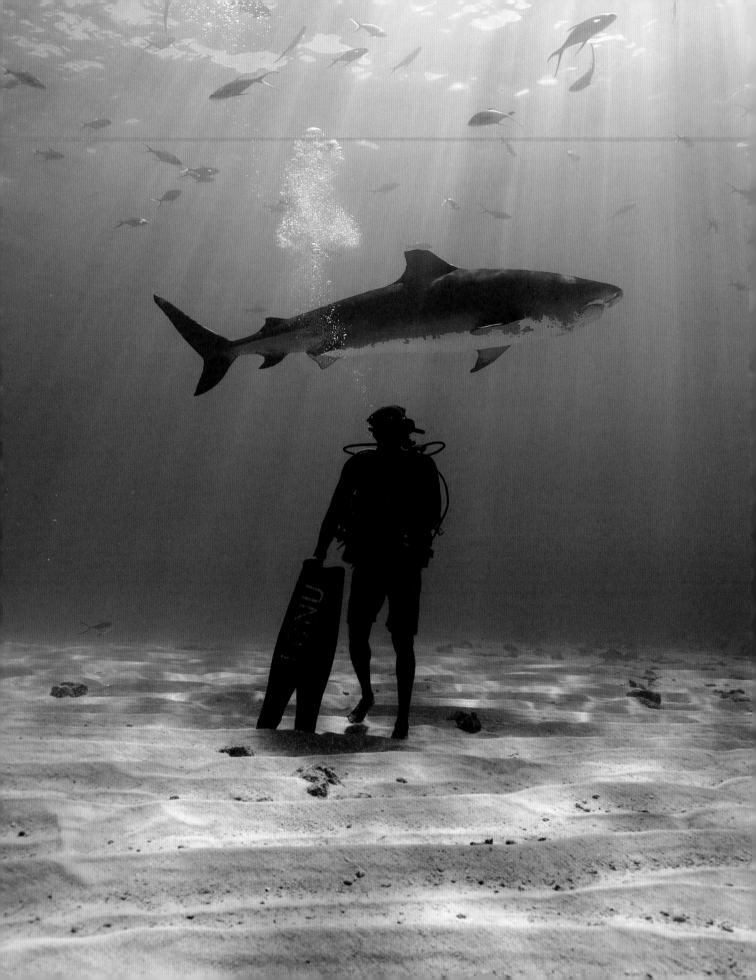

who understand the transformative power of narratives. This unique blend of expertise allows us to approach the task of authoring *The Ocean Speaks* with a depth of knowledge and passion that sets us apart.

The ocean, an awe-inspiring sanctuary of life, remains vulnerable, facing the relentless impact of human activities. Climate change, pollution, overfishing and habitat destruction threaten its delicate balance. *The Ocean Speaks* is an endeavour born from our passion for the sea – a book that aims to bridge the gap between humanity and the ocean. Within its pages, we strive to showcase the mesmerizing beauty and fragile essence of this vast aquatic world, while addressing the pressing environmental challenges it faces. The book serves as a tribute to the ocean and a call to action for every individual to become a guardian of this precious asset. We believe in the radical power of stories; they possess the unique ability to touch the soul, evoke emotions and inspire meaningful change. Over 60 such stories are included in this book, presenting a tapestry of narratives that weaves together tales of hope, resilience and determination.

Within these chapters, you will discover firsthand accounts from the courageous individuals who dedicate their lives to ocean conservation. From scientists diving to unexplored depths to activists tirelessly advocating for change, each story is a testament to the indomitable spirit of those who protect and cherish the ocean.

Split geographically by ocean, the narratives in this book span the globe and take the reader on a journey of discovery. Dive into the vibrant coral reefs of the Indian Ocean, explore the majestic migrations of marine creatures in the Atlantic Ocean and encounter the ethereal wonders of the Polar Oceans. Embark on a voyage to the vastness of the Pacific, where untold mysteries and untamed beauty await. On an expedition to the Sea of Cortez, one ocean enthusiast's dedication inspires responsible tourism and conservation efforts to safeguard mobula rays (see pages 164–9). In the Maldives, a passionate individual, named after the sea, has not only grown up swimming with tiger sharks daily but has also succeeded in inspiring his local community to cherish these magnificent creatures (see pages 114–19). We explore the captivating world of a photographer who uses their lens to capture the tiniest marine wonders (see pages 68–71), aiming to ignite your passion to protect and preserve these creatures and the biodiversity they represent.

Amid this celebration of life, we do not shy away from the harsh realities facing our ocean. The stark images of destructive fishing methods, damaged creatures and habitat devastation serve as poignant reminders of the urgent need to act collectively to preserve this delicate ecosystem.

The Ocean Speaks aspires to achieve something far greater than an anthology of ocean tales. We envision a world where the beauty and fragility of the ocean become ingrained in the hearts of individuals everywhere. We aim to foster a deep appreciation for the interconnectedness of all life, instilling a profound sense of responsibility for the preservation of our planet's greatest treasure. As you turn each page, we invite you to become a part of this transformative journey, standing with us as guardians of the ocean. Welcome to *The Ocean Speaks*, where the ocean's voice resonates and our story unfolds.

A beautiful moment with a misunderstood apex predator, the tiger shark (*Galeocerdo cuvier*). ('Co-existing with Sharks in Fuvahmulah', pp. 114-19).

THE
ATLANTIC
OCEAN

In the azure depths of the vast Atlantic, we encounter a tapestry of stories that shed light on the remarkable diversity and fragility of the oceanic realm. Delve into the enigmatic world of sperm whales and witness the transformation of the whaling industry in the Azores. Join Sea Shepherd in the fight against illegal fishing in Israeli waters. Discover the unique and vulnerable species interactions at the convergence of two habitats on South Africa's coastline. This chapter offers a captivating exploration of the Atlantic's wonders, and the delicate balance of life in its depths.

Shoals of fish gather in the kelp forests that hug the coastline off Cape Town, South Africa ('Where Two Worlds Meet', pp. 26-9).

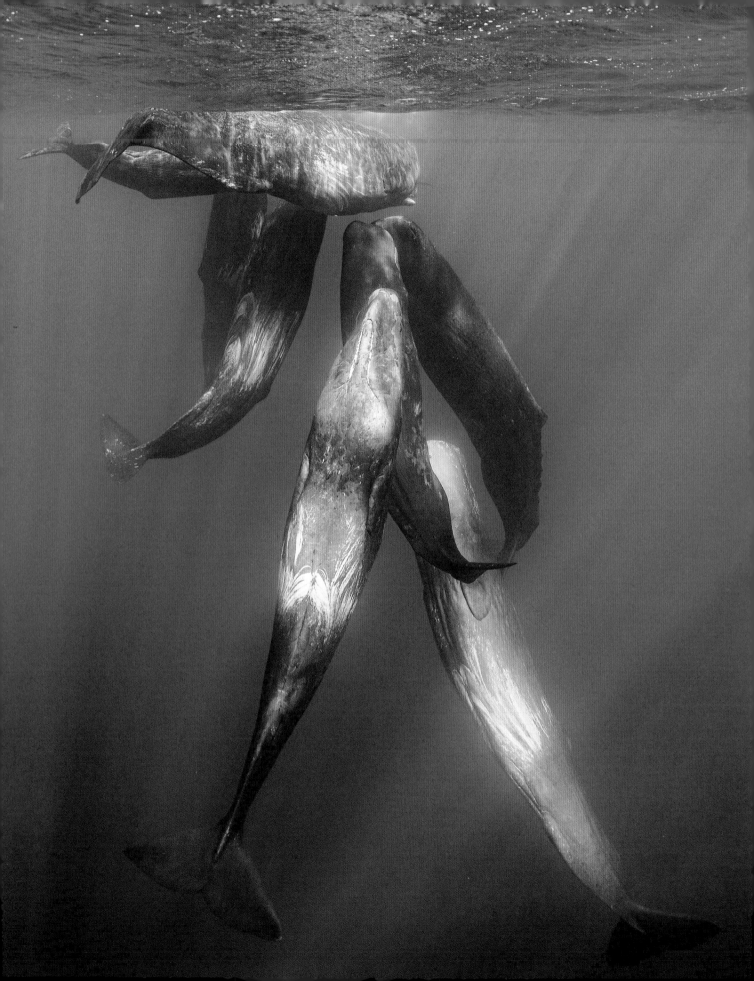

Giants of the Deep

THE AZORES

JAVI GARCÍA

With these photographs I wanted to give visibility to an animal - the sperm whale - about whose amazing capabilities there is still a huge amount to learn, and to highlight the changing nature of the whaling industry in the Azores.

A pod of sperm whales (*Physeter macrocephalus*) gathers in the Atlantic Ocean, in the waters of the Azores.

The Azores – sitting in the middle of the Atlantic Ocean, on the northern portion of the Mid-Atlantic Ridge – are a group of volcanic islands whose waters are home to some of the most important marine ecosystems in the North Atlantic. These islands act as a magnet for marine life, and the migratory routes of many large marine animals pass along their coasts. The waters reach depths of thousands of metres and contain multiple seamounts (or underwater 'mountains') that are of great importance. The Gulf Stream brings nutrients up from the depths here, causing an explosion of life. Krill, plankton and schools of small fish attract large predators, making the Azores an incredible oasis of marine life.

One such predator is the sperm whale (*Physeter macrocephalus*), and it is not just any predator; it is the largest in the world. These incredible animals can dive to great depths – around 1,000 metres (3,280 feet), even 2,000 metres (6,562 feet) – in search of food, especially squid, in dives that last about an hour. Their bodies are perfectly adapted to these deep dives. By echolocation – a system of clicks, generated by the spermaceti organ inside the whale's head – they detect their prey and

also communicate with each other. Between dives (if they are not socializing) the sperm whales come to the surface to rest for ten minutes and prepare their bodies to dive again in search of food.

Whales are of enormous importance to the proper balance of the ecosystem here. While they are at the surface, sperm whales defecate and urinate, providing nutrients that are consumed by phytoplankton and algae – one of the largest marine animals providing nutrients to some of the smallest. Even when they die, their bodies enrich the waters, leading to their being called 'gardeners of the oceans'.

The Azores are an essential feeding, calving and mating area for sperm whales in the North Atlantic. This is one of the best places in the world to observe and study the behaviour of these incredible animals, about which we know very little, as they spend most of their lives at great depths. Crucially, in the Azores, there has been a shift towards building a whale-watching industry that respects these creatures, which were hunted here until relatively recently. Whaling began in these waters in the eighteenth century, when American whaling ships frequently stopped off at the islands, and the last whales were caught at the end of the 1980s, following a 1982 moratorium on the trade. Whale-watching activities began in earnest in the 1990s, bringing the whaling culture back to the Azores, but in a more exciting and environmentally friendly way. In a short period of time, people from the islands have been able to transform their engagement with the animals, taking advantage of the ecological richness of the waters and ensuring that the activities carried out in them are undertaken in a sustainable way.

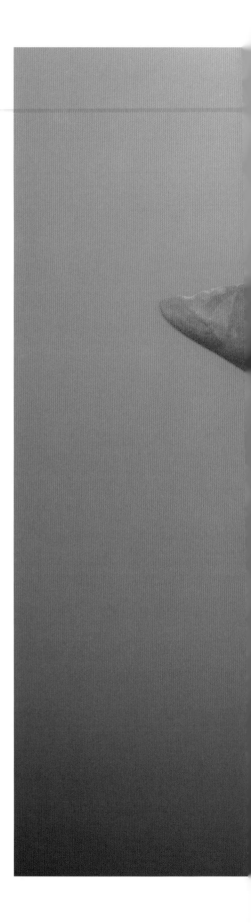

'This is one of the best places in the world to observe and study the behaviour of these incredible animals, about which we know very little.'

Sharing an intimate moment with this curious sperm whale as it approached my lens.

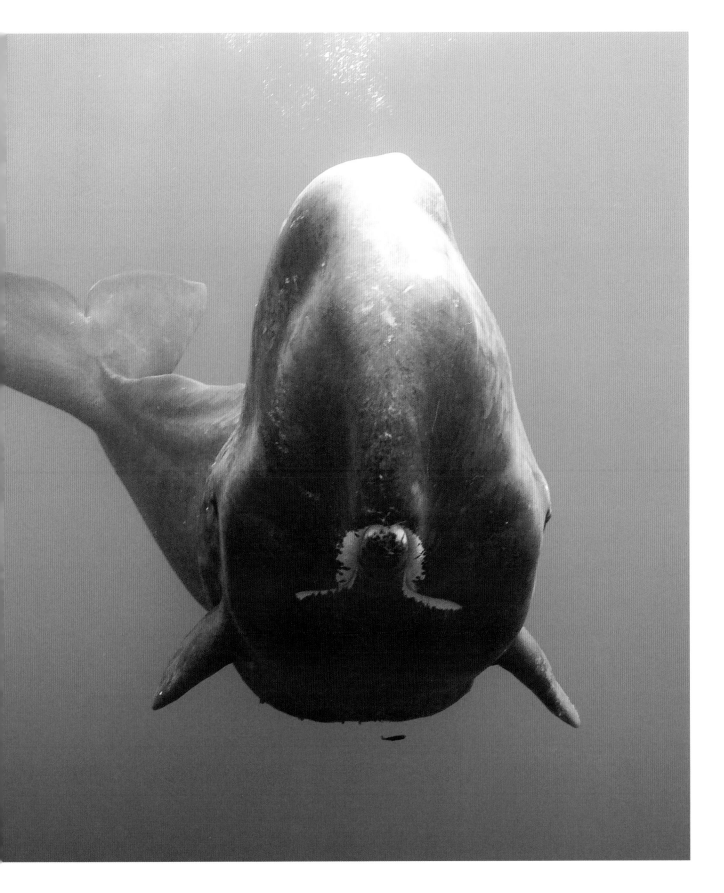

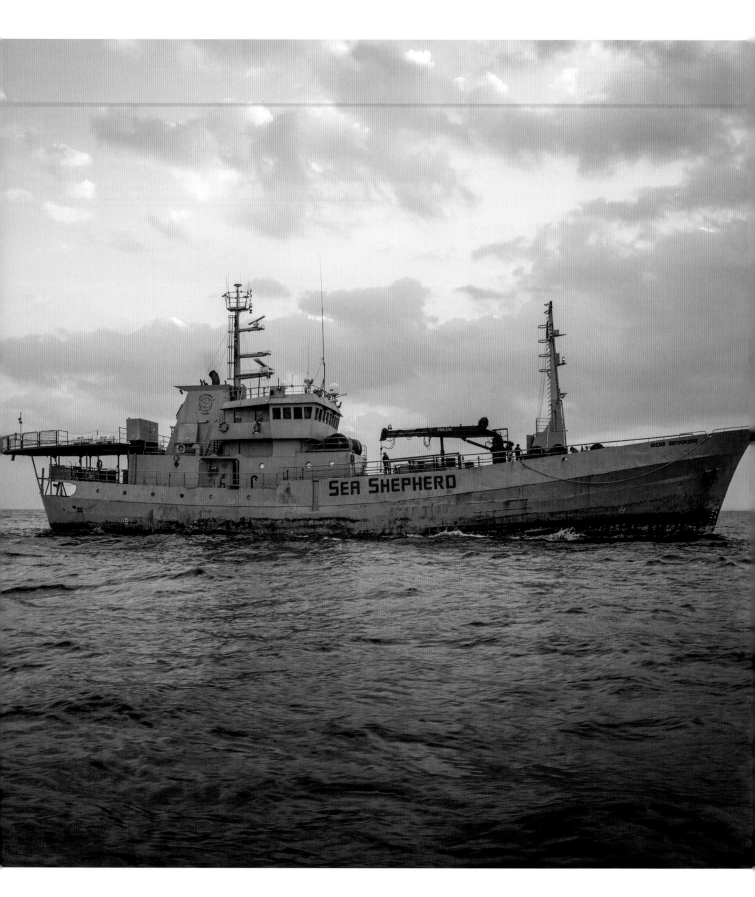

The *Bob Barker*, a ship that served thirteen years on its final campaign in Israel.

Fighting Illegal Fishing in Israeli Waters

MEDITERRANEAN SEA

MIKA VAN DER GUN
ADDITIONAL PHOTOGRAPHS
BY DANIELA BELTRAN

Under the campaign Operation Living Sea, and working in partnership with national governments in the region, marine conservationists from Sea Shepherd are helping to enforce bans on fishing, especially bottom trawling, in the world's most overfished sea.

Sea Shepherd is an international direct-action ocean conservation movement with a mission to protect marine wildlife and end the destruction of habitat. In Israel, the organization is monitoring bottom trawlers – ships with big nets that drag along the bottom floor, destroying everything in their way.

Bottom trawling accounts for one quarter of all global catches, more than any other single fishing practice. It targets bottom-dwelling fish and shellfish, but millions of non-targeted sea creatures like dolphins or turtles are also being killed in this way every year. Bottom trawling is also extremely destructive to seabed habitats, literally 'turfing up' anything that gets in the net's way. Seabed damage is not the only major environmental impact of bottom trawling. Overfishing and

RIGHT: The Sea Shepherd crew lifting the anchor.

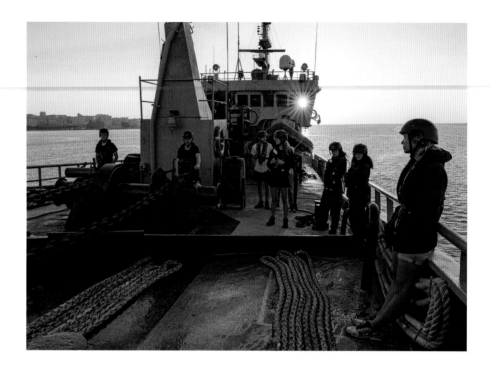

bycatch via bottom trawling are taking a toll on the biodiversity of our precious oceans. These threats to vital marine ecosystems are particularly dangerous when bottom trawling is poorly managed. In Israel, it is estimated that 3,000 sea turtles and thousands of rays, sharks and other marine animals are caught in fishing bycatch from bottom trawlers annually. In September 2022, oceanic conservation zones known as MPAs were set up in this region of the Mediterranean Sea, notably the Palmahim Slide, to protect the spawning grounds of overfished Atlantic bluefin tuna (*Thunnus thynnus)* and a reproductive hot spot for deep-sea sharks. This means that all fishing is banned inside this MPA.

As a videographer for Sea Shepherd, I had two main objectives: to catch evidence of bottom trawlers fishing inside MPAs on film, and to make the Israeli people aware of their problem. The campaign objective was to find out if there were bottom trawlers operating in MPAs or no-trawling zones. To find out, we were monitoring the vessels using radars. Once they were about to enter the MPA we would launch a small boat to the relevant coordinates to take photos and videos of the trawlers.

After one month of the campaign, we had managed to capture seven trawlers fishing inside restricted areas. This was out of a total fleet of sixteen (twelve active) trawlers. After the campaign was finished we heard that the campaign had garnered political attention. The ruling coalition has made a written declaration committing themselves to the expansion of marine protections in the Israeli Exclusive Economic Zone: creating new marine protected areas, and pursuing a compensation program to buy out the licenses of the last remaining industrial trawlers. This would amount to a de facto bottom trawling ban, which was a major goal of the campaign. The coalition said that our monitoring had contributed to this course of action.

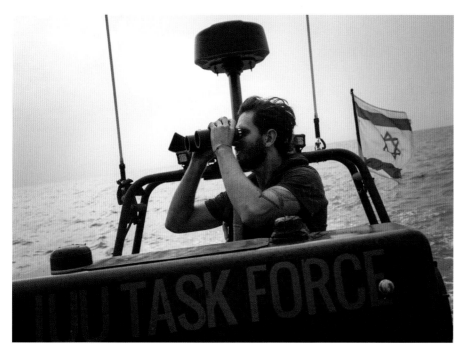

LEFT: Jesus in the small boat, patrolling the waters of Israel.

BELOW: A bottom-trawling fishing vessel in Israeli waters.

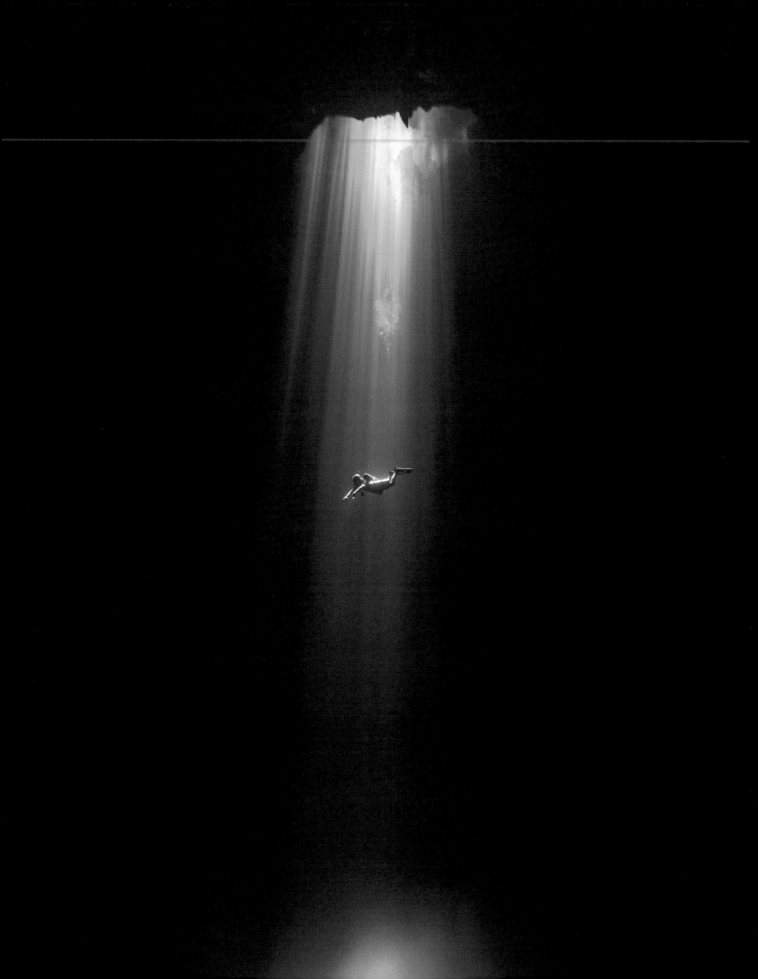

Exploring Cenotes

YUCATÁN PENINSULA, MEXICO

NADINE BAUER

Deep in the jungle of Mexico's Yucatán Peninsula lie more than 10,000 naturally formed limestone caves, which form part of a subterranean aquifer system running across the entire Caribbean peninsula. The sheer number makes this area uniquely special to underwater and cave explorers.

A cenote – the name is derived from the ancient Mayan word *Dz'onot*, meaning a cave with water – is formed by the collapse of sedimentary limestone, the resulting underground cavity exposing clear groundwater. These can be divided into three types: open cenotes, with a completely collapsed roof; semi-open or 'cavern' cenotes, where part of the limestone roof is still intact; and closed cenotes, which are completely underground and accessible only through caves or tunnels. Usually, the cenotes are wells filled with groundwater and also filtered rainwater. On the Yucatán Peninsula, an extensive coastal aquifer system also connects the cenotes' underground freshwater system with the ocean's saltwater. The cenotes are density stratified, with high-density saline water from the coast lying at the greatest depths, with lower-density ground- and rainwater floating above. The intrusion of saltwater into the freshwater caves results in an interface between the two aquifers, called the halocline. In addition to the interference of salt and fresh water, the decomposition of organic material – trees and leaves, for example – in the cenotes can produce a thick, toxic cloud of hydrogen sulphide.

A diver floating in the radiant beauty of Cenote Maravilla.

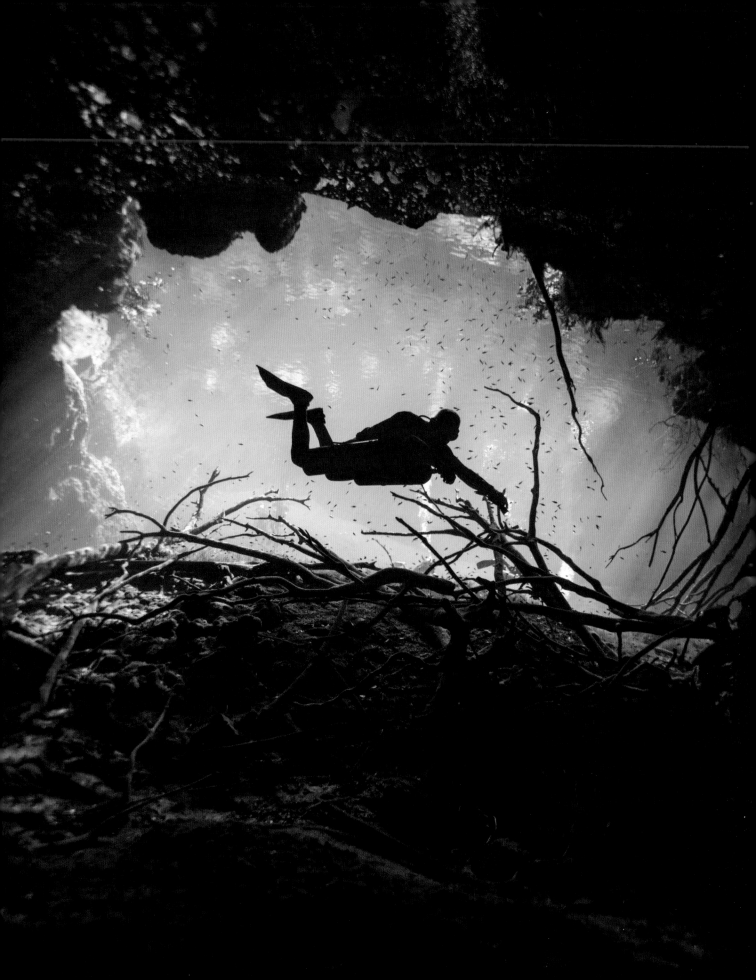

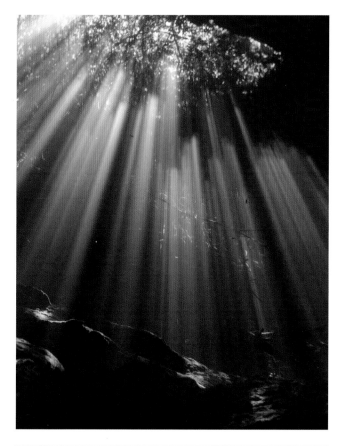

The importance of the cenotes dates back to the ancient Maya people, who used the cenotes as their main source of potable water. Many ancient cities, such as Chichén Itzá, were built around these natural wells. In recent years, more and more ceremonial artefacts and human remains have been found in the freshwater caves, some more than 13,000 years old. Their discovery suggests that the cenotes also had ceremonial significance to the Maya.

Today, the cenotes attract divers and water lovers from around the world. While exploring the unique formations, you can see a remarkable spectrum of flora and fauna, though less than is found at sea, due to the lack of natural light. The cenotes are home to alligators, small turtles and a variety of fish that thrive in the caves; these creatures have developed features such as blindness and long feelers to explore the darker environment.

I want to convey the historical and archaeological significance of the cenotes, their importance to Mexican culture and their place in the ecosystem of the peninsula. Pollution, including plastic waste, is affecting this ecosystem. To this day, the cenotes are an important source of groundwater for farmers and for the locals who are responsible for taking care of them where they are on private properties. Plastic pollution, and thus the contamination of our oceans, directly and indirectly affects the freshwater system in Mexico. Because of their weak limestone structure and their rarity, the cenotes must also be protected from destructive forces such as the construction of the *Tren Maya* (Maya Train, started in 2023). This government project is causing the collapse and contamination of several cenotes, and threatens historical sites and relics that, once destroyed, cannot be replaced. It is of crucial importance to preserve this unique ecosystem and its culture.

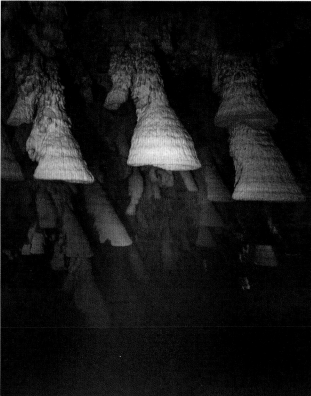

OPPOSITE: A diver explores Cenote Carwash's clear waters, beside ancient cavern walls.

ABOVE: Sunlight filters through tree roots, illuminating Cenote Jardín del Eden's surreal underworld.

LEFT: A 'Hell's bells' formation, a geological wonder, in the captivating depths of Cenote Zapote.

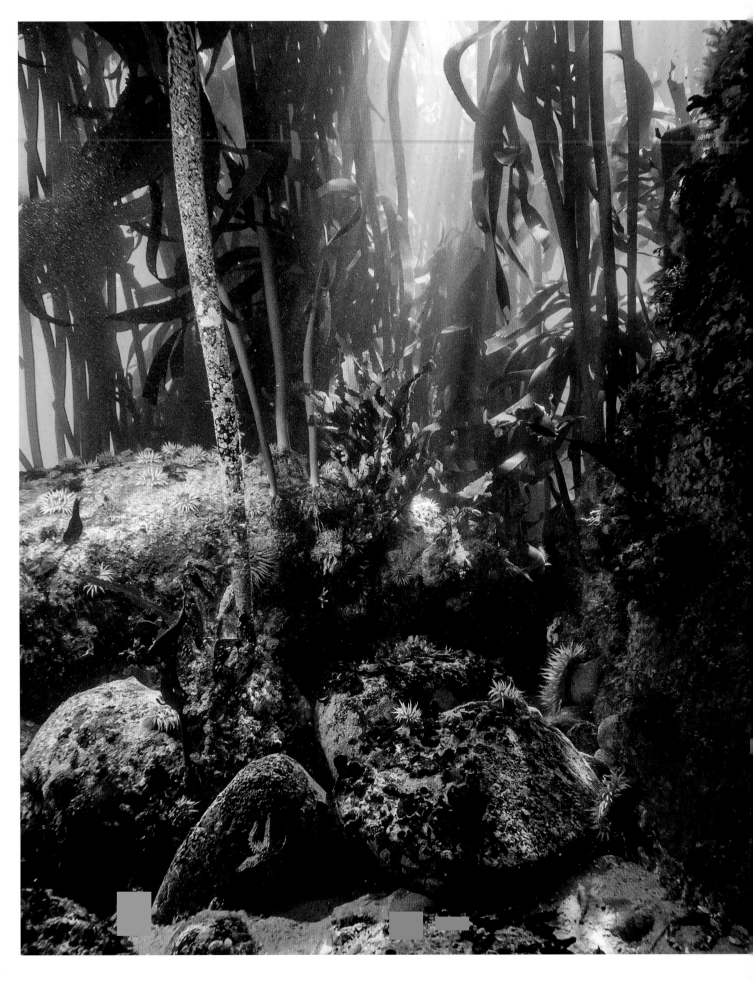

Where Two Worlds Meet

TABLE MOUNTAIN NATIONAL PARK, CAPE TOWN, SOUTH AFRICA

CALLUM EVANS

On the coastline of the South Western Cape of South Africa, two richly biodiverse habitats meet, giving rise to interactions between species that are unique but also uniquely vulnerable to human intervention.

Where the fynbos biome– a narrow strip of unique scrubland, characterized by a mild Mediterranean climate and an incredible variety of low-lying plant life – meets the kelp forests of the ocean, there is a transition zone that shapes this unique portion of coastline. Here, animals from the land (including baboons and otters) can directly access the resources that the ocean provides, and larger marine animals (like octopus and several species of shark) can come into very close contact with terrestrial ecosystems as well. However, rapid urbanization has drastically altered large areas of the coast and natural areas are still exposed to a range of anthropogenic problems, from pollution – even on the more secluded beaches, plastic, netting, polystyrene and other items of trash can be found washed up – to invasive species. Our coastlines are crucially important ecosystems for many species and provide millions of people with food and recreation. In Cape Town, this transition zone between habitats has an essential

Kelp forests flourish in the shallow waters just off the coast of the Cape Peninsula.

part to play in our future; transition zones such as these act as wildlife 'corridors', allowing animals to move freely. We must be far more vigilant and aware of how we interact with these habitats.

The Cape Point section of the Table Mountain National Park contains some of the most intact fynbos on the peninsula, with clear areas of coastal Strandveld (beach scrub), in which the plants have adapted to the loose, nutrient-poor soils and grow, stabilizing the sand dunes on the coast. Large herds of bontebok (*Damaliscus pygargus*) and eland (*Taurotragus oryx*), as well as other herbivores, feed here, getting vital salts by feeding on vegetation that grows in close proximity to the ocean and gets covered in spray from the waves. Birds like kelp gulls (*Larus dominicanus*) and sacred ibis (*Threskiornis aethiopicus*) scavenge on what gets washed up on the shore, while the endangered African black oystercatcher (*Haematopus moquini*) nests on the undisturbed beaches and relies on the intertidal zone for the shellfish it feeds on.

The Cape clawless otters (*Aonyx capensis*) that live along the Cape Peninsula do much of their hunting in the shallow waters just off the coast, searching for crab, fish and shy sharks among the rockpools and kelp forests, returning to shore to eat their catch and rest. Larger animals like Cape fur seals (*Arctocephalus pusillus*) and occasionally Southern elephant seals (*Mirounga leonina*) also use the coasts here to rest or sometimes to breed.

Rockpools created by the tides are a dominant feature of the intertidal zone and can be full of life – the larger the pool (and the closer to the ocean it is), the greater the diversity of life it can support. Cape sea urchins (*Parechinus angulosus*) carpet the rocks at the bottom of many pools, while sea anemones (*Actiniaria*) will often be nestled in cracks in the rock. Some pools can be less than 30 centimetres wide, while others can be 20–30 metres wide and almost 2 metres deep. In large pools, there is a good chance of finding an octopus on the hunt. They are one of the few animals that can leave the water and move between the pools and the ocean.

This is just a snapshot of life on Cape Town's coastlines, both above and below the waves, illustrating the importance of the ecological connections between the land and the ocean. What happens in one ecosystem can influence another.

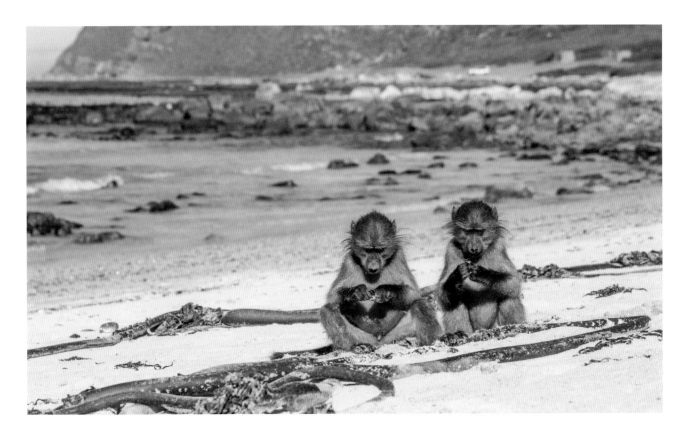

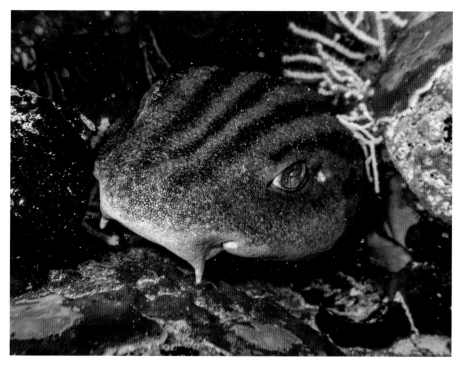

OPPOSITE: Juvenile chacma baboons (*Papio ursinus*) feeding on mussels on a beach in Cape Point.

LEFT: A pyjama shark (*Poroderma africanum*), one of the kelp forests' top predators, resting in a small crevasse.

BELOW: A hawksbill sea turtle (*Eretmochelys imbricata*) visiting the coastal kelp forests close to Cape Point.

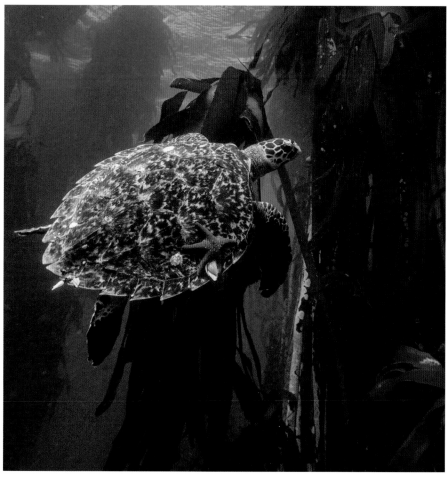

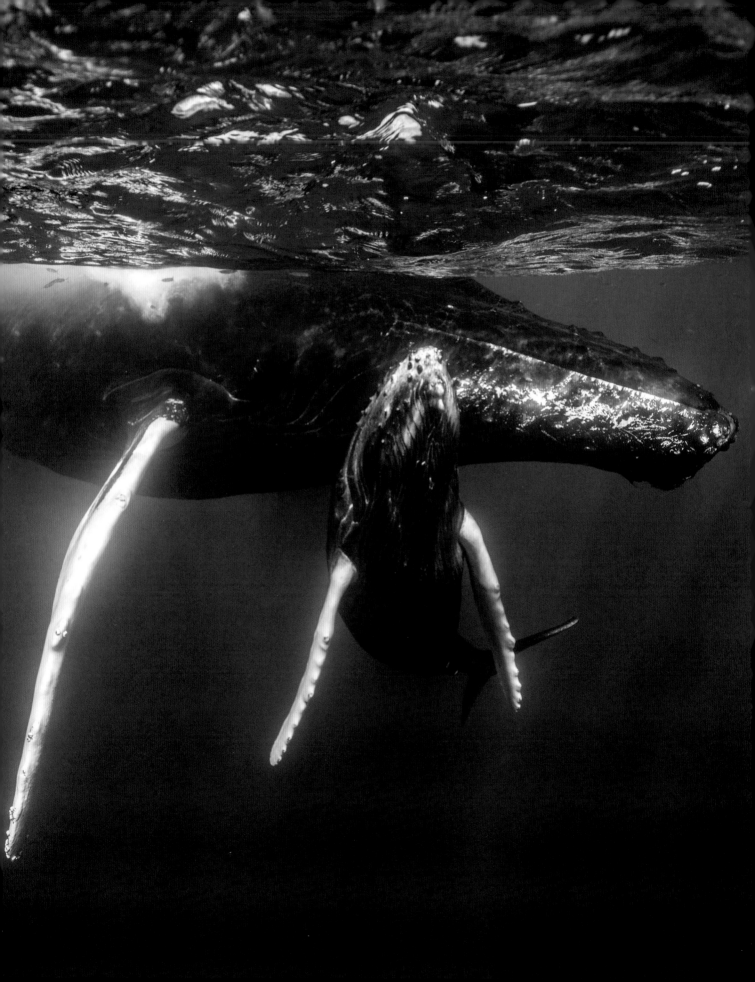

Journey of the Giants

SILVER BANK, DOMINICAN REPUBLIC

CATHERINE CUSHENAN

Each year, in the region of the Silver Bank – a shallow submerged bank approximately 125 kilometres (78 nautical miles) north of the Dominican Republic – the Sanctuary for the Marine Mammals of the Dominican Republic plays host to over 3,000 humpback whales (*Megaptera novaeangliae*).

These leviathans pass through the waters of the Sanctuary to mate and give birth, spending up to six months without food or sustenance in the time between travelling and returning to their feeding grounds. They travel from Greenland, Iceland, America, Norway and locations further north. I capture just the end of this journey, which has brought these creatures halfway around the world to ensure the survival of their species.

Most individuals travel solely for the purpose of mating, while pregnant females will also make this long journey to give birth safely in the remote shallow waters after a year-long gestation period. The whales do not feed at the Silver Bank, and these new mothers will usually lose a third of their body weight by the time they return to the north, sacrificing their energy stocks to nurse their newborns while spending months training their young to survive and giving them time to grow enough blubber to survive the colder northern waters.

For us humans, being out in their breeding ground gives a rare opportunity to capture insights into the tiny moments taking place

OPPOSITE: A calf sneaks closer to the camera, while the mother hovers patiently behind.

OVERLEAF: Mother and calf coming up for air, the calf shyly positioned between mum's flippers.

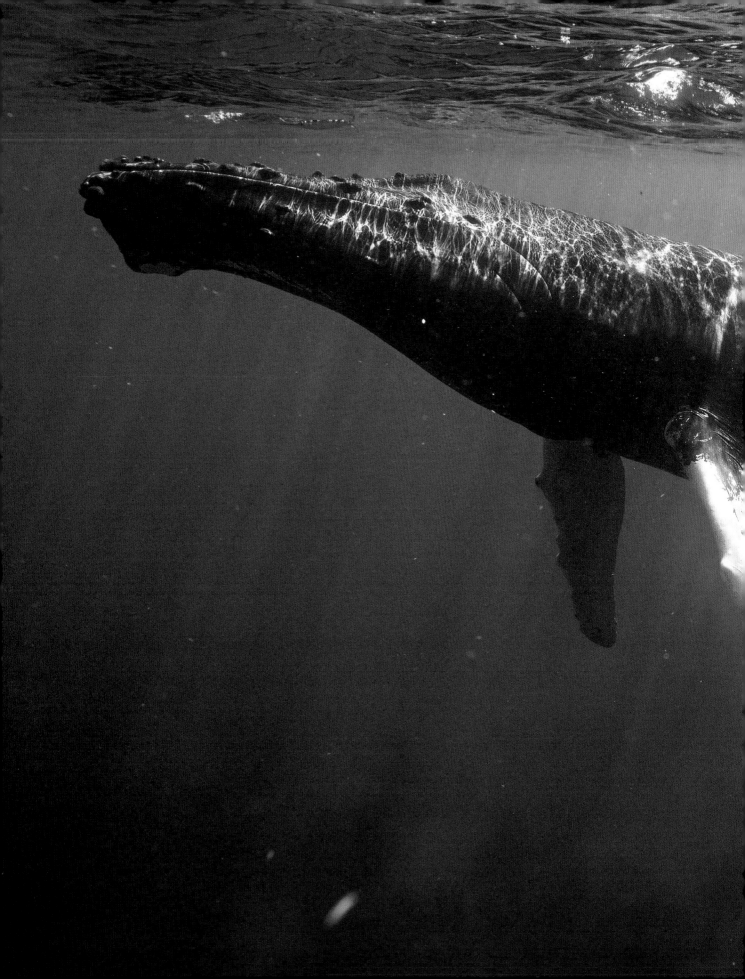

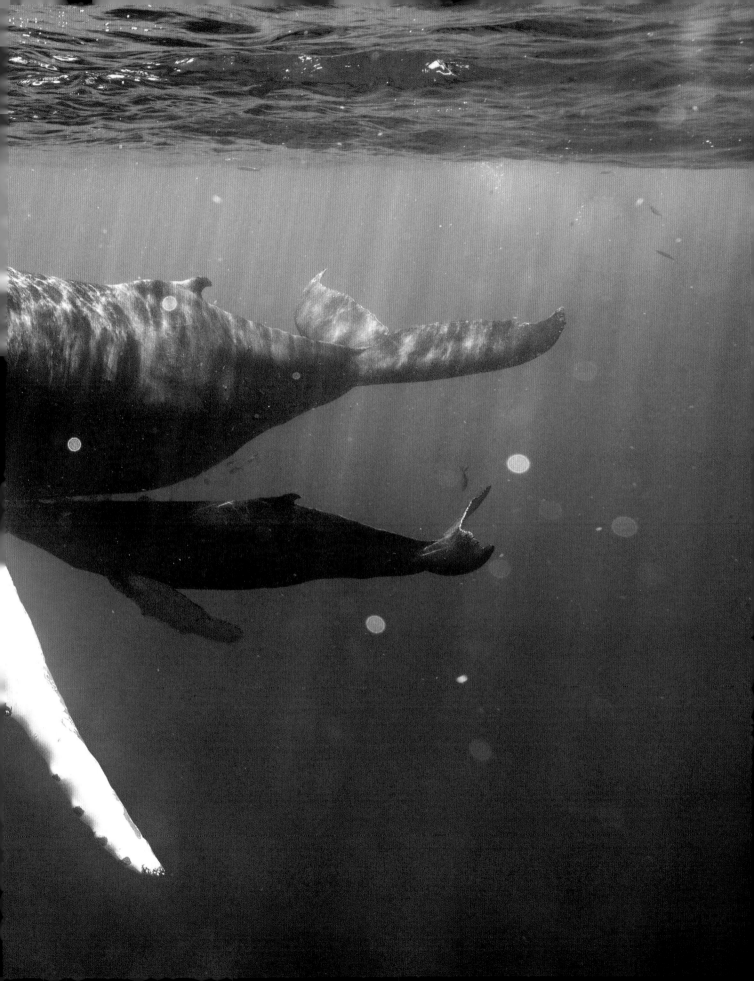

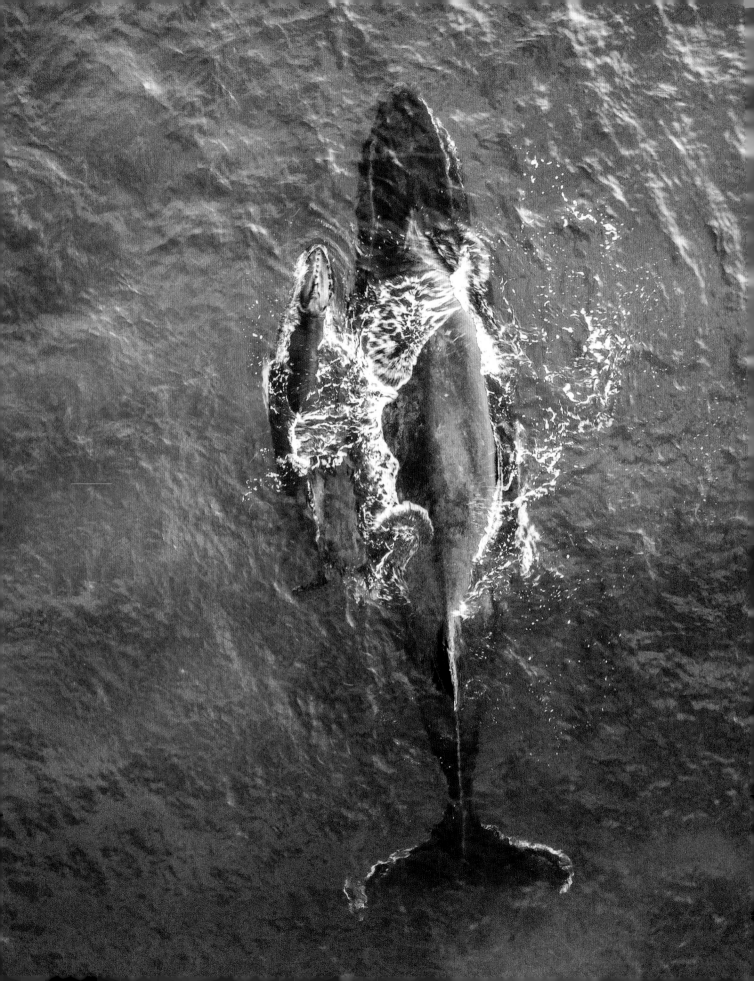

within these extraordinary families.

The Sanctuary itself was established in 1986, and has been expanded twice since, so that it covers an area of 64,000 square kilometres (40,000 square miles). To reach this particular remote area of the world, you must spend half a day travelling by boat. Once you arrive you have no access to the outside world; no phone reception, no internet, nothing. You're alone with the whales. In addition, visitor numbers are limited, with only three boats allowed on the bank each year. Very little footage and documentation exist for this location – images of these individuals in their breeding ground have rarely been seen.

There are huge learning opportunities here, with a chance not only to observe the behaviours of the whales, but to investigate their origins and just how far they travel to arrive on the Silver Bank. Spotting and identifying whales in this tiny little protected area provides proof of their migrations, which are not otherwise seen.

'Once you arrive you have no access to the outside world: no phone reception, no internet, nothing. You're alone with the whales.'

Aerial shot of a female whale with her newborn calf, floating at the surface of the water.

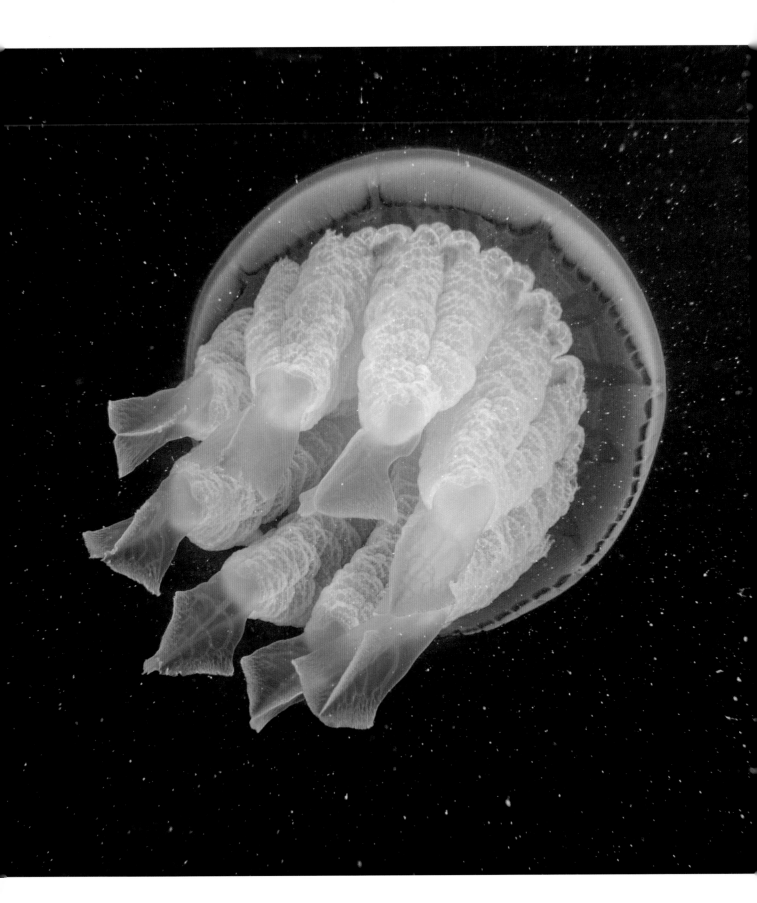

A barrel jellyfish (*Rhizostoma pulmo*).
The 'backscatter' effect makes this
photograph especially dramatic.

Magnifying the Macro

JERSEY (CHANNEL ISLANDS)

GRACE BAILEY

Cold-water diving here in Jersey requires robust
equipment and technical diving skills, but the reward is
a glimpse into an exceptional marine environment, home
to extraordinary and often-overlooked macro life.

Some of the world's most beautiful and challenging cold-water dive
sites are found in Jersey. The magic of this kind of diving comes not
from crystal-clear visibility or warm waters, but the anticipation of the
challenge that awaits, the thrill of excitement when you discover a
hidden gem. In Jersey, especially, big tidal range, changeable currents
(testing your ability to stabilize yourself and maintain buoyancy)
and weather require divers to be vigilantly well-prepared, but it is a
challenge worth taking on, as the reward is a kaleidoscope of vibrant
macro marine life that sways gracefully in the current.

The waters here are teeming with life and a dive provides a unique
and enriching experience for anyone with an interest in the natural
world. Jersey's seascapes are punctuated by majestic shipwrecks that
have become home to colourful soft corals – a delight for the senses,
with their vibrant colours and intricate forms – and countless other
thriving species. Jellyfish, with their graceful movements and delicate
tentacles, are always a highlight of any dive. And nudibranches, so
flamboyant, so bright and uniquely shaped, are a true wonder of the
natural world.

For me, the special beauty of the marine life here lies in the often-

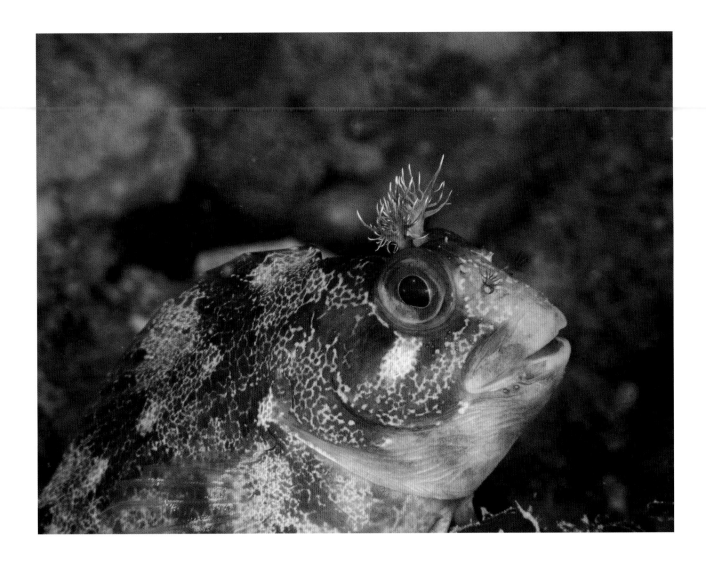

unnoticed and overlooked creatures. Underwater macro photography has allowed me to capture the concealed beauty of these tiny lifeforms, and the art form has transformed the way I experience the underwater world, heightening my appreciation for the fragile ecosystem that exists beneath the surface.

When you have successfully located the perfect spot to photograph charismatic critters like the Tompot blenny (*Parablennius gattorugine*) – a cheeky chap with a vibrant look – then the fun can begin. These tiny fish are known for their curious nature and will approach the lens of an interested photographer. However, capturing images requires particular attention to detail, precision, and patience. Tompot blennies often retreat to their dens, darting back when they sense you aren't there. It is an intimate experience when they finally make eye contact with you, and you catch their look with the camera.

Jersey is vulnerable to the same environmental threats as other locations around the globe: overfishing, pollution, climate change. One of the most significant issues here is the presence of invasive species, which disrupt the natural food chain and

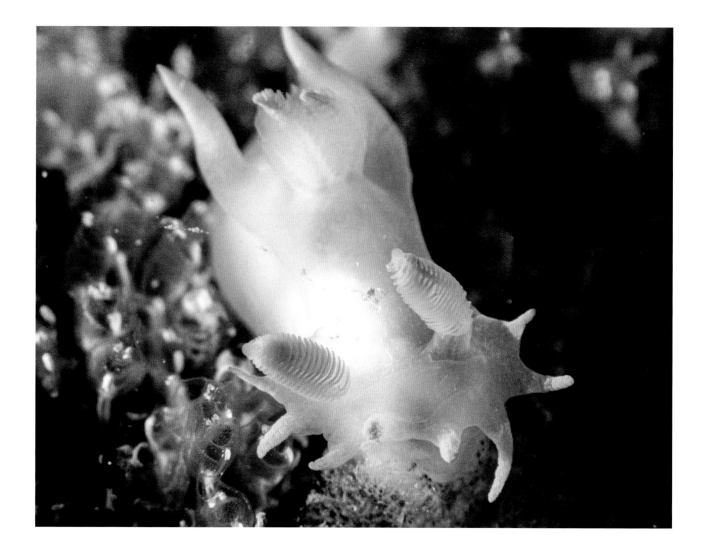

out-compete native species, leading to a decline in biodiversity. With climate change causing shifts in temperature and weather patterns, it is becoming increasingly common to see non-native creatures in Jersey's waters, and for avid macro-photographers such as myself this is a bittersweet opportunity. On the one hand, it provides a chance to capture interesting shots of these unfamiliar creatures. However, on the other hand, their very presence is a deflating reminder of the real impact of climate change.

My own photography is used to aid in conservation efforts, helping researchers to track environmental health on Jersey and build an accurate database of local critters. Additionally, my aim is to educate the public on what lives beneath the surface, why this matters and how it can be better protected. By working together and taking small actions to reduce pollution and promote sustainability, we can all do our part to protect this fragile ecosystem.

ABOVE: Nudibranchs (*Nudibranchia*), though small, offer a variety of photo opportunities.

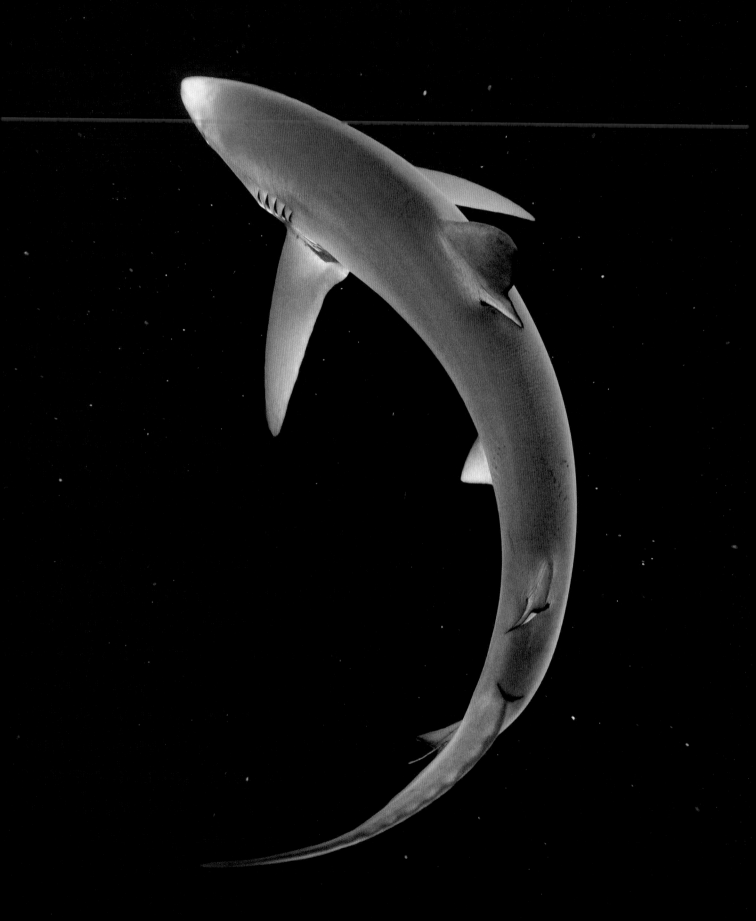

Fighting for the Blue

CELTIC DEEP, WALES

LIAM WEBB

Every minute, approximately 200 sharks are killed by humans – a statistic that prompted artist Francesca Page to launch the 200 Sharks project, bringing humans face to face with lesser-known species through art. The blue shark is one such species, sighted by this photographer in the astounding waters of the Pembrokeshire coast.

Collaborators on the 200 Sharks project are on a mission to shed light on lesser-known species of sharks and rays (*Elasmobranchii*), using the power of art and film to transform fear into curiosity and love. My own part of this work is a documentary film that aims to showcase the enchanting world of the blue shark and raise awareness about its protection from overfishing and exploitation.

The goal is to challenge the common misconception of sharks as mindless killers and, instead, reveal them as diverse and intelligent creatures in need of our protection. The blue shark (*Prionace glauca*) was a natural choice to kickstart our efforts, as it is one of the most exploited species globally. These creatures are very vulnerable to being caught as bycatch due to their proximity to other commonly caught fish. However, this species is also extensively fished for its meat and fins, and its products are sold under various (sometimes misleading) names worldwide such as 'flake' and 'white fish'.

Diving regularly with blue sharks in the Celtic Deep, Wales, I've been amazed by their personalities, playful behaviour and stunning beauty.

A blue shark (*Prionace glauca*) drifting through the deep waters, with traces of the fish it was feeding on moments ago.

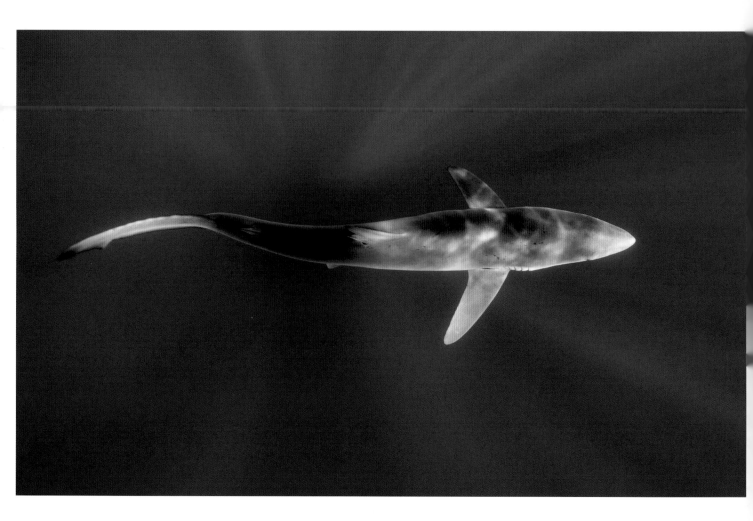

A shark that shines a deep electric blue, sleek and elegant in build, this is one of the most effective and mesmerizing of all the ocean's travellers.

They are regular visitors to the UK; the Celtic Deep, in particular, is a favourite spot for them to spend their summers, as this area between England, Wales and Ireland is rich in nutrients and food. There are plans to protect this area, due to its vital role in the health of the seas around the UK. It is vital for blue sharks, but also for many other endangered and vulnerable animals that inhabit these waters, such as fin whales (*Balaenoptera physalus*) and leatherback turtles (*Dermochelys coriacea*). While much remains unknown about the blue shark's exact migration patterns, it's evident that young females travel north to our rich waters for feeding, while the males stay in tropical waters off the coast of Africa.

While globally they are listed by the International Union for Conservation of Nature (IUCN) as 'Near Threatened', this is not the case for all the distinct populations. In the North Atlantic, where I am diving, they are thought to be in a 'Vulnerable' or 'Critical' state, according to a recent IUCN report. This is very alarming; the global listings for species can often mean that local populations are missed, and we could lose this population before anyone pays attention. There is still very little known about blue sharks and, therefore, raising awareness is key for this species.

ABOVE: Looking down into the Celtic Deep; the beautiful blue shark in its element.

RIGHT: An inquisitive blue shark comes to check out the photographer.

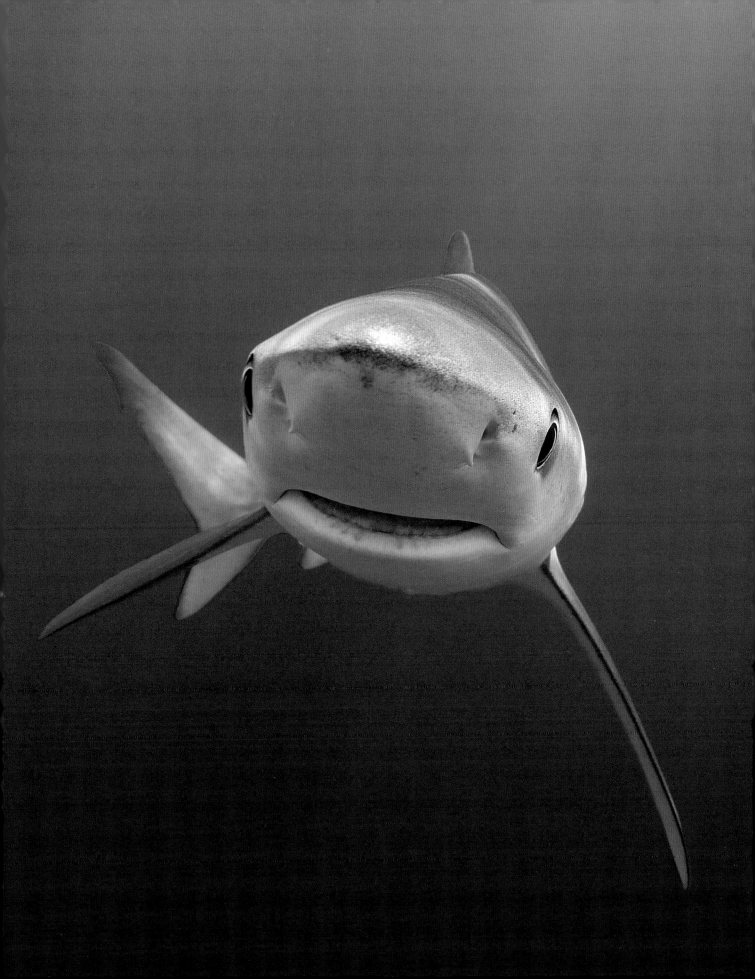

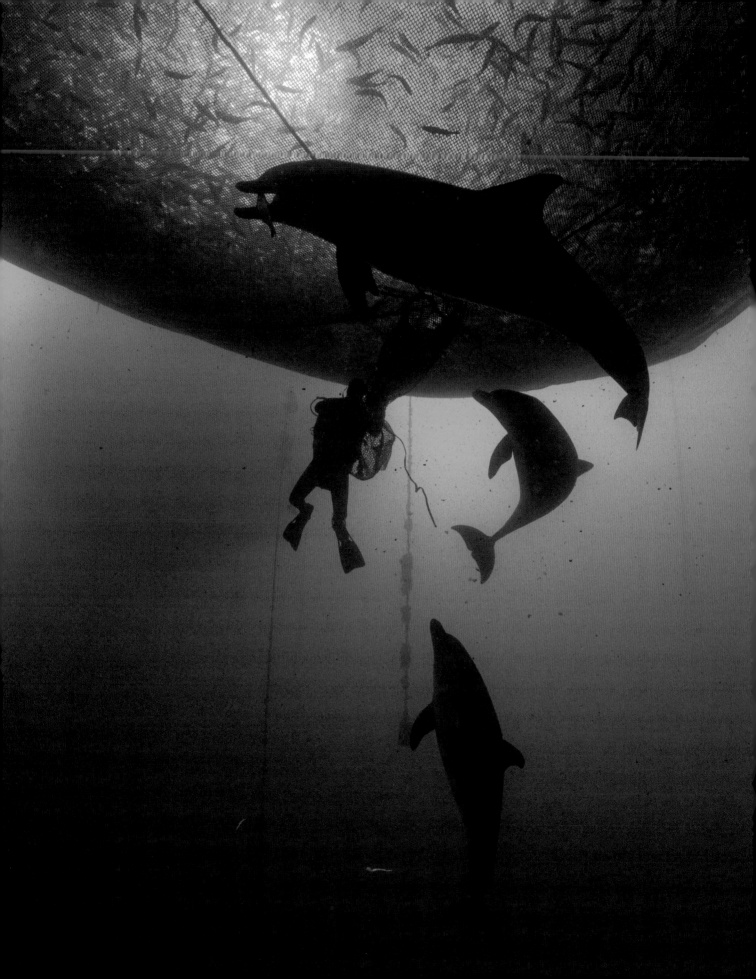

The Leftovers

AEGEAN SEA, MEDITERRANEAN SEA

CLAUDIA SCHMITT

On a recent trip to the Mediterranean Sea, I was treated to the sight of two incredible, and increasingly rare, creatures. The sight of these animals feeding on human 'leftovers' was a stark reminder of the impact humans have on our oceans.

In the Mediterranean 86 per cent of the fish populations are overfished. Marine predators now often struggle to find enough food and are forced to move closer to the shore – and to humans – in search of sustenance. Atlantic bluefin tuna (*Thunnus thynnus*) are such a predator, themselves hunted almost to extinction to satisfy our hunger for sashimi and sushi. Stricter regulations have finally been put in place to save them from disappearing from the Mediterranean altogether, and populations are slowly recovering, but their future still lies in our hands (and nets, and on our plates). I had become convinced I was never going to see bluefin tuna in the wild and alive, until a recent summer spent cruising the Mediterranean Sea.

Some of our dive sites on this trip were incredibly beautiful, but others clearly showed signs of the devastating impact humans have on this small sea. Only a narrow channel connects the Mediterranean Sea with the Atlantic Ocean. This limits the exchange of water and wildlife, which, together with some other factors, makes it the most polluted and overfished sea in the world. When we came to a small island in the southern Aegean, we had the opportunity to dive with a team of

A commercial diver doing maintenance work on a local fish farm.

commercial divers at a local aquaculture farm. I had heard stories and rumours about what was going on at this farm, but I wanted to see for myself. I didn't have to wait long: as soon as the dive boat arrived at the fish farm, large fins appeared on the surface, cutting through the waves.

The fins belonged to a group of bottlenose dolphins (*Tursiops truncatus*). They have learned that commercial divers regularly come to release any dead wolffish that have sunk into small holding nets at the bottom of the aqua-farm pens. The small group of dolphins followed the divers around, whistling and clicking eagerly, while the divers untied the nets. That was the moment the dolphins were waiting for – an easy meal! But they are picky, choosing only the best and freshest fish to eat. Others were less selective: around a dozen bluefin tuna were lurking in the deep and quickly scooped up whatever the dolphins spurned. Measuring a length of over 2 metres (6½ feet) and weighing in at more than 250 kilograms (551 pounds), these fish are incredibly impressive. The dolphins and the tuna followed us and the commercial divers from one towering fish pen to the next, until all nets were checked and emptied.

Diving with social and intelligent dolphins is always a great experience, and one on many divers' wishlists. It's usually not easy to find them in the Mediterranean, though, with population numbers decreasing. This is even more the case for the majestic tuna, king of the ocean. To see, photograph and film these incredible creatures was definitely one of my greatest moments underwater – one that still resonates with me. It was, however, a double-edged experience: amazing to see families of dolphins and tuna up close, yet they were feeding on the scraps that humans discard. For the dolphins, the tuna, the wolffish, the ocean is home. We share it with them and they all suffer from our greed, be it directly or indirectly.

Bottlenose dolphins (*Tursiops truncatus*) surround a fish pen and diver in search of an easy meal.

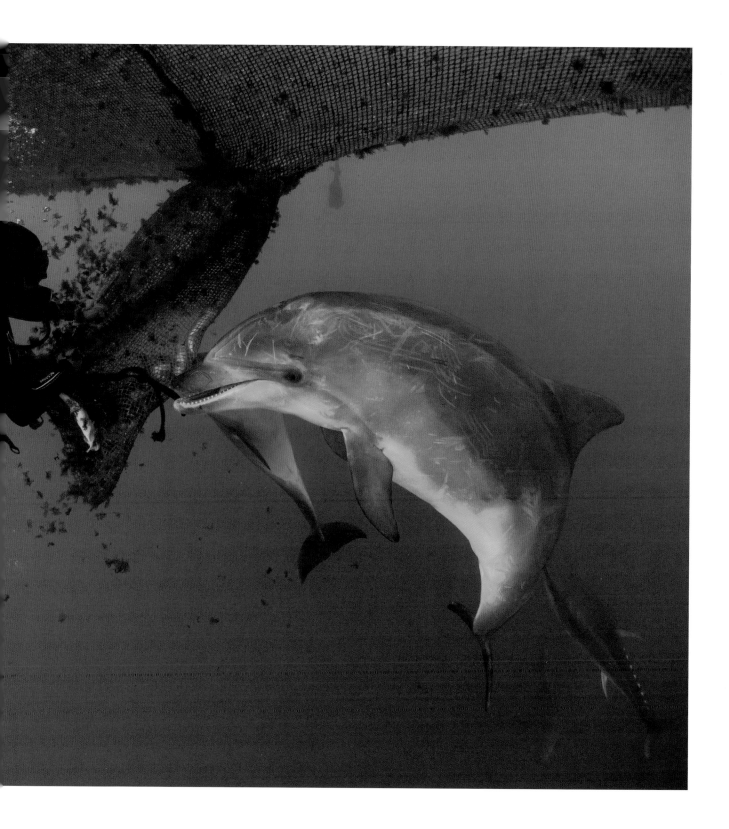

'Diving with dolphins is always a great experience,
and one on many divers' wishlists.'

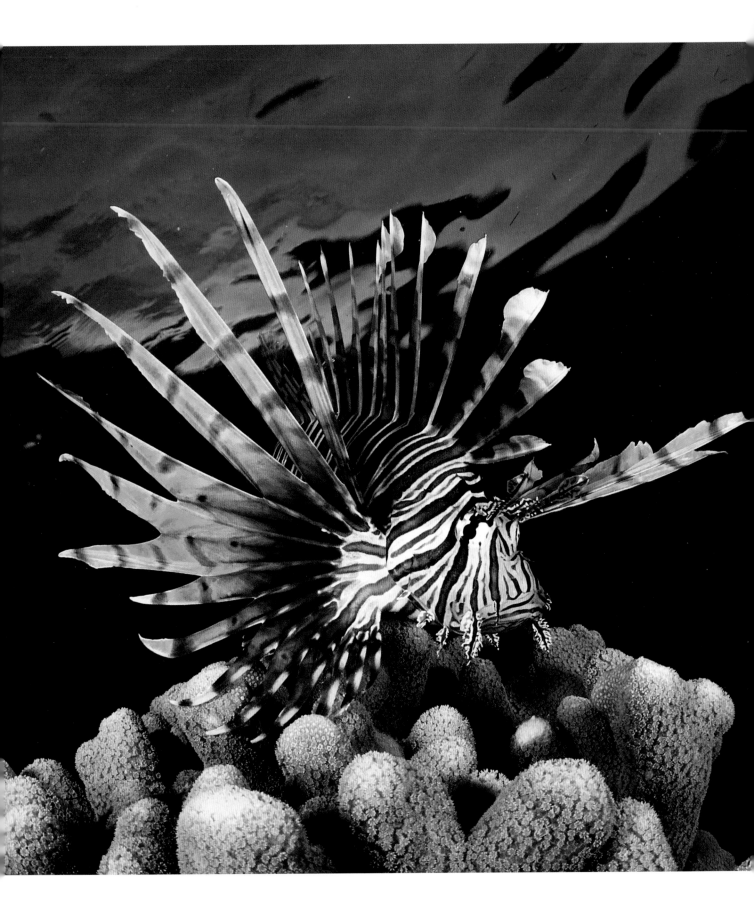

Invasive red lionfish (*Pterois volitans*) in the Caribbean do most of their hunting at dusk and into the night.

Beautiful and Dangerous Invaders

THE BAHAMAS

TAMSIN RAINE
PHOTOGRAPHS BY SHANE GROSS
AND MATT PORTEOUS

Gracefully drifting through the water with their elegant, fan-like fins and delicate tentacles, lionfish (*Pterois*) create an aura of beauty. However, don't be deceived! These enigmatic creatures are equipped with venomous spines and have become invasive in tropical waters worldwide, beyond their native Pacific home.

The lionfish invasion is often traced back to 1992, when Hurricane Andrew wreaked havoc on an aquarium tank in Florida, releasing several venomous lionfish into the Atlantic Ocean. While this event is often cited as triggering the current proliferation of the species, lionfish had been caught in the region previously, likely as a result of fish and eggs being deliberately released into the wild.

Lionfish possess insatiable appetites and reproduce vigorously throughout the year, with a single mature female releasing approximately 2 million eggs annually. Lacking natural predators in the Atlantic, they jeopardize reef systems in the Bahamas by preying on fish that play a crucial role in cleaning and maintaining the health of

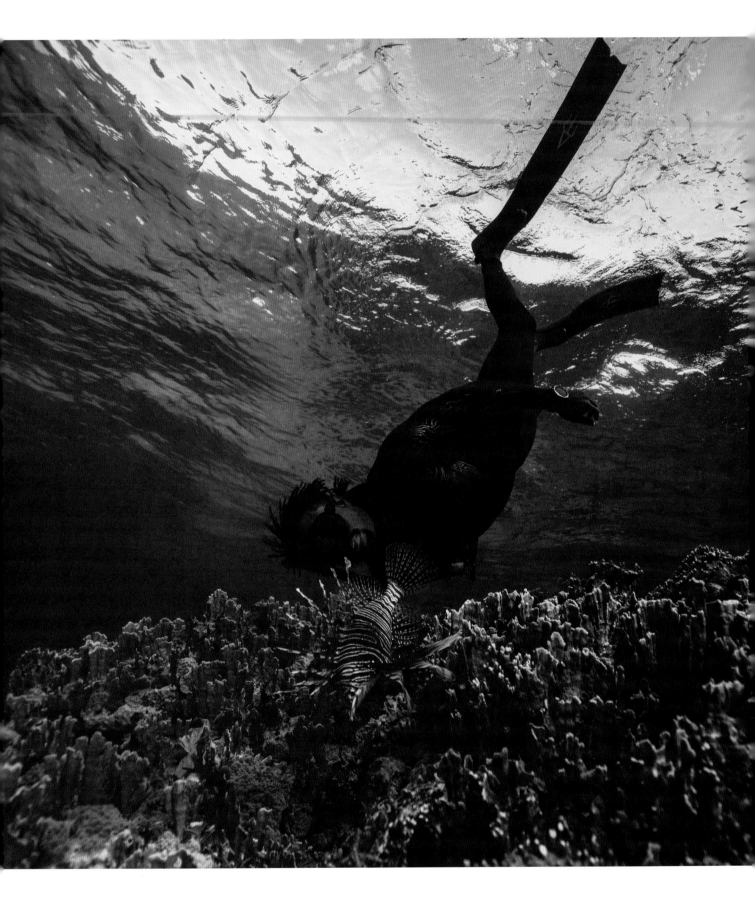

THE ATLANTIC OCEAN

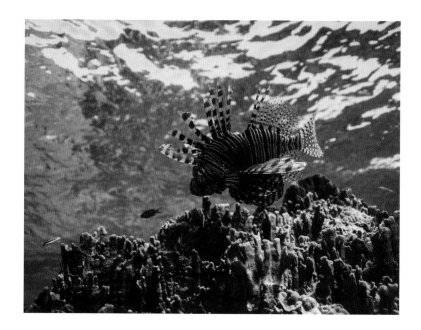

the reefs. In turn, the threat to the reefs imperils the commercially and recreationally significant fish species dependent on them. Recognizable by their striking red-and-white stripes and a row of venomous spines adorning their backs, lionfish resemble a lion's majestic mane. Like their namesake, they are formidable predators, capable of decimating up to 75 per cent of a reef's fish population in a mere five weeks.

While juveniles measure less than 2.5 centimetres (1 inch) in length, adult lionfish grow to approximately 33–38 centimetres (13–15 inches). Remarkably, they have been found thriving at depths of up to 91 metres (300 feet), with larger specimens exhibiting even greater breeding and feeding capabilities. In the wild, lionfish can survive for up to 15 years. Regardless of their size, all lionfish possess spines along their back, pelvis and underside, which they employ for defense. When a lionfish spine punctures flesh, a toxin is released from venom glands along the fish's backbone. In the Bahamas, where invasive lionfish thrive, local communities have taken action to control their proliferation. Without their spines, lionfish pose no risk of venom injection; this characteristic enables people to safely capture, cook and consume lionfish, provided they take precautions to avoid the venomous spines.

Research teams are now looking into the ways in which the lionfish population might come under control, beyond manual removal. The species seems currently to be resistant to the spread of certain marine parasites – if lionfish fall victim to local predators or to parasitism, it may form a natural control on their numbers.

OPPOSITE: Local freediver and Ocean Culture Life Guardian André Musgrove monitoring lionfish populations.

ABOVE: A lionfish gliding through the vibrant coral reefs of the Bahamas.

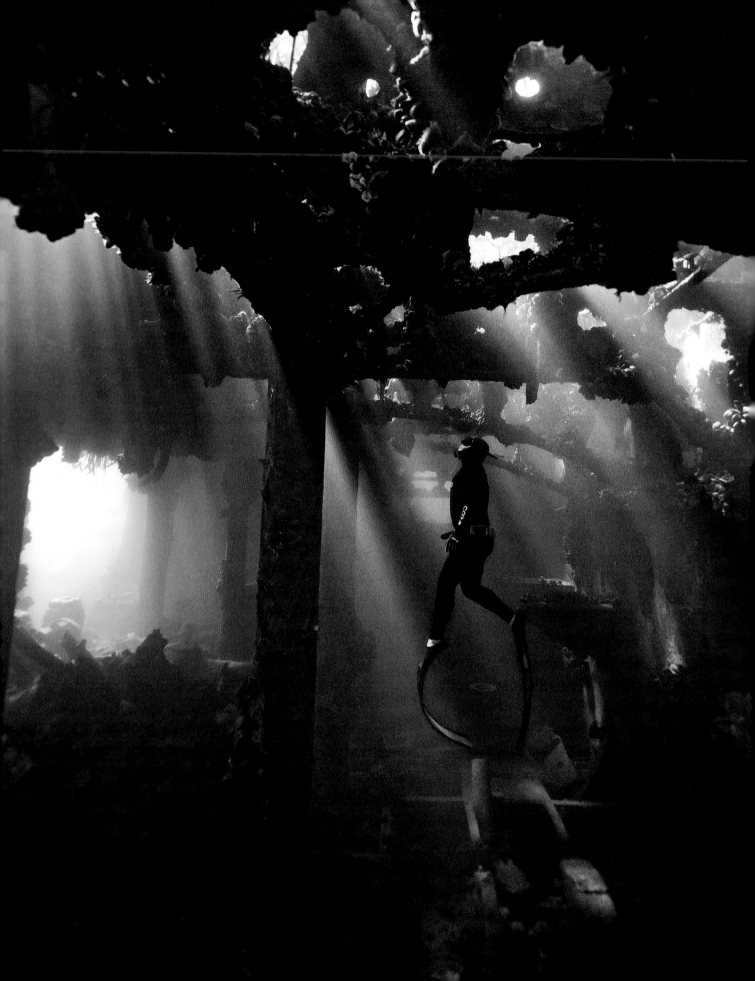

Diving through History

CAPE TOWN, SOUTH AFRICA

PIER NIRANDARA

Initially settled as a refuelling station by the Dutch East India Company, Cape Town is a city whose history is interwoven with that of the two oceans that meet here: the Indian and Atlantic. There is perhaps no better way to discover Cape Town than through its icy waters.

National Geographic Explorer Mogamat Shamier Magmoet dives through the *Antipolis* shipwreck off Oudekraal Nature Reserve.

My own first encounter with the Cape's complex history comes not long after my arrival in Cape Town, when I learn of a shipwreck just off the world-famous beaches of Clifton. The tiny bungalows tucked away against the bluffs here were once home to 'Die Sestigers' ('The Sixtyers') – a literary set that included figures like André Brink and Ingrid Jonker – and nowadays the properties are some of the most expensive in the city, with comparisons made to Malibu and the French Riviera. Mere metres from this luxurious neighborhood lies the wreck of Portugese slave ship the *São José Paquete d'Africa*, rediscovered over two hundred years after its demise in 1794. On its voyage from Mozambique to Brazil, the ship was carrying a cargo of 500 slaves when it struck a rock and sank. The archaeological site's proximity to Clifton is dizzying – two worlds juxtaposed, two timelines side by side.

On exploratory dives of another wreck – the *Antipolis*, a shallow oil tanker wreck in the waters of Oudekraal Nature Reserve – I am joined by Zandile Ndhlovu, South Africa's first Black freediving instructor, and National Geographic Explorer Mogamat Shamier Magmoet, cofounder of Sea The Bigger Picture, a non-profit focused on

environmental awareness and education. They tell me that diving a shipwreck as a person of colour carries a different weight. Historically, many wrecks in this region are mass graves – sites where countless slaves perished, shackled to sinking ships. I blame the tightness of my wetsuit, but there's a pressure in my chest that makes it hard to breathe. Together, we photograph a series of images that seeks to reclaim such spaces from the past for the future.

In a city defined by water, surprisingly little has appeared in mainstream media about the region's people of colour and their relationship to the sea. There's a sense that history's fingers have left bruises and imprints on the communities that are yet to heal. But many are working hard to rectify that. Grassroots organizations seek to empower future generations to learn about their history with the water. Groups like Sentinel Ocean Alliance, based in the suburb of Hout Bay, encourage Cape Town youth to (re)discover the ocean and thus to care for their marine environment. After all, with the city's history of slavery and displacement stemming from the Apartheid-era Group Areas Act, which segregated residential and business areas by race, access to the sea has been a legislative privilege not afforded to all.

As I wander Kalk Bay early one morning, I pass glassy storefronts shimmering in the dawning light, reflecting the ridges of the Hottentots Holland Mountains across the bay, the jagged shapes tapering off into the drama of Cape Hangklip. 'I learned to dive there as a kid,' a South African friend later tells me. 'It was this idyllic little cove brimming with crayfish and perlemoen [South African abalone]. It wasn't until years later that I learned it had been the site of one of the largest colonies for runaway slaves who hid in the nearby caves. The area holds a different meaning when I dive it now.'

There are layers of history embedded in the blue – liquid tributaries running through a melting pot of a thousand cultures and communities descended from indigenous African tribes, European settlers, smuggled slaves and waves upon waves of immigrants. Cape Town is nothing without these communities, and the connective tissue between them all – the city's life source and blood – is her water.

'There's a sense that history's fingers have left bruises on the communities that are yet to heal.'

OPPOSITE, ABOVE: Lion's Head and the Twelve Apostles are glimpsed above the kelp forests of Cape Town's Atlantic Seaboard.

OPPOSITE, BELOW: A scuba diver penetrates the SAS *Pietermaritzburg* wreck in False Bay.

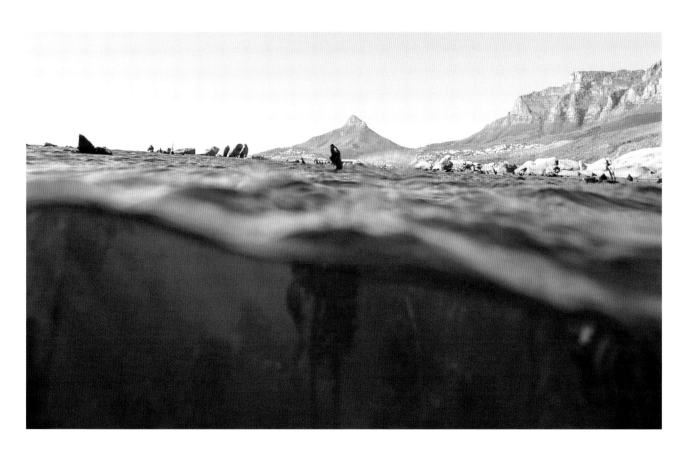

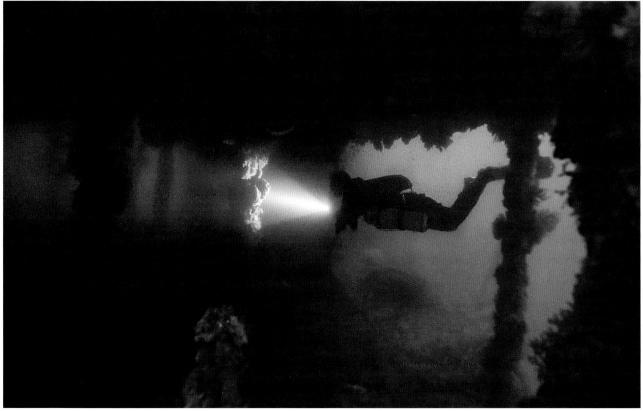

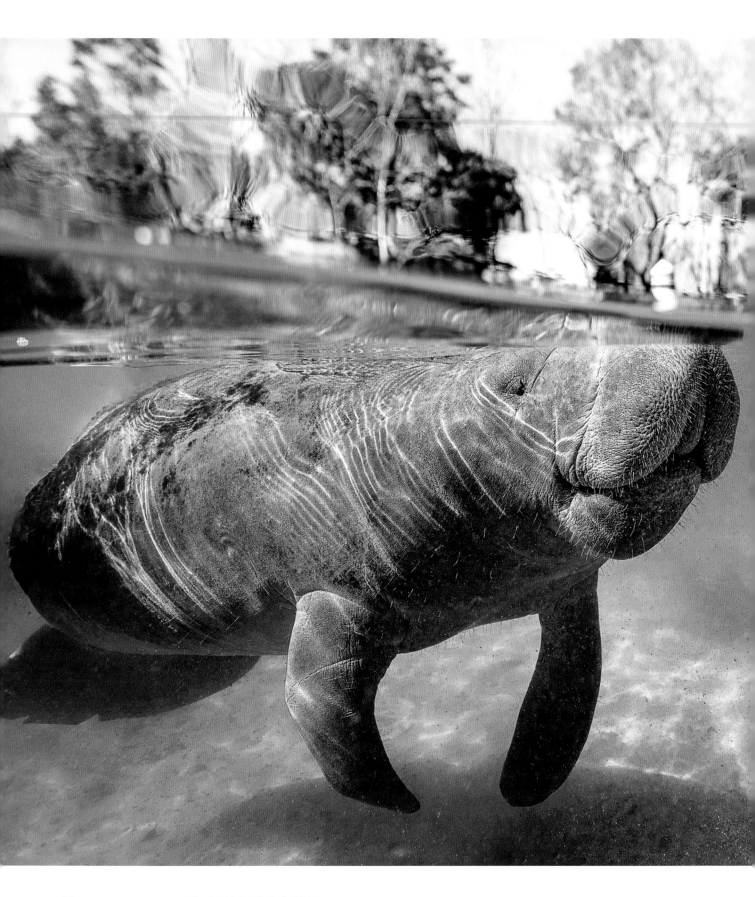

THE ATLANTIC OCEAN

During the winter months, manatees (*Trichechus manatus*) come inshore to enjoy the warm, shallow waters.

Watch Out for Sea Cows

FLORIDA, USA

COREY NEVELS

Sleepy, slow-moving manatees are an important part of the marine ecosystem and, just like all other animals, deserve to be protected from threat in their natural homes. A recent 'mortality event' in Florida waters highlights the vulnerability of this gentle species.

Florida manatees (*Trichechus manatus latirostris*, a subspecies of the West Indian manatee) are large, aquatic mammals that consume 4–9 per cent of their body weight in aquatic vegetation daily. This is where they get their nickname, 'sea cows', as they can often be found grazing on seagrass in shallow waters. Most of the year they can be found in coastal waters, although in the winter months manatees migrate inland to warm freshwater springs to maintain their internal body temperature (prolonged exposure to water temperatures below 18 degrees Celsius, or 65 degrees Fahrenheit, can be lethal to manatees), and are largely to be found in the southern two thirds of the Florida Peninsula.

Manatees are a delight to see in the water, especially mother-and-calf pairs; truly gentle giants, they attract the attention of visitors from all over the world. They also play a crucial role in balancing the ecosystem of the shallow waters, estuaries and canals they inhabit, fertilizing

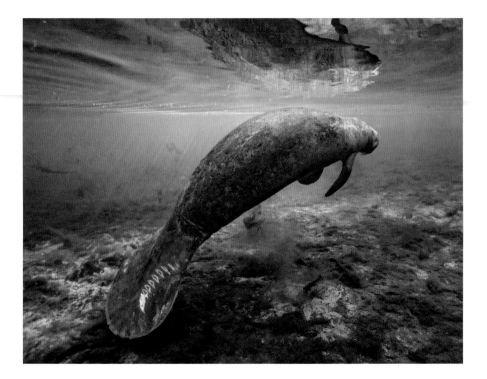

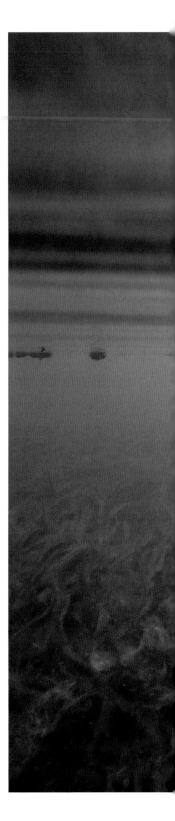

aquatic vegetation but also controlling it – preventing vegetation from becoming overgrown and also controlling invasive species such as water hyacinth.

Unfortunately, manatee mortality remains high in Florida. In 2022, the total number of manatee deaths (800 reported) was higher than the five-year average, and an overall uptick in mortality and injury since December 2020 caused the Florida Fish and Wildlife Conservation Commission (FWC) to declare an Unusual Mortality Event. The primary causes of manatee mortality in Florida are known to be starvation and watercraft-related accidents.

Unnaturally high levels of nutrients in waterways – caused by a variety of factors, including runoff from agriculture, dissolved chemicals introduced into water supplies via rainfall or irrigation, and effluent from sewage treatment plants – have been found to cause harmful algal blooms (HABs) that kill off aquatic vegetation like seagrasses, which is a main food source for manatees.

Slow-moving and surface-dwelling in shallow waterways, manatees are also frequently the victims of watercraft collisions (see pages 56–7). While manatees are strong swimmers, capable of reaching speeds of 15 miles per hour (approx. 24 kilometres per hour) in short bursts, they are better known for their idle behaviour. They rest anywhere between two and twelve hours a day, either suspended near the water's surface or lying on the bottom, and must regularly surface to breathe air. As more favourable weather returns and people take to the water, watercraft-related incidents make up nearly half of the manatee mortalities statewide. Scars caused by these hits have become so common that scientists even use them to identify individual manatees.

There is a growing movement in Florida to upgrade this species to endangered status, and press for stronger protections for both the manatees and their habitat.

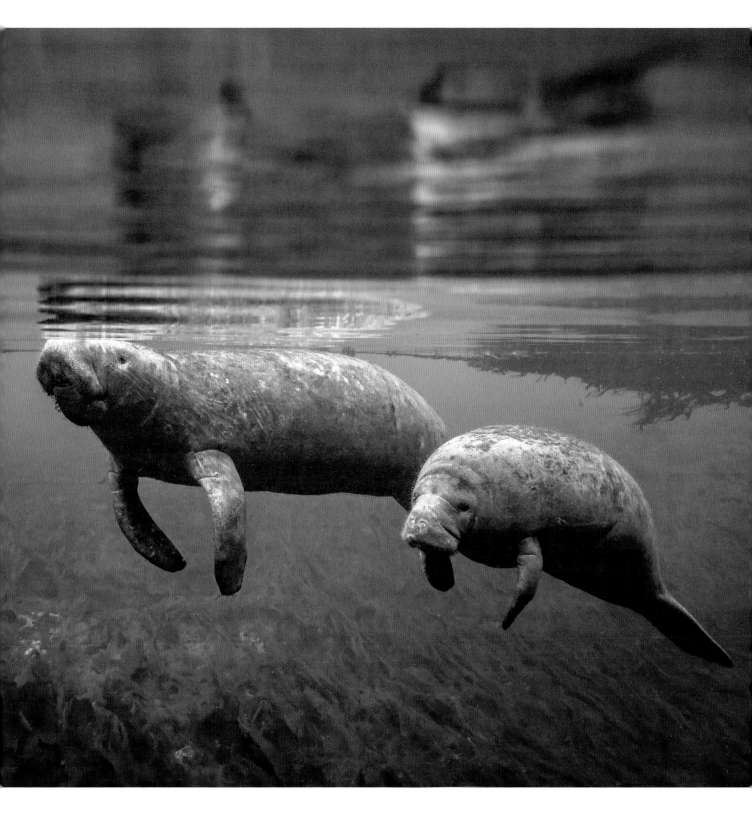

OPPOSITE: Boat-related injuries are now so common that scientists use these scars to identify individual manatees.

ABOVE: A mother-and-calf pair take refuge in a warm, shallow freshwater spring during the cold winter months.

WATCH OUT FOR SEA COWS 59

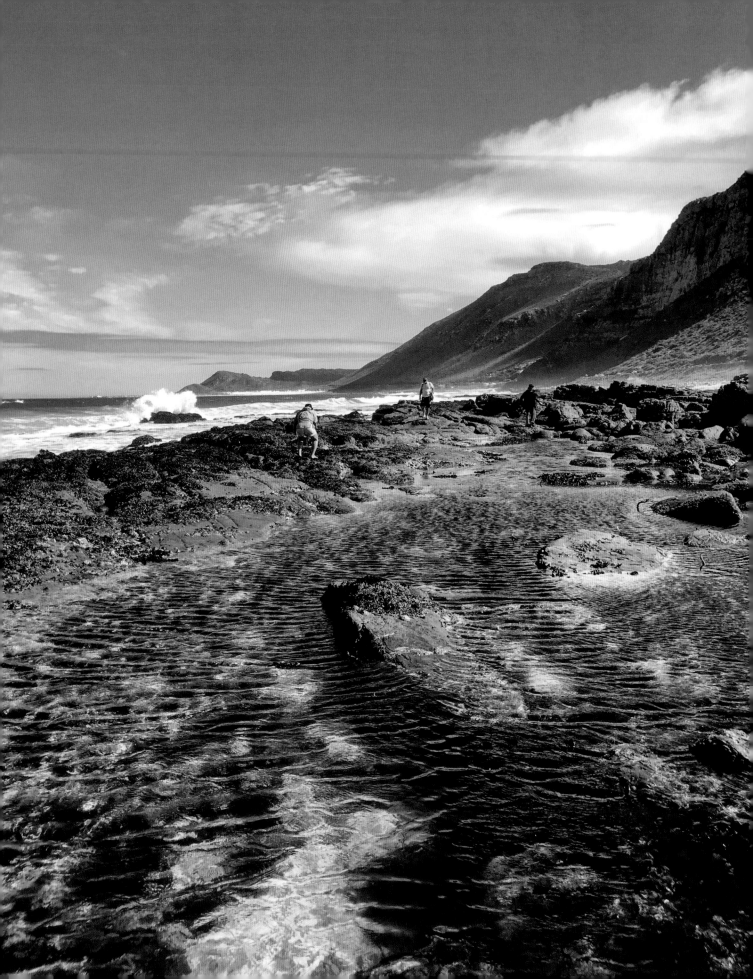

Foraging the Shoreline

CAPE PENINSULA, SOUTH AFRICA

ROUSHANNA GRAY
ADDITIONAL PHOTOGRAPHS BY
ALEX OELOFSE AND JANIK ALHEIT

Gathering food from the source feels like reawakening an embedded memory in your body. At the coast, our senses open up and we can slow down enough to connect with the rhythms of nature.

An avid forager and foodie, I first began my edible ocean journey by stepping into rock pools and looking at ocean vegetables as a sustainable seafood, inspired by my local surroundings on the Cape Peninsula; I would return to the same rock pools every spring low tide, learning intertidal ecology and ecosystems, documenting and understanding how best to sustainably and regeneratively harvest seaweeds. I became aware of factors such as how the moon affects the tides, perceiving just when that magical slice of intertidal zone would open to reveal its allure and abundance. On a pushing tide, I would head back home and use what I had found to create meals cooked over fire, decorated with flowers and perfumed with echoes of the ocean.

Over time I observed how the seasons and cycles affect the seaweeds: some of these perennial ocean ingredients are available year-round, while other annuals are only available to us once a year, or even have micro-seasons. This coastal knowledge and passion overflowed into my work as an educator and into my home, where

Intertidal coastal foraging on a spring tide low.

cookbooks and scientific volumes jostled for space on my kitchen shelves, the research and recipe books expanding and growing over the years. Collecting food from the ocean provides a unique opportunity to work in harmony with nature, carefully mapping the edible coastline, studying the growth patterns of algae and marine life – their preferred environments and the other species that share their habitat. This curiosity leads us to ask more questions and delve deeper into our understanding of this space.

By gently gathering and savouring wild foraged foods, we not only deepen our connection to the ocean but also begin to foster reciprocal relationships that allow us to sustainably harvest these precious resources for generations to come. Just like in any other endeavour we undertake – whether it's cleaning a house or building one – if we start from scratch ourselves, we're more likely to care deeply about the outcome. Foraging seaweeds and other wild edibles requires time invested in truly understanding their environment and responsibly practising regenerative harvesting techniques.

By processing, preparing, preserving and honouring these gifts from nature with care and attention, we can discover an array of wonderful flavours that are simply unparalleled. This paradigm shift towards mindful consumption enriches our lives while sensitizing us towards caring for our fragile marine ecosystem.

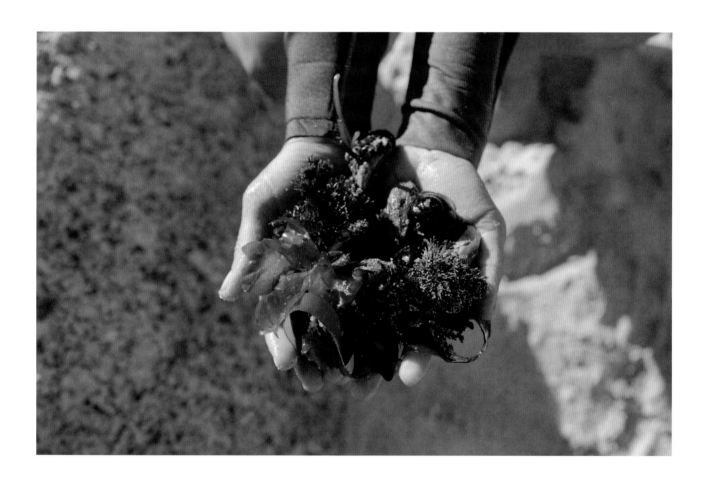

ABOVE: A selection of hand-harvested seaweeds and shellfish.

BELOW: A gentle exploration of the kelp forests.

RIGHT: Wild Atlantic Nori (*Porphyra capensis*) growing on the rocks in the intertidal zone.

RIGHT, BELOW: There is so much life, even at the surface of the sea.

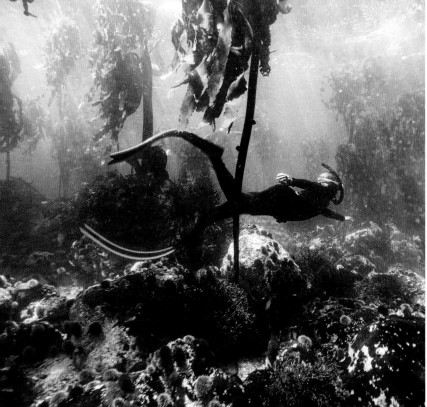

'By gently gathering and savouring wild foraged foods from the coastline, we deepen our connection to the ocean.'

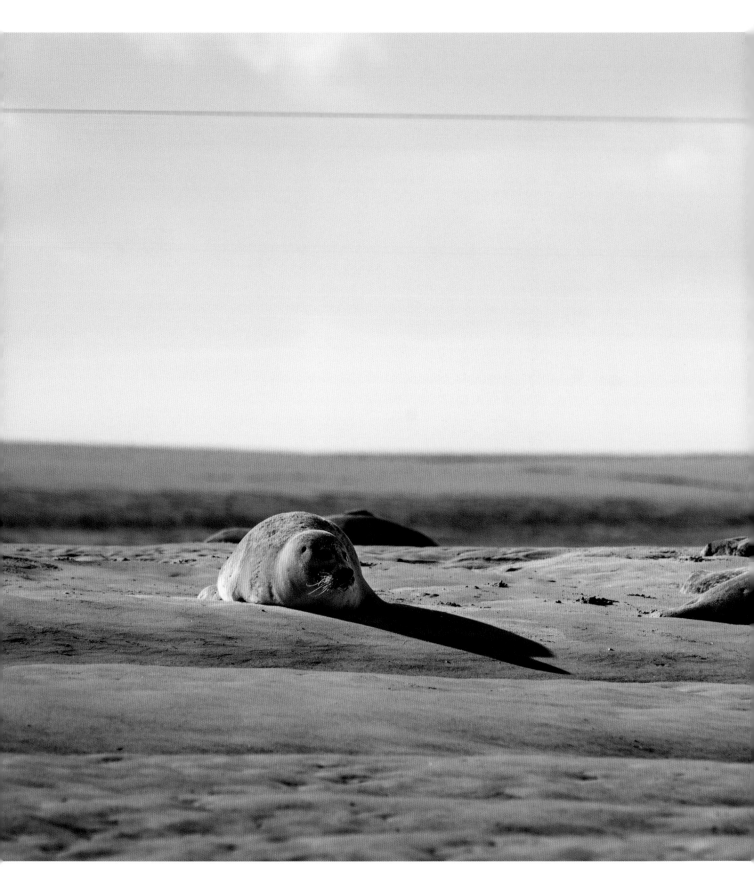

THE ATLANTIC OCEAN

Harbour seals (*Phoca vitulina*) – known as 'sea veals' in France – are the most common species of the *Phocidae* group.

Northern Colonies

FRANCE

ARTHUR CAULLIEZ

Where many see the present-day relative abundance of seals in northern Europe as a reason to ignore them, this photographer sees a way to involve us all in their preservation and protection, as we learn the lessons of a more brutal past.

Born and raised in the north of France, I never though of this place as any kind of emblematic marine life paradise. Seals (the wider family *Phocidae*), in my imagination, lived in faraway, cold and icy places such as Canada, Norway or even Antarctica, and I could never have imagined that hundreds of these animals used to live on our coasts, a few steps from my door.

Demand for their meat and fur fuelled a boom in seal hunting in Europe from the nineteenth century to the middle of the twentieth. The population was brought close to extinction, with some hundreds-strong colonies being reduced to only ten individuals. It was only in 1972 that seals started to be protected in France, and since then, populations have begun to slowly increase in several key places on the northern coast. Indeed, I chose to start documenting seals, particularly colonies, as they are marine mammals that anyone can observe by taking a walk on the beach in this region.

Within the *Phocidae* family are 18 different species, 2 of them observed in France: the harbour or common seal (*Phoca vitulina*), sedentary and the most common species in the world, and the grey seal

(*Halichoerus grypus*), bigger in size and more migratory. Both species were affected by the collapse of their populations in France, but the migratory pattern of grey seals made the trend more impactful on a European level. Both populations have made an incredible comeback and are now considered stable in several areas (Baie de Somme, Baie de l'Authie, Phare de Walde, for example), benefiting from efficient protection. The return of seals on the coast is great news for the ecosystem, as these animals play a key role as predators and regulators of other species within the food chain. But seals are also believed to be important contributors to necessary nutrient circulation in our oceans, fertilizing the water through their excrement just like many other marine mammals.

These beautiful mammals face new challenges, however, that need to be considered with great attention. The tourism generated by these colonies brings a tremendous amount of stress for the animals, especially during reproduction and the pupping season; seal pups are weaned for 3-4 weeks, and therefore minimal disturbance is essential during this time. Pollution, overfishing and the presence of offshore windfarms can also affect the seals' life cycles in ways we don't yet fully understand. This is why rigorous monitoring and management of their populations along the coast of France is necessary, in coordination with other countries such as the UK, Belgium and the Netherlands.

Seals' extinction could have had terrible consequences for the wider marine ecosystem, impacting human fisheries as a result. Moreover, seals are part of the incredible biodiversity that we have ignored in Europe and wiped out for the profit of our cities, agriculture and our way of living. Nature is now giving us a second chance to find a way to coexist with these species, in a world that is entering a whole new era of challenges.

A colony of grey seals (*Halichoerus grypus*) take a rest on a sandbank at low tide.

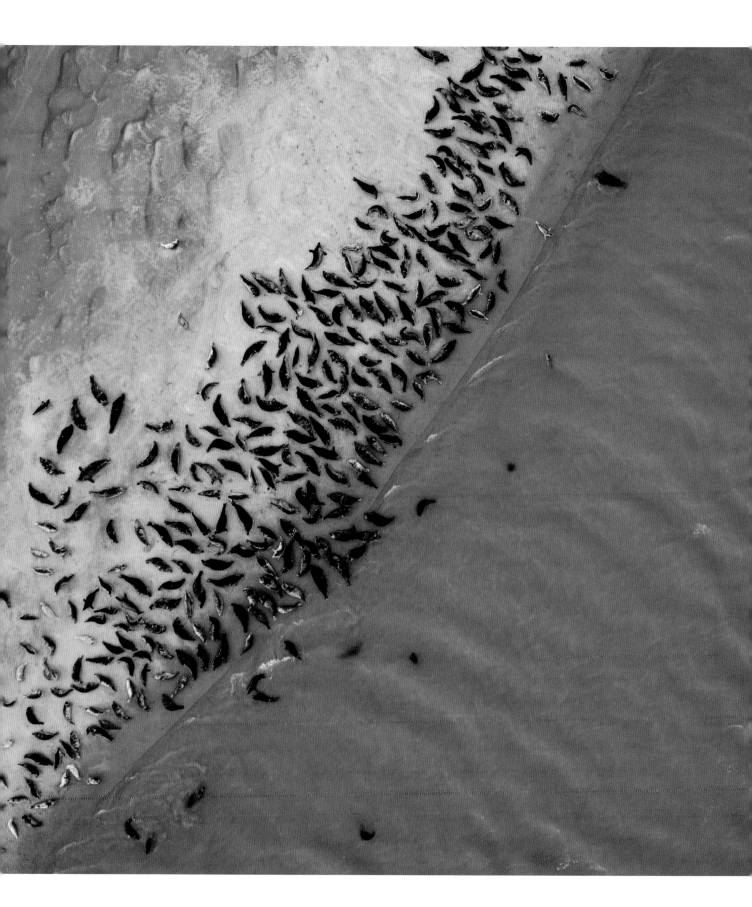

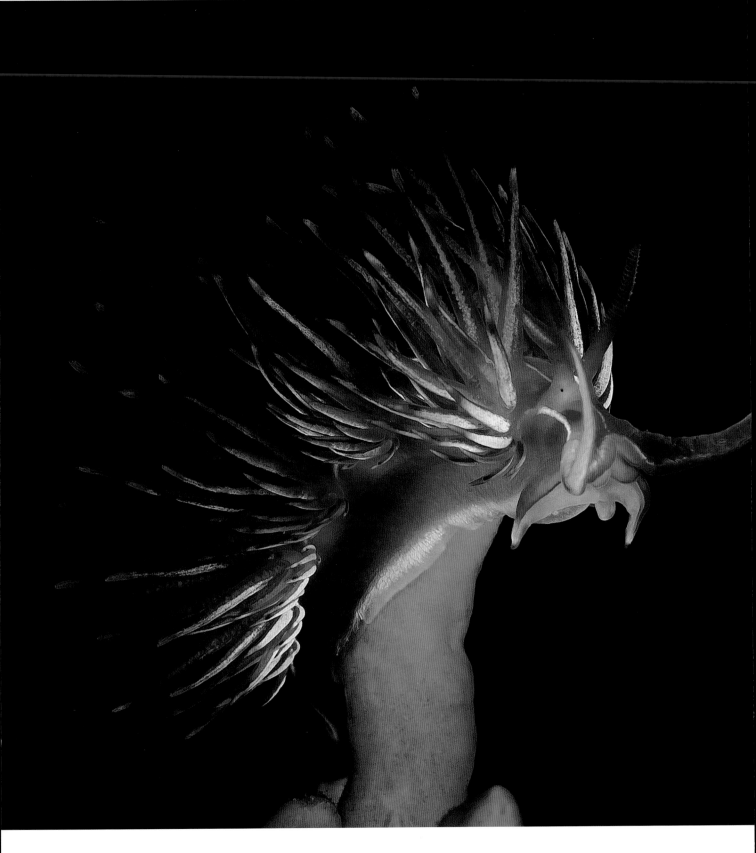

THE ATLANTIC OCEAN

The Little Ones

MEDITERRANEAN SEA

ÒSCAR MONTFERRER

The pioneering work of filmmakers like Jacques Cousteau brought images of the underwater world to people around the globe. The further technology develops, the deeper and closer we can look into the oceans, revealing its most wonderful and colourful inhabitants.

The 1956 documentary film *The Silent World* opened a door that was never to be closed again. It was a prize-winner, receiving an Academy Award (Best Documentary Feature) as well as the Palme d'Or and two awards from the National Board of Review (USA). Cousteau's vision – one of the first films made using colour underwater cinematography – gave land-dwellers a new world, a new ecosystem, to dream of. Since then, the evolution of the mass media – mostly TV – and, more recently, the internet and social media, have played a major role in bringing the underwater world to our screens and our attention.

My own story has no particular interest: soon after I became a scuba diver, and having a previous interest in photography, I bought my first underwater camera – 36 film shots, those were different times! – and tried to do my best. Now, years later, technology has provided almost everybody with some of the tools that only three decades ago belonged to the realm of science fiction. Thanks to this, the underwater world has a fairly strong screen presence. And that's a really good thing; it can only be loved if it is known.

Amid the seductive power of these images – the mysterious wrecks,

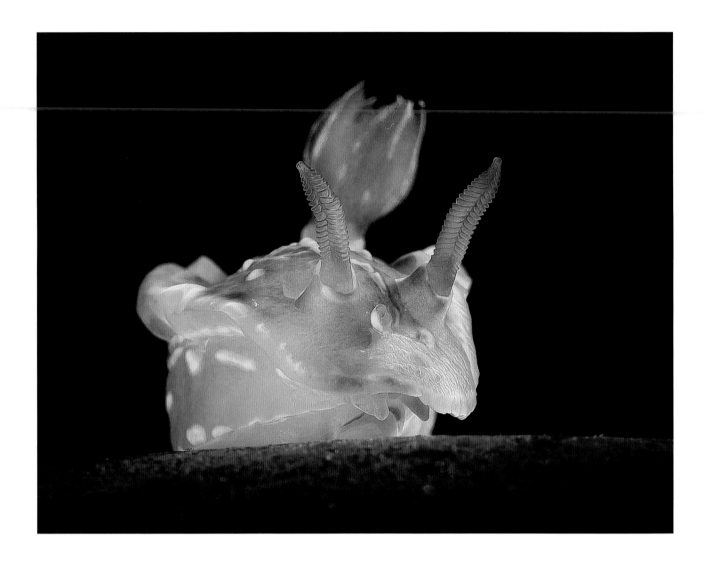

ABOVE: Colourful sea slug species *Felimare picta*.

the whales and sharks, the turtles, the great coral fans – it is easy to overlook the animals that are too small or elusive to be easily seen. These creatures, perhaps not so impressive at first sight, are less frequently portrayed, but they matter as much as the big ones. I began to take an interest in them due to underwater photographer buddies, who looked for them with a passion. Now, the little creatures – very specifically, the nudibranches – are my number-one target when I'm down there with a camera. And, luckily for me and the other skilled photographers working underwater, the digital world has no limits. My aim is to show the world the beauty of creatures that might be only a few millimetres long but, because of their shape, their texture, their colours, deserve a place in the hypothetical Museum of Underwater Art.

Nudibranchs are soft-bodied marine molluscs without shells, a variety of sea slug with over 3,000 known species. They are carnivorous – eating sponges, coral and fish eggs from the sea floor – and their food gives them their brilliant colours and patterns; when a sea slug eats, it absorbs and displays the pigments of its prey. They can even perform this trick with toxins from the creatures they eat, secreting

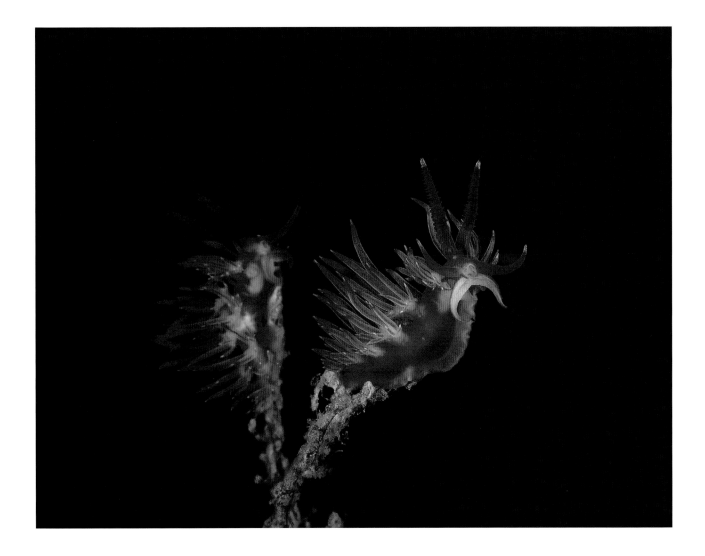

ABOVE: *Flabellina affinis* is widespread in the Mediterranean Sea.

the poisons from their own skins to ward off predators.

I post my photography to social media and occasionally receive messages from people who have discovered the charms of the 'little ones', and ask for information about what they are seeing. That's my job done – the little ones become a little bit better known, a bit better loved and, hopefully, a bit better cared for.

'Luckily for me, digital photography has no limits. My aim is to show the world the beauty of creatures that are just a few millimetres long.'

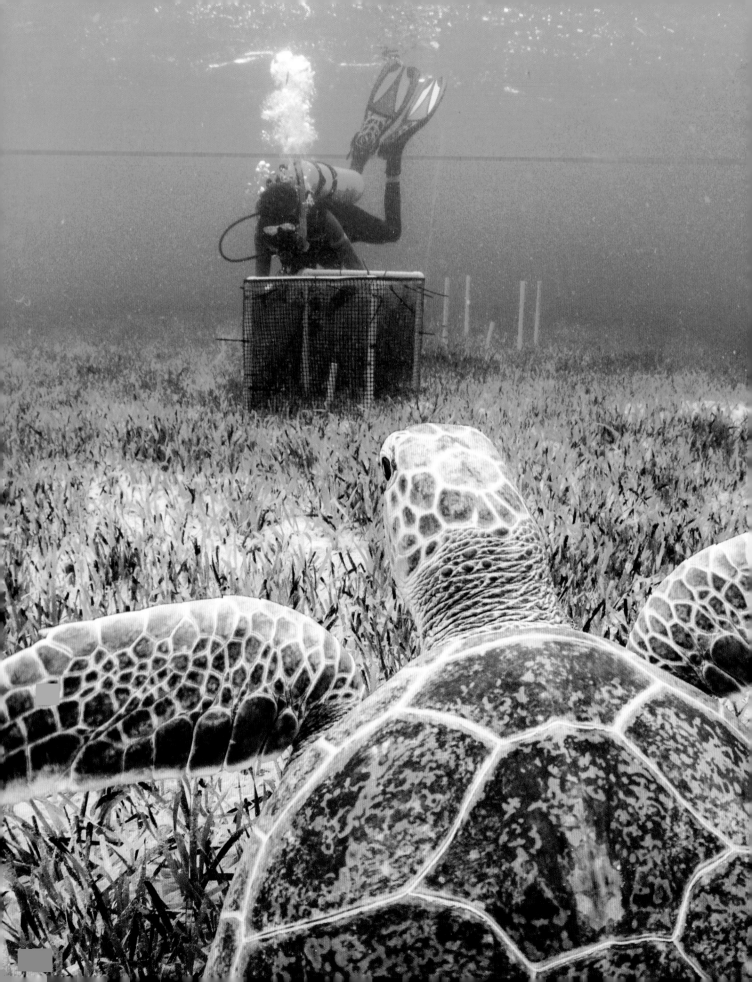

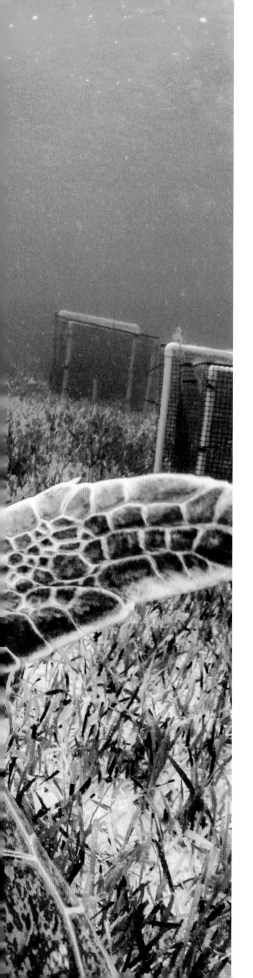

A volunteer collects seeding eelgrass (*Zostera marina*) shoots for a massive seagrass restoration project taking place in Virginia, USA.

Celebrating Seagrass

USA AND CANADA

SHANE GROSS

Seagrass purifies the water, helps protect against coastal erosion, sequesters carbon, alleviates poverty and increases fish populations and biodiversity in general. All reasons to celebrate, and protect, this natural resource.

I'm sitting in a seagrass meadow, hoping a shy bonnethead shark (*Sphyrna tiburo*) will swim in front of my lens. These mini hammerheads were recently reclassified as the world's first omnivorous sharks. In a study led by Dr Samantha Leigh of the University of California, Irvine, bonnethead sharks in captivity were fed a 90 percent vegetarian diet and the nutrients from the seagrass were traced to the shark's tissues; the sharks gained weight. Plant-eating sharks are just one example of how science is changing our view of seagrass and revealing just how amazing and important it is.

Seagrasses are different from algae and seaweed; they are flowering plants that migrate from the land into the ocean. There are over 60 different species of seagrass, found in coastal seas on every continent except Antarctica, stretching from the equator to cool and cold areas under ice. Just a few weeks before I was enjoying the Florida heat I found myself wearing a drysuit, shivering in 2-degree-Celsius (35-degree-Fahrenheit) water in Newfoundland, Canada, exploring how, in the early 1990s, the world's largest fishery collapsed, costing

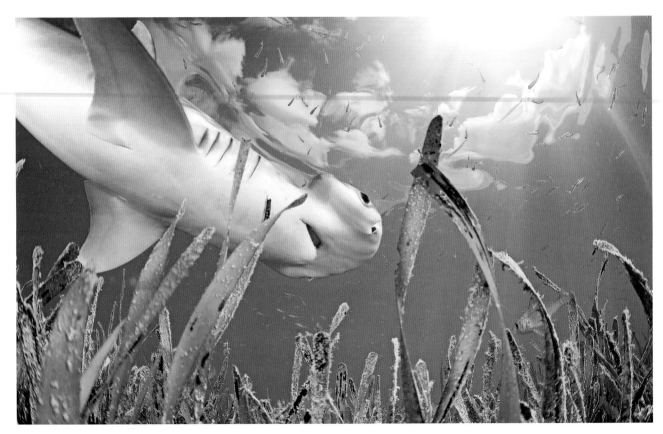

approximately 40,000 jobs. The Atlantic cod population had been severely over-fished. In the 30 years since then, the population hasn't returned to a level at which it can be commercially fished. Part of the key to bringing back cod numbers is having ample seagrass for the juveniles to hide and feed in. In fact, one fifth of the world's fisheries depend on seagrass, including that of the world's most-caught fish, the billion-dollar fish, the fish in your McDonald's Fillet-O-Fish Sandwich – the Alaska pollack (*Gadus chalcogrammus*).

In Spain's Mediterranean Sea, I swam among the oldest and largest living organism on the planet: *Posidonia oceanica*, a seagrass species that is endemic to the Mediterranean. The plant's root system is connected beneath the sea floor, stretches over 9 miles (14.5 kilometres) of coastline and has an estimated known spatial distribution of 1,224,707 hectares. Scientists estimate this organism to be between 80,000 and 200,000 years old!

The Mediterranean Sea is warming three times faster than the world average and, so far, *P. oceanica* is declining by 5 per cent per year. In fact, most seagrass around the world is in decline. Best estimates suggest we have already killed 19 per cent of our seagrass since the 1880s, and the destruction continues at an alarming 1.5 per cent per year. Pollution, coastal development, poor fishing, mooring and boating practices, reduced water clarity and, of course, climate change all contribute to the decline.

Seagrass sequesters carbon at a rate more efficient than rainforests and it reduces ocean acidification. In the early 1930s, the Chesapeake Bay was the United State's leading oyster fishery. A combination of factors including increased trawling and hurricanes basically wiped out the seagrass, killing the fishery. Now, with restoration, they are starting to mount a comeback. In May 2019, I joined a team of volunteers and researchers from the Virginia Institute of Marine Science (VIMS) as they continued a twenty-year seagrass restoration project using a technique developed by VIMS Professor Robert 'JJ' Orth. His system is incredibly effective, re-establishing over 9,000 acres of seagrass and all the benefits that go with it, including the oysters.

So, can this method be replicated elsewhere? The answer is yes, but not in every instance. Protecting what we still have should be the priority and the benefits cannot be overstated. Healthy seagrass means a healthy ocean!

'Estimates suggest we have killed 19 per cent of our seagrass since the 1880s, and the destruction continues at an alarming 1.5 per cent per year.'

OPPOSITE ABOVE: The bonnethead shark (*Sphyrna tiburo*), seen here in the Florida Keys, is the first known omnivorous shark. They eat and digest copious amounts of seagrass while hunting for crabs and other prey.

OPPOSITE BELOW: A lobster (*Homarus americanus*) takes shelter in a seagrass meadow off Newfoundland, Canada.

THE INDIAN OCEAN

Explore the Indian Ocean's vibrant coral reefs, where myriad captivating tales unfold. Begin by descending into the enigmatic Turtle Tomb off the coast of Sabah, Malaysia – the planet's sole known turtle 'graveyard'. Continue your journey in Indonesia, where a world of marine life awaits the keen-eyed observer. Then witness the resurgence of super corals in the Red Sea, a reminder of the global need to protect such vital ecosystems. This chapter unveils the Indian Ocean's mysteries and the remarkable individuals committed to its preservation.

An inquisitive tiger shark emerges fropm the blue in the Maldives ('Co-existing with Sharks in Fuvahmulah', pp. 114–19).

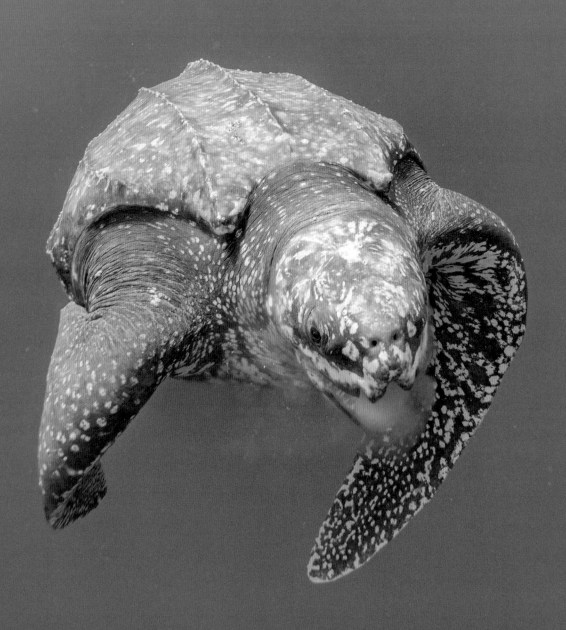

The Future of Leatherback Turtles

BANDA SEA

SUNG HUA CHENG

Leatherback turtles – creatures that have existed in close to their present form for over 110 million years – are a link to the past and an indicator of the future, their population health reflecting the state of our oceans. Grassroots conservation efforts have a key part to play in their survival.

The leatherback sea turtle (*Dermochelys coriacea*), the largest sea turtle in the world, can weigh hundreds of kilograms and reach up to 1.8 metres (6 feet) in length. These reptiles are master divers – the deepest-diving species among all sea turtles – but must return to the surface to breathe with their lungs. Apart from when they are hatchlings, leatherbacks live in the ocean all of their lives, migrating thousands or even tens of thousands of kilometres, and therefore the ocean plays a critical role in their survival.

Although the distribution of leatherback turtles is wide, numbers have seriously declined during the last century as a result of intense egg collection and fishery bycatch. Globally, leatherback status according to the IUCN is 'vulnerable', but many subpopulations (such as those in the Pacific – including the Banda Sea – and Southwest Atlantic) are 'critically endangered'. The main drivers in this decline include human

A leatherback turtle (*Dermochelys coriacea*) hunting jellyfish.

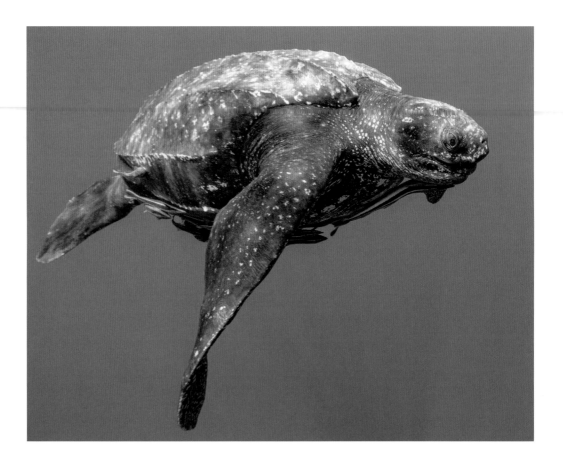

fishing activities, plastic waste (entanglement in or ingestion of which are fatal), hunters (historically) seeking their meat and eggs for sale and consumption, and the destruction of spawning grounds by humans.

The leatherback turtle is at the upper middle of the food chain. The removal of this species from our oceans will seriously damage the operation of the entire ecosystem. They specialize in consuming jellyfish, keeping populations under control in the Banda Sea and surrounding ocean waters. If leatherbacks were to disappear from our oceans, the waters would be swamped with jellyfish, which would, in turn, over-consume fish larvae, therefore stripping fish populations from our oceans.

There are still traditional hunters in Indonesia who pursue leatherback turtles, continuing to collect their eggs and hunt them for their meat. However, most fishing villages in Indonesia have changed their hunting practices, in cooperation with the government and the World Wide Fund for Nature (WWF), to protect leatherback turtles that come on shore to lay their eggs. The WWF and Program Indonesia aim to save these sea turtles by focusing on population monitoring and field surveys. What I can do as a wildlife lover and ocean photographer is to help educate traditional turtle hunters that a leatherback turtle is worth much more alive than dead. During my time in Banda, I was happy to cooperate with the local fishermen and speak to villagers about why we must not approach nesting turtles, but observe from a distance, with minimal disturbance to their activities.

ABOVE: Close-up encounters with leatherback turtles are rare.

OPPOSITE: Leatherbacks like this individual, named Mola Mola, often come to the surface to enjoy the sun.

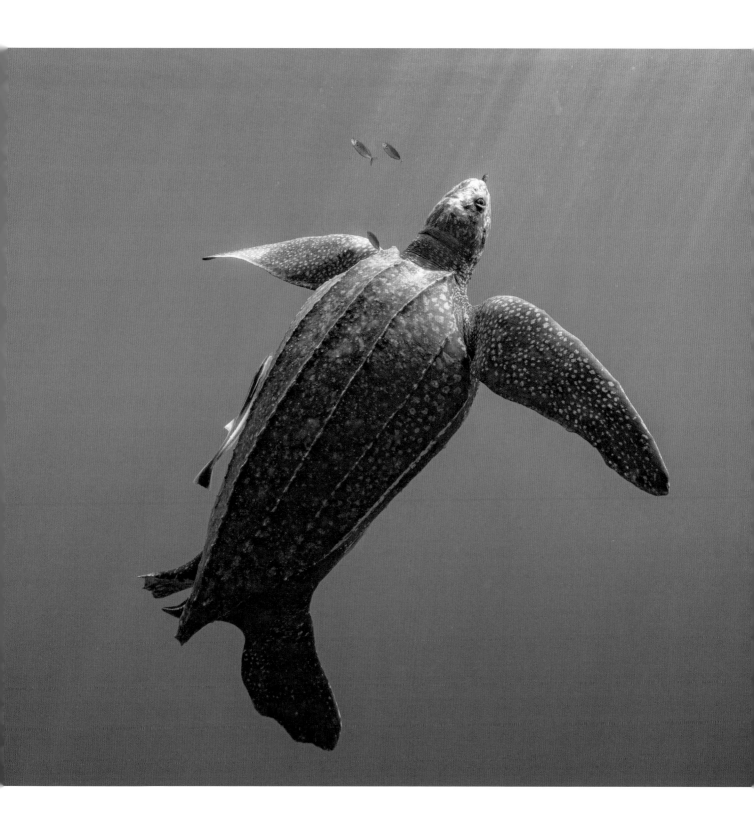

'The removal of this species from our oceans will seriously
damage the operation of the entire ecosystem.'

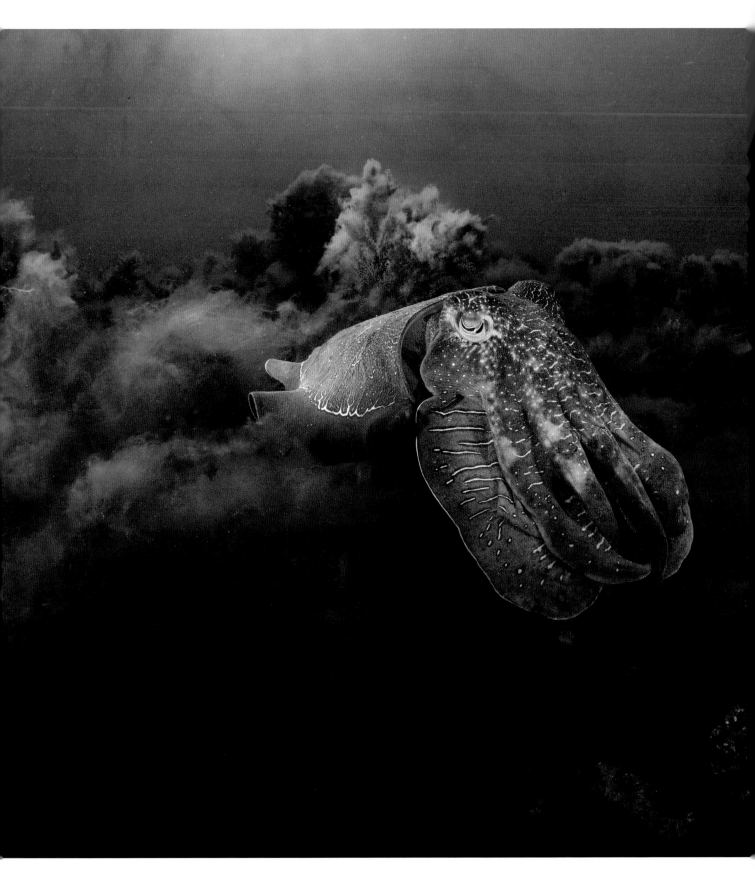

THE INDIAN OCEAN

A male giant cuttlefish (*Sepia apama*) squirts out ink so it can escape from potential predators.

The Mating Game

WHYALLA, AUSTRALIA

ROWAN DEAR

Each year, between May and August, around 25,000 Australian giant cuttlefish gather in the waters of a small port town called Whyalla. They take over the shoreline to gather and mate, in what is one of nature's truly great events.

In the 1990s the fishing industry almost wiped out the Australian giant cuttlefish (*Sepia apama*) but, thankfully, a ban on fishing during the mating season has meant numbers have since recovered exponentially. I have dived around the world, with many marine animals, but there are very few animals in the ocean that have the charisma and charm of a cuttlefish – with their ability to change colour using chromatophores, and change shape using their eight arms and two tentacles, you can feel the emotion they are emitting as they go about their everyday life.

As soon as your head drops under the water here in Whyalla, you can see cuttlefish scattered everywhere, as far as the eye can see, and the 'mating game' begins. Cuttlefish mate via head-to-head contact, whereby the male will slip its sperm into the female's mouth ready for her to fertilize her eggs. She will then find a rock ledge and lay her eggs underneath, away from potential predators. This is one of the reasons scientists believe Whyalla is the perfect site for cuttlefish mating, with the topography of the rocks providing the perfect place to lay eggs.

One behaviour you will see wherever you go is that of two (or more) males doing a mating dance – battling it out for territory, supremacy

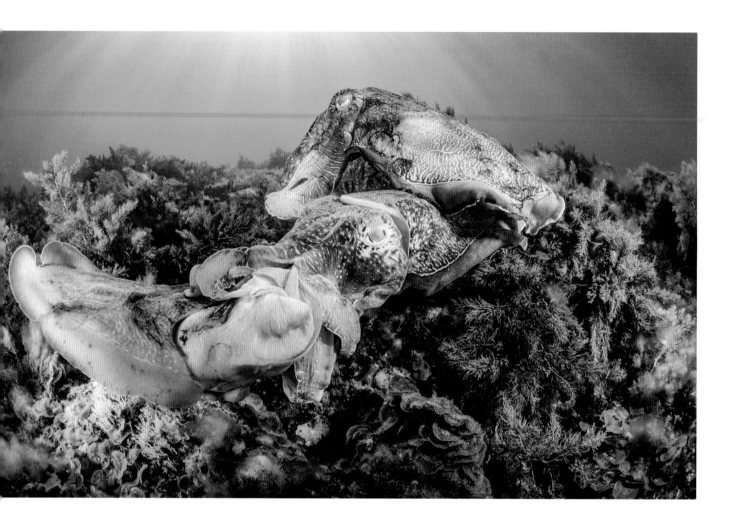

and, ultimately, the right to mate with one of the 'lucky' females. The secret to winning is to make yourself as big and as colourful as possible; the males are therefore constantly changing colours and textures, all the while extending their arms and tentacles and flaring out their skirts to make themselves look as big and as imposing as possible. Sometimes you will see males in their pairs battling it out, and then other males from around the bay will swim over to see what's going on and wait in the wings to do battle themselves, or occasionally to try and steal the female from under the tentacles of the two males. Sometimes it gets a little heated and the males will grab hold of each other by the flank and go into a kind of death roll, or even rip off parts of each other's tentacles.

Once the battle is complete, a male will try and grab hold of the female face-on and begin the mating process. This is often not a romantic experience, as other males harass both the male and the female and try to break up

their embrace. While a lot of the cuttlefish here are quite small – especially the females – some of the mature males, who are 2–3 years old and have not yet mated, can grow up to 1 metre (3 feet) in length. Often you will see them swimming around aggressively and attacking other males at random, or just sitting on top of as many as three females and guarding them from the much smaller males.

The colour and life inside the ocean, the array of strange or sublime animals that you can see, and the intimate moments you can have with beautiful creatures like cuttlefish or manta rays are like no other experience on earth.

ABOVE: A male and female mate face to face, while another male waits in the wings.

OPPOSITE: Two males engage in a mating dance, changing colours and making themselves look as big as possible.

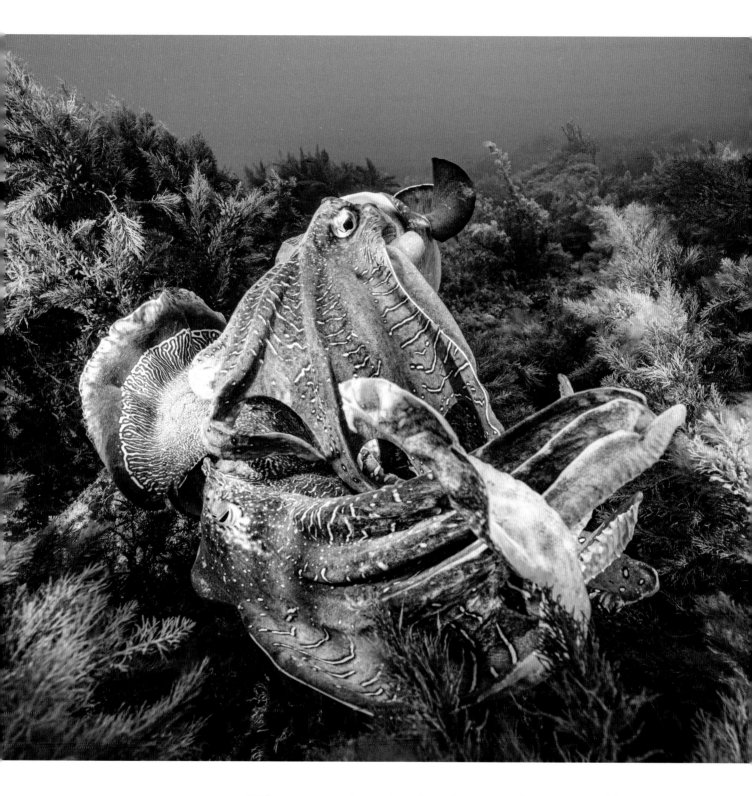

'The secret to winning is to make yourself as big and as colourful as possible; the males are constantly changing colours and textures.'

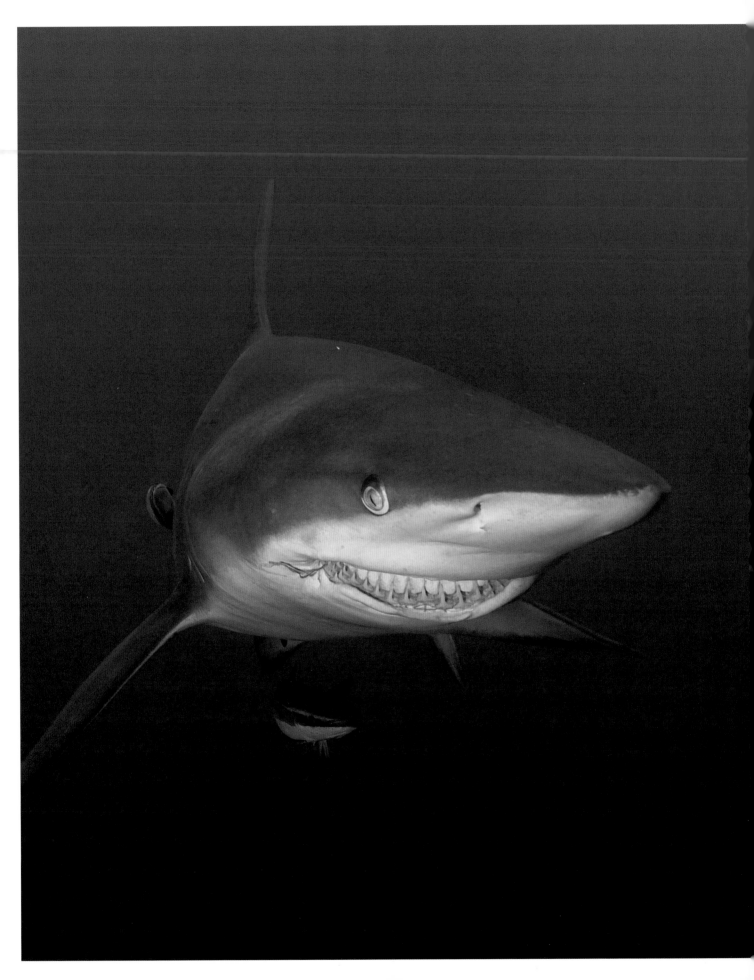

Sharks of the Shoal

CAPE TOWN COAST AND ALIWAL SHOAL MPA, SOUTH AFRICA

ANDREA KOZLOVIC

Named one of the best dive sites in the world by no less than Jacques Cousteau, this region is protected but nevertheless feels the impact of human activity, with many larger visitors to these waters bearing battle scars from close encounters with fishing lines.

Aliwal Shoal is a marine protected area that covers 670 square kilometres (259 square miles) off the coast of KwaZulu-Natal, South Africa, including the part of the Aliwal Shoal reef known as 'The Crown'. The diversity in these waters is due in part to the geographical location of the Shoal. The Agulhas current moves warm, nutrient-rich water down the eastern coast of South Africa and brings with it a large array of marine life, from migrating whales to schooling hammerhead sharks – you never know what you might see here.

Unfortunately, even though the area is protected – limited fishing is permitted, with areas where it is banned entirely – there are still signs of human debris scattered across the reef and surrounding areas, and the permanent impact can be seen on a variety of pelagic species of sharks and other animals. After diving here for an extended period (each year for the past nine years), I have noticed a sharp increase in the number of sharks with injuries from battling a fisherman's line; these used to be few and far between. These are the animals that always catch

An oceanic blacktip shark (*Carcharhinus limbatus*) at Aliwal Shoal displays her twisted smile.

my eye. Many of these animals have broken or injured jaws and they have difficulty feeding. Typically, over time, these individuals become thinner and more lethargic, until we just don't see them anymore. Whether they become prey to healthier sharks or simply pass away, we don't know. I hope that by giving people a glimpse into the daily lives of these animals and the struggles they face, together we can push for change.

Mother Nature isn't simply beautiful moments of beams of light cascading around a tiger shark (*Galeocerdo cuvier*) in crisp, clear waters. Sometimes, she's an oceanic blacktip (*Carcharhinus limbatus*) in hazy waters with a broken jaw, tangled in fishing line. These images may not be as visually pleasing or peaceful, but they are very moving and can make a lasting impact. I urge readers to look at these tough moments captured, find the raw beauty in these imperfect individuals, and try to understand them. We can empathize with these animals, envision their previous encounters with humans and, even for a moment, try to imagine what they are feeling.

'I urge readers to look at the tough moments captured here, and find the raw beauty in these imperfect individuals.'

A juvenile blue shark (*Prionace glauca*), marred by a large stainless-steel hook, is observed by divers off the coast of Cape Town.

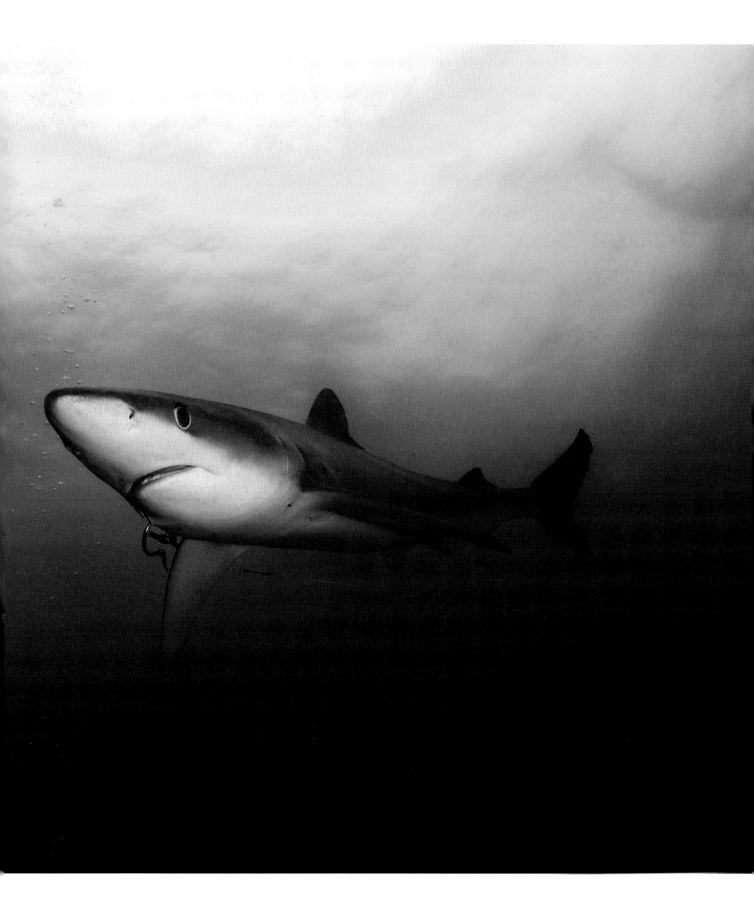

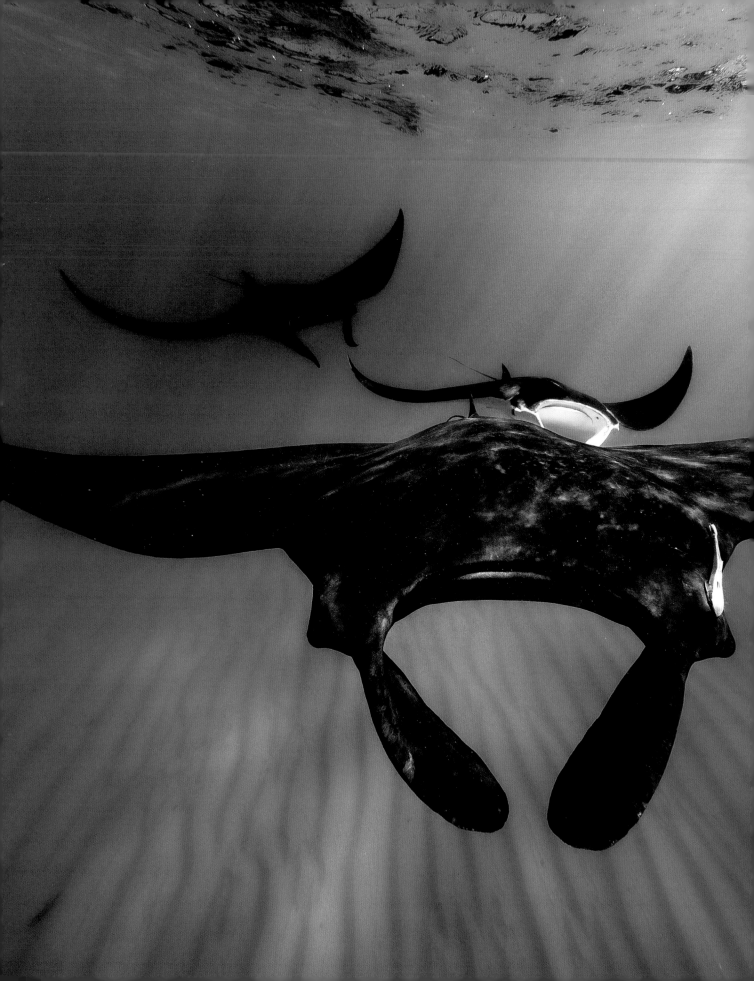

In spring, rising ocean temperatures mark the arrival of reef manta ray (*Mobula alfredi*) mating season.

The Bucket List

NINGALOO COAST, AUSTRALIA

WILL NOLAN

On this, the largest fringing coral reef in Australia, and one of the largest near-shore reefs on the planet, opportunities to photograph marine life are abundant, and these visual documents are crucial to research and conservation efforts.

The Ningaloo Reef is a biodiversity hotspot spanning 270 kilometres (168 miles) and is influenced by two different currents, making it an appealing destination for a variety of marine animals. And humans. People from all over the world travel to a tiny 'one-road' village to experience swimming with the ocean's largest creatures and I capture these experiences on camera. By highlighting the beauty and importance of this unique ecosystem, I hope to inspire people to appreciate and care for the ocean as a whole.

I am especially interested in identification photos of sea creatures, which are important for a variety of reasons. Understanding the oceans and their inhabitants is crucial for maintaining a healthy marine ecosystem. Conducting research and taking identification photos of sea creatures can help us understand their behaviour, migration patterns, habitat requirements and other important aspects of their biology. It is a vast task in an area like Ningaloo, where there is a massive range of marine life – more than 300 coral species alone, over 700 reef fish species, and roughly 600 crustacean species. This is in addition to the estimated 300–500 whale sharks that appear here annually.

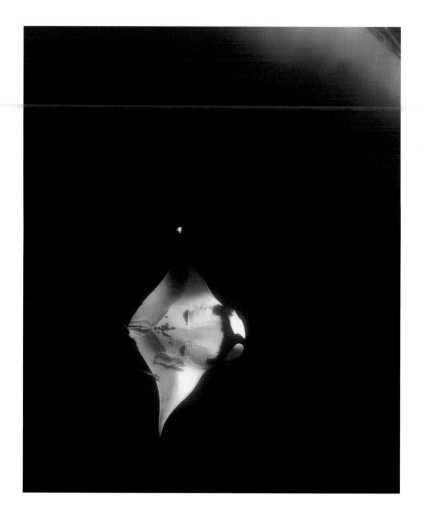

Second, the oceans are changing rapidly due to human activities: climate change, overfishing, pollution and habitat destruction threaten our seas. Tourism also plays a part, with UNESCO identifying associated threats such as damage to vegetation, illegal fishing, sewage and waste disposal, and disturbance to wildlife in Ningaloo, where many visitors come to tick off species from their 'bucket list' of marine life. Monitoring these changes and their impacts on marine life requires ongoing research and identification efforts. By comparing historical photos with those taken today, scientists can assess changes in the distribution, abundance and diversity of sea creatures, and identify species that are declining or endangered.

Third, by accurately identifying species, researchers can better understand their ecology and develop effective management strategies to protect them. Photos and videos of unusual, rare or undocumented species can also generate public interest and support for marine conservation efforts, as when a rare all-white juvenile whale was captured off the coast near Ningaloo.

'Ningaloo is home to a massive range of marine life – more than 300 coral species, over 700 reef fish species, and roughly 600 crustaceans.'

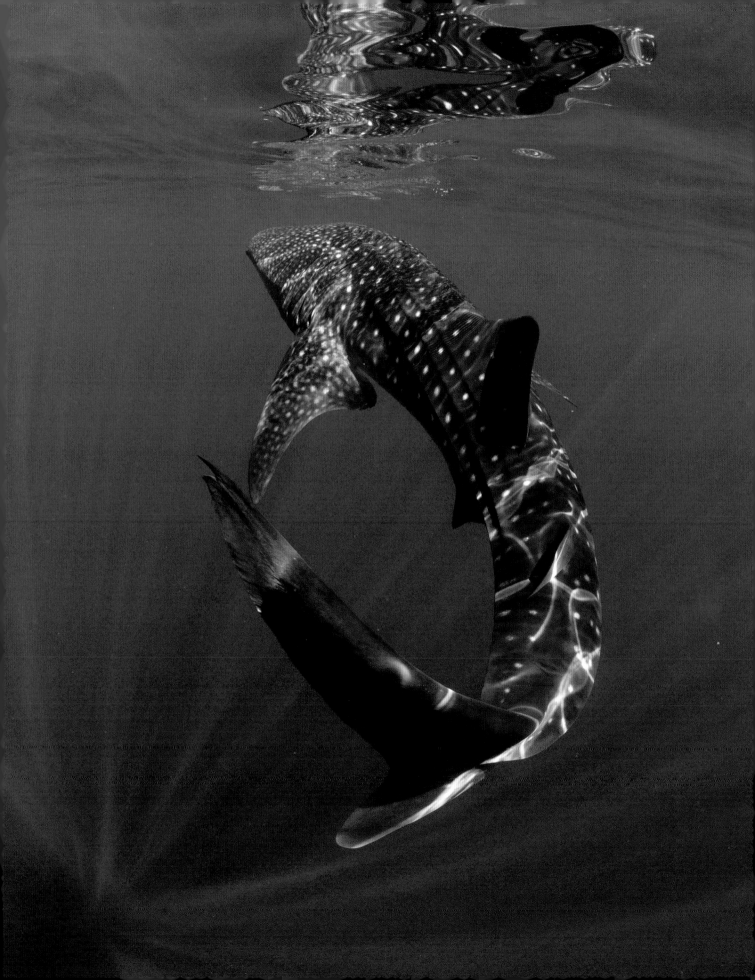

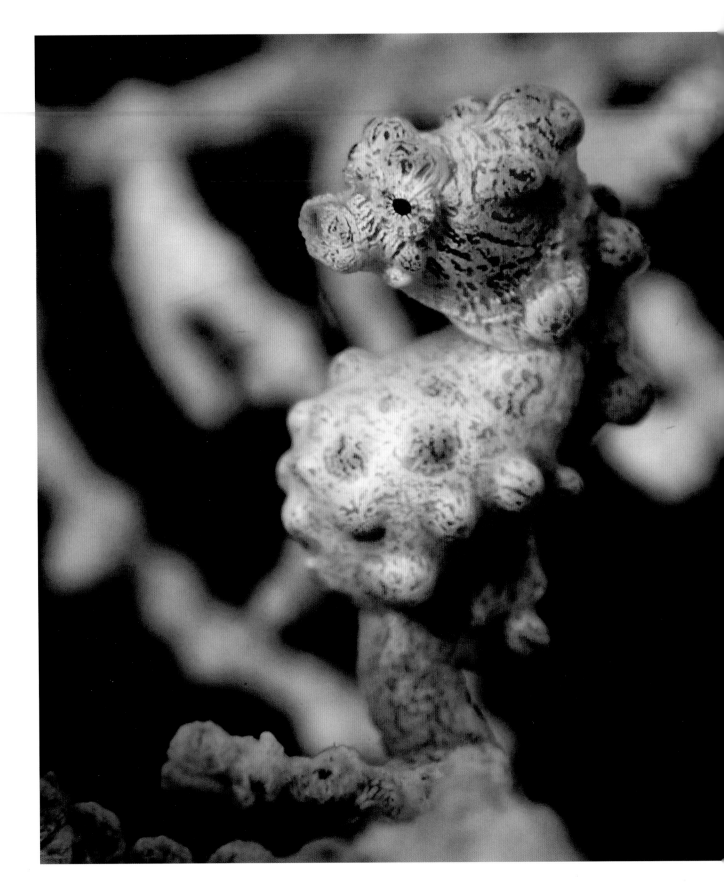

THE INDIAN OCEAN

A pygmy seahorse (*Hippocampus bargibanti*) at Tulamben, Bali.

Discovering the Disguised

ALOR, BALI, KALIMANTAN AND SULAWESI, INDONESIA

GEORGIA LAFFOLEY

Indonesia really has it all when it comes to marine life, from huge pelagics to the tiniest critters. Yet some of the wonders here require a keen eye - these are the creatures you might blink and miss, the masters of camouflage.

When people think about diving, there does tend to be much more excitement around larger animals like sharks and rays; as an active dive professional I've seen and experienced first-hand how people dismiss a dive as disappointing if they haven't been able to see either of these. By contrast, frogfish (*Antennariidae*) and seahorses (*Hippocampus*), for example, will always be on my list of top ten things to see on a dive – there are many different species of each and some that can only be found in Indonesia. Seahorses are ones we all know, with their unique shape and elegant features, while with frogfish on the other hand, 'beauty' is not always the first word that comes to mind. With their odd shape and sometimes quite 'dull' colours it's easy to see why people don't always get as excited about them as I do!

These creatures have shared habitats, as they live among seagrass beds and coral reefs. These are two of the habitats most at risk today, being deeply sensitive to pollution, climate change and disturbance.

RIGHT: A Lembeh sea dragon (*Kyonemichthys rumengani*) at Derawan Island, East Kalimantan.

BELOW, LEFT: Denise's pygmy seahorse (*Hippocampus denise*) at Kakaban Island, East Kalimantan.

BELOW, RIGHT: : A juvenile painted frogfish (*Antennarius pictus*) at Lembeh, North Sulawesi.

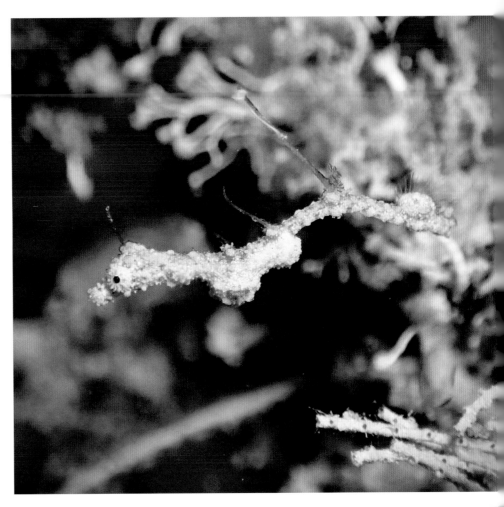

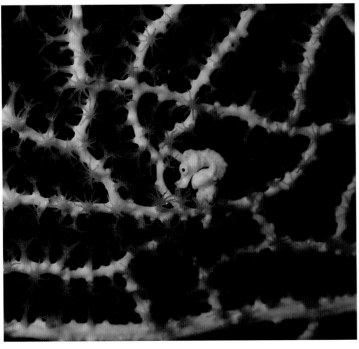

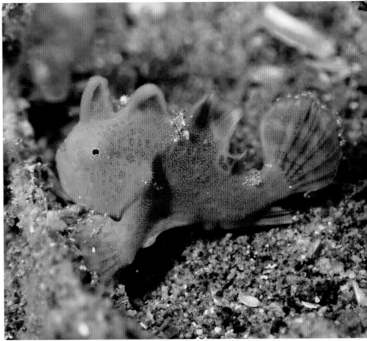

Seahorses, particularly, are under threat, as they are used for pseudo-medicinal purposes and captured to live in captivity (or even dried and made into souvenirs for tourists). Showcasing their beauty is not a challenge, but they are extremely shy and have a tendency to turn their backs towards their camera. Pygmy seahorses, in particular, are extremely sensitive to light; this is why they tend to be found at slightly greater depths. All of this means that you have to be very mindful of your camera set-up and how much time you spend photographing them. This actually applies to all marine life – my goal is not to get the perfect image but rather to ensure I am causing as little disturbance as possible. Going down the 'rabbit hole' of wanting to get the most unique and impressive image can lead to a lack of care towards these animals and the reefs on which they live.

I want to bring attention to smaller creatures and share the information that I've gained from my photography and research, creating excitement about the creatures that live within the Indonesian reefs while showing the important impact they have on their environment as predators of bottom-dwelling marine organisms and camouflage masters. One of the reasons I love photographing frogfish is that it's possible to capture the most intricate of details, which you would not normally be able to see with the naked eye. By showcasing these details, and the incredible camouflage, shapes and movements creatures such as this display, I hope that it will help to change the common misconception that 'muck dives' or dives without the big creatures, are lacking excitement. I also hope it will make people think twice about damaging the reefs they visit. I feel a huge responsibility when instructing to produce divers with good underwater conduct – we are simply visitors to the enchanting world that lies beneath the surface of the sea.

BELOW LEFT: A juvenile clown frogfish (*Antennarius maculatus*) at Tulamben, Bali.

BELOW RIGHT: Diane's Chromodoris nudibranch (*Chromodoris dianae*) at Alor, East Nusa Tenggara.

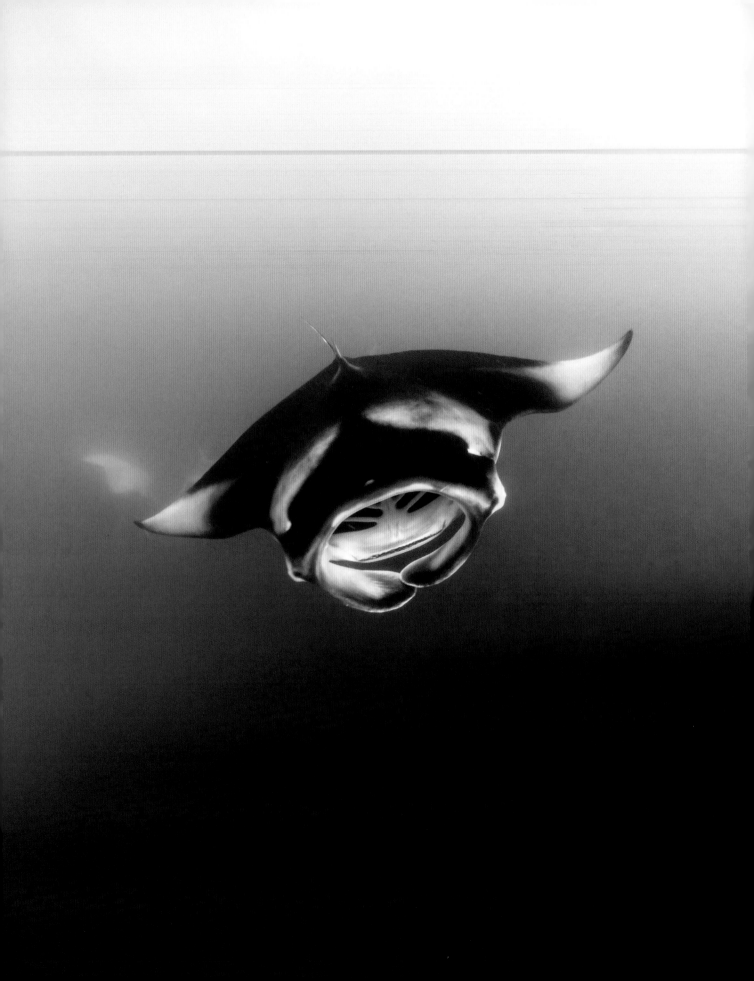

Rays of the Deep

THE MALDIVES

CARLA VIRGOS

PHOTOGRAPHS BY ALI AGEEL

The Maldives provides an ideal environment for eagle rays, manta rays and stingrays due to the warm waters, abundant food sources and suitable breeding grounds. The conservation of these creatures is of utmost importance, as they play a crucial role in maintaining the marine ecosystem's balance.

Manta rays, of the genus *Mobula*, and stingrays (in the suborder Myliobatoidei, and including eagle rays, or *Myliobatidae*, and whiptails, or *Dasyatidae*) are captivating marine creatures commonly found in the tropical paradise of the Maldives. The rays share some similarities but have distinct differences.

Mantas are characterized by their large size, graceful movements and unique, flattened body shape, with wing-like pectoral fins. They are filter feeders, primarily consuming plankton, small fish and microscopic organisms. Hundreds of these creatures from around the Maldives come together to feed in Hanifaru Bay (see images right), in one of the largest such gatherings seen globally. The site is a protected marine park and the whole Baa Atoll, where Hanifaru Bay lies, has been declared a UNESCO Biosphere Reserve, home to one of the largest groups of coral reefs in the Indian Ocean and notable for its rich biodiversity. The mantas here are a popular attraction for divers and

An opened-mouthed reef manta ray (*Mobula alfredi*) in Hanifaru Bay, the Maldives

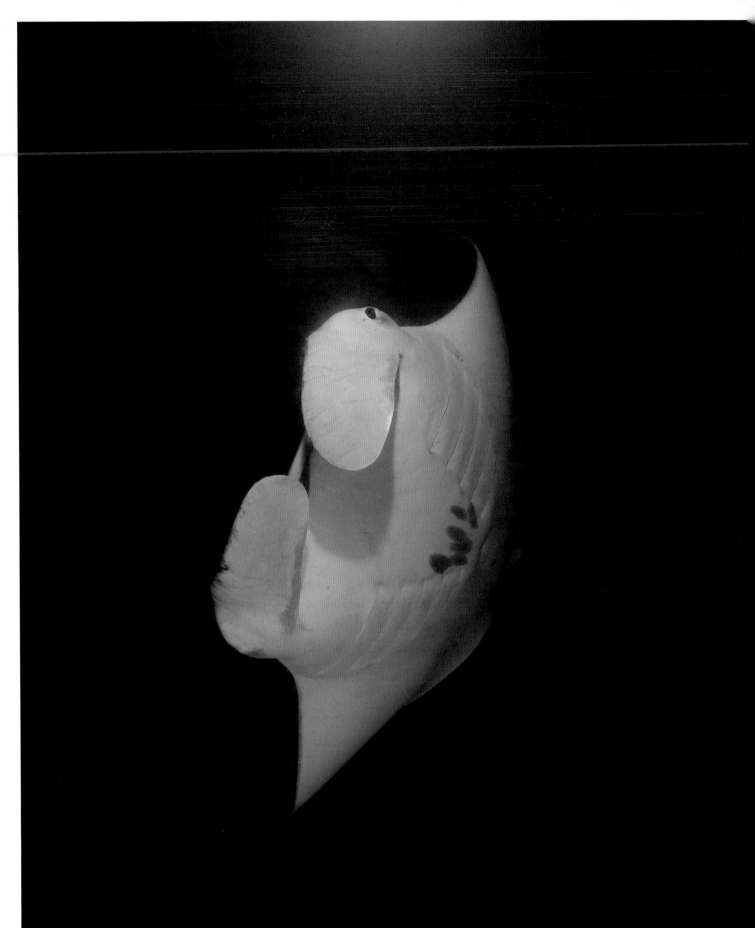

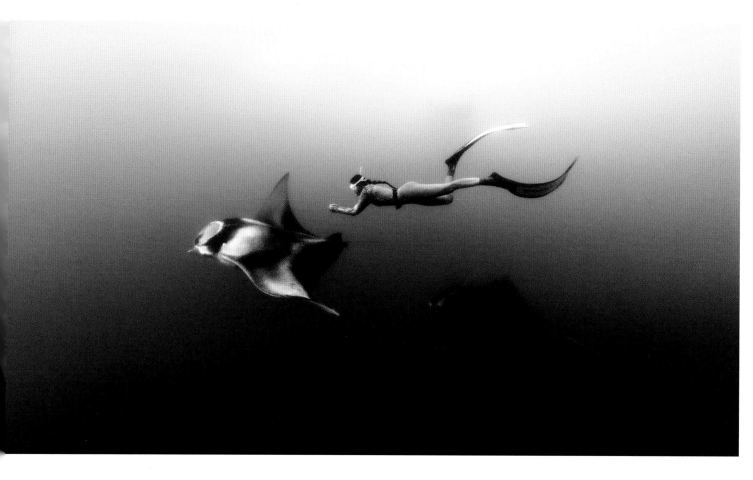

snorkellers, who can see these gentle giants making their elaborate courtship displays.

Stingrays have a more compact body structure than mantas and grow to a less gargantuan size. They are also equipped with venomous tail spines, which they use for self-defence when threatened. While they are generally not aggressive, it's essential to respect their space and avoid provoking them in their natural habitat.

Efforts to protect manta rays and stingrays in the Maldives include establishing marine protected areas, promoting sustainable tourism practices and raising awareness about their significance in the marine ecosystem. This is essential not only in the Maldives, but in all oceans. Manta rays and stingrays both play critical roles in marine ecosystems; without them, planktonic organism populations would grow out of control, causing harmful algal blooms (HABs). By understanding and preserving these magnificent creatures, we can contribute to the overall health and diversity of the Maldivian marine environment for future generations to enjoy.

OPPOSITE: A reef manta ray (*Mobula alfredi*) photographed at night.

ABOVE: The author swims alongside a reef manta in Hanifaru Bay, the Maldives.

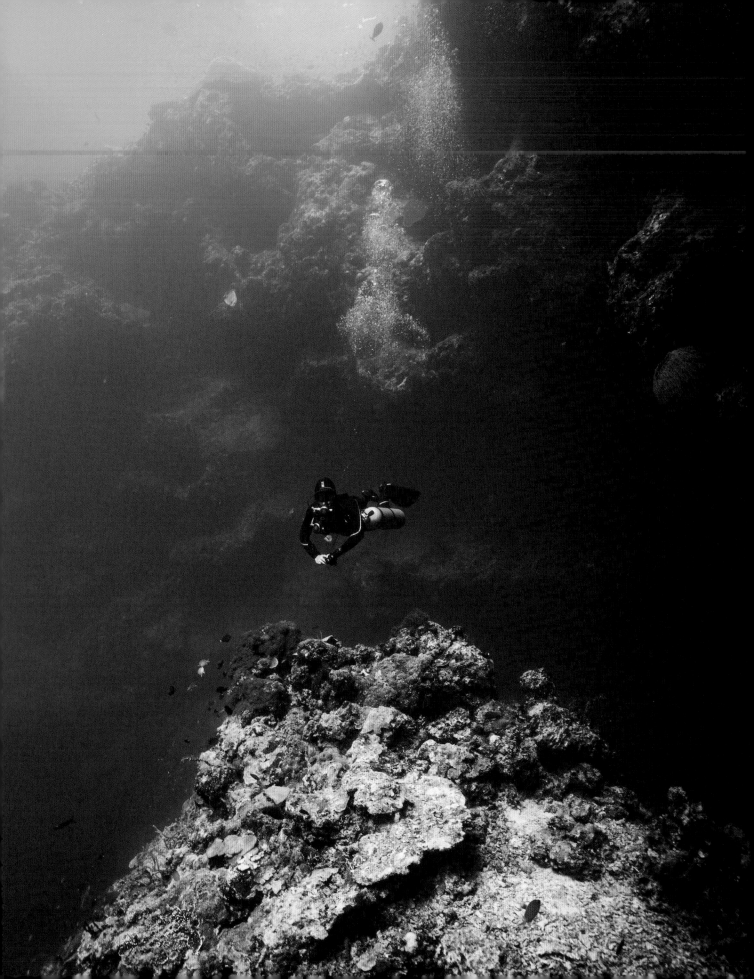

The Turtle Tomb

SIPADAN, MALAYSIA

MAXIME CHEMINADE

Sipadan, situated off the coast of Sabah, Malaysia, is an internationally renowned dive site and home to a complex underwater cave network, full of mystery (and peril, for inexperienced divers). The Turtle Tomb, part of this network, is the only known turtle 'graveyard' on the planet.

Turtle Tomb itself is the lower part of a wider cave system, sometimes called 'Turtle Cave', to which both tourists and scientists are drawn – the latter attracted by the promise of new species living in its depths. The entrance to this cave is 18 metres (59 feet) deep, with the entrance to the smaller 'tomb' even further within. An intricate system of tunnels leads to the lowest parts of the cave system, whose floor is covered with a layer of white sand, on top of which rest numerous turtle skeletons. The cave, which reaches 600 metres (1,969 feet) in depth, was famously visited by ocean explorer Jacques Cousteau in the 1980s, and he suggested that the turtles had come here to die 'peacefully', though locals state that the remains here are of turtles that have visited the cave system, become disorientated and asphyxiated in the depths.

Sea turtles – green turtles (*Chelonia mydas*) and hawksbill turtles (*Eretmochelys imbricata*) are the two species known to nest on Sipadan – are keystone species, helping to define their entire ecosystem. They are widely studied but the reason they are entering this cave system remains a mystery. It is amazing to think that these creatures would come here to rest, often next to each other, hundreds of metres within

An underwater explorer at the front entrance of the Turtle Tomb.

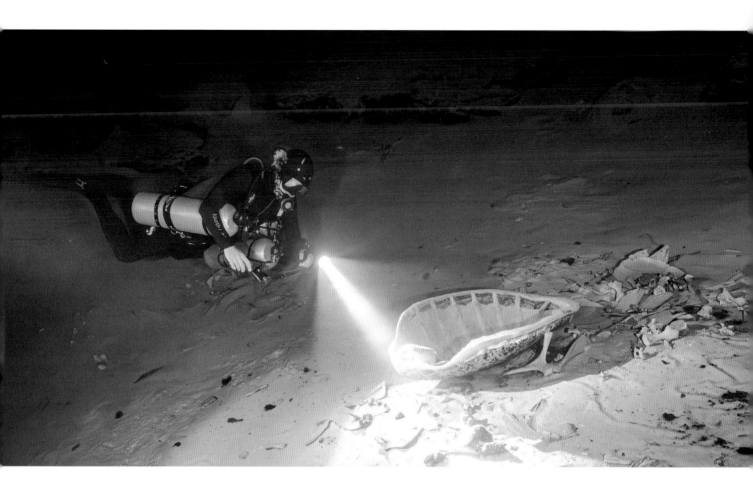

ABOVE: Lighting the remains of a turtle while searching for a suitable candidate for 3D photogrammetry.

OPPOSITE: This image was collected by our team for 3D photogrammetry of the remains.

a dark cave without any light. One can only imagine the secrets that this cave holds, and what we may learn about nature and the world around us by exploring it further. On our last expedition together, renowned marine biologist Professor Azman Abdul Rahim made an extraordinary discovery: the existence of unicorn shrimp (*Nebalia pugettensis*) in this cave. This minuscule creature, with its vibrant colours and horn-like protuberance, captivates the scientific community, as it is found only in the most extreme environments. Measuring just a few millimetres in length, the unicorn shrimp can only be observed and studied using specialized tools and techniques and, at this time, the population discovered at Turtle Tomb is believed to have a genome different to that of specimens previously discovered.

The Malaysian government has recognized the tourism potential of the tomb, and there are plans to open it to visitors in the future. However, it is important to balance the potential economic benefits of tourism with the protection of the delicate ecosystem here. It is essential to ensure that any tourism activities are sustainable and do not harm the environment or its residents in any way. As we continue to learn more about the Turtle Tomb and the creatures that inhabit it, we must also recognize our responsibility to protect the dive site for future generations.

'It is amazing to think that these creatures come here to rest, hundreds of metres within a cave, without any light.'

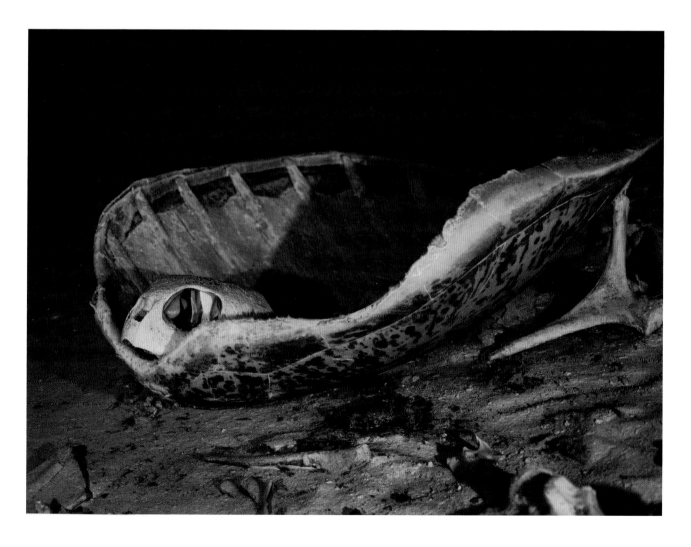

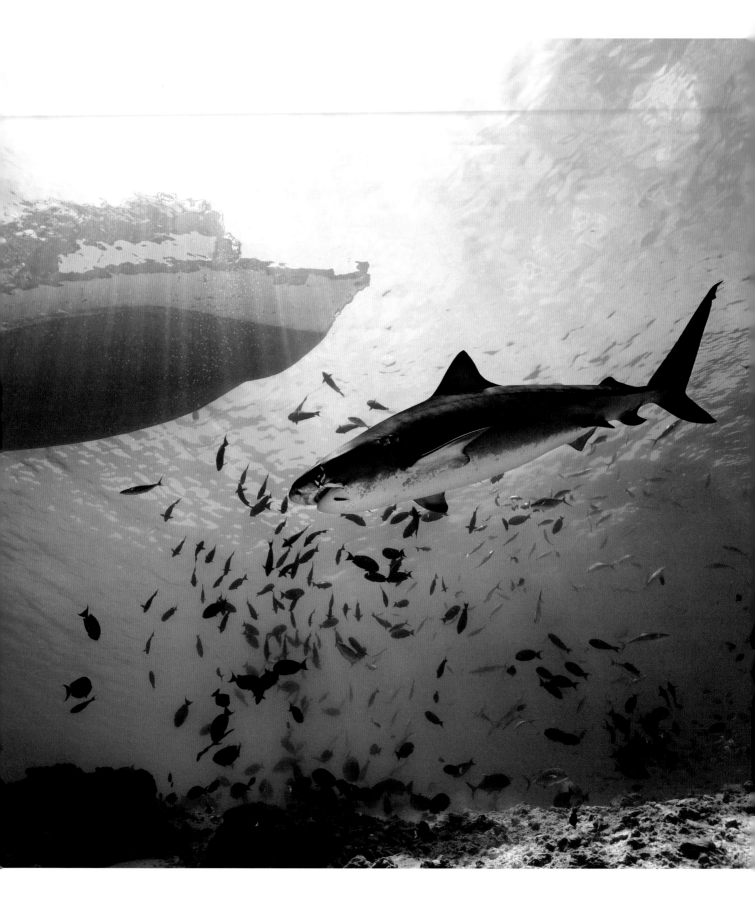

A tiger shark named Pirate by local dive centres approaches a traditional Maldivian *dhoni.*

The Miyaru Project

THE MALDIVES

ARZUCAN ASKIN

PHOTOGRAPHS BY JONO ALLEN

The Indian Ocean stands out as the epicentre of global shark decline. Defying this trend, however, is a nation made up of 1,192 tiny, low-lying coral islands: the Maldives. Dhivehi Raajje, as locals call their home country, is a globally significant hotspot for a vast diversity of shark species.

When people hear the word 'Maldives', the first things that come to mind are luxury resorts and honeymooners holding hands on dazzling white sand beaches. But below the surface of its luminous turquoise waters, the Maldives is a treasure trove, with some of the richest marine biodiversity found anywhere in the world. The country's coral reefs are the seventh largest in the world, representing over 3 per cent of the global reef area. In addition, the nation's 21,000 square kilometres (8,108 square miles) of reefs provide a safe haven for more than 31 species of shark, 29 of which are globally threatened. The blue waters of the Maldives are home to what is suspected to be the world's largest resident population of tiger sharks (*Galeocerdo cuvier*), a species that is currently listed as 'Near Threatened' on the IUCN Red List, with global population numbers forecast to continue to decline.

This is part of a general global trend: the most recent comprehensive assessment of extinction risk for all 31 oceanic species of sharks and rays has determined a decline in their global abundance by 71 per cent – due to a severe lack of fisheries management and a growing demand for shark fins, whose meat is thought to have medicinal properties.

In 2010, in response to the 'shark crisis', the Maldives made history by following the lead of Palau and becoming the second country in the world to declare its entire exclusive economic zone a shark sanctuary. All forms of shark fishing, as well as all imports and exports of shark fins, are banned in the country's waters, which encompass over 90,000 square kilometres (30,749 square miles) of ocean. A true testament to the power of a rapid political response to biodiversity loss, especially considering that, historically, sharks were actively fished here for their meat and liver oil. If shark populations continue to decline at the current rate, in the future the Maldives may be one of the last remaining 'fortresses' ensuring the survival of these predators.

Despite the critical importance of Maldivian waters for the future of large predatory shark species, large research and conservation gaps remain; while sharks may be safe from fishing, they continue to face threats from rapidly increasing tourism, habitat loss due to land reclamation, net entanglement and injuries from vessel strikes, as well as climate change. With that in mind, my colleagues and I founded the Miyaru Programme – a collaborative platform bringing together scientists, storytellers and conservationists on a mission to study, document and fiercely protect the shark species of this island nation. 'Miyaru' means shark in Dhivehi, the national language of the Maldives. Through our work, we seek to fill the large knowledge gaps that persist about the shark populations of the Maldives. We also want to shine a light on this nation, which has not received the (scientific) attention it deserves. We tell the tales of some of the many brave and bold locals here who have built unique bonds with sharks. We believe that it is time to redefine the intersection of humans and sharks and highlight the global lessons that can be learned from this island nation.

OPPOSITE, ABOVE: A large female tiger shark swims past a local diver in the waters of Fuvahmulah, the Maldives.

OPPOSITE, BELOW: National Geographic Explorer Arzucan Askin surrounded by sharks.

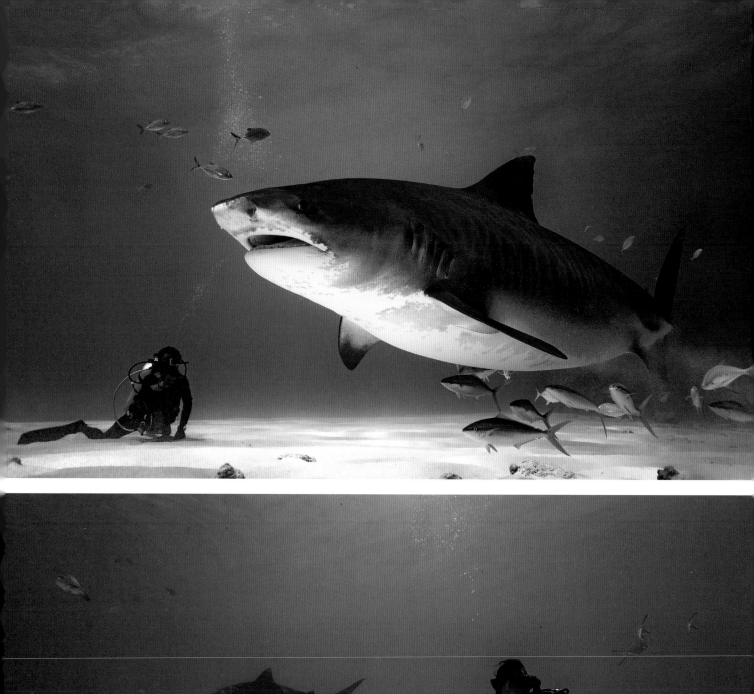
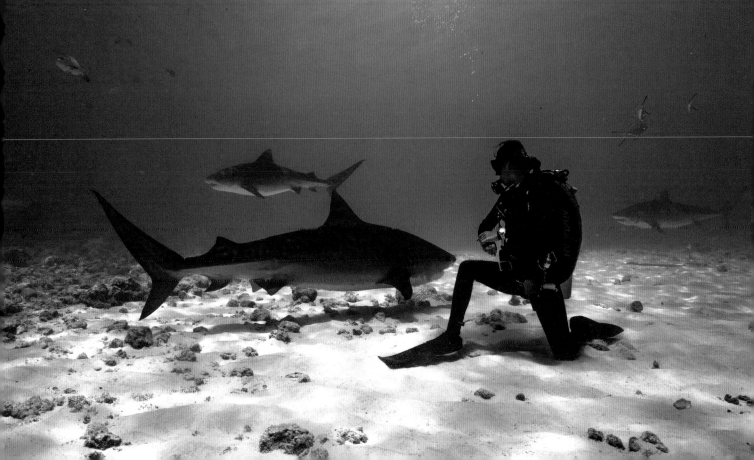

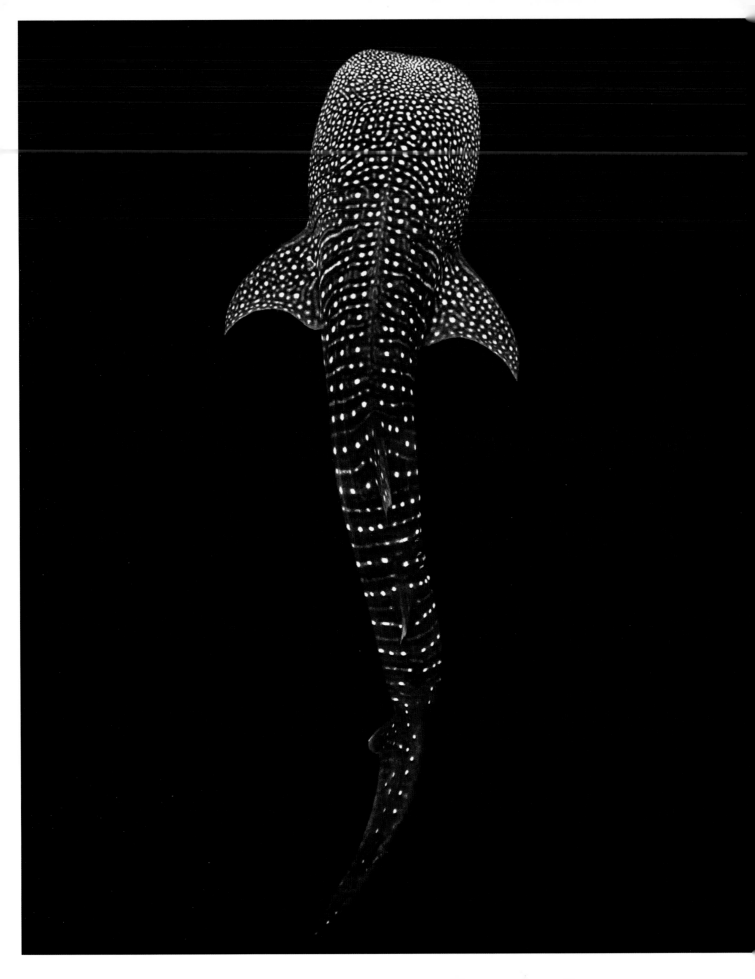

The Starry Shark

ALIFU DHAALU ATOLL, THE MALDIVES

KAUSHIIK SUBRAMANIAM

The only place in the world where whale sharks can be found all year, Alifu Dhaalu Atoll (also known as South Ari Atoll), is a crucial location for the conservation of the biggest fish in the world. By studying the sharks here, we can start to better understand the lives of these gentle giants.

Each whale shark (*Rhincodon typus*) has a unique spot pattern, which can be used to identify the individual.

The largest fish in the world is also one of the most elusive. Whale sharks (*Rhincodon typus*) can be found across the tropical oceans of the world, but there is only one place where they can be seen all year. Alifu Dhaalu Atoll, in the Maldives, is a hotspot for these gentle giants, with the bathymetry of the area and nutrient-dense waters making it the perfect location for young sharks to feed and grow before venturing out into the big blue. Very little is known about the lives of these moving constellations, with many unanswered questions surrounding their mating and birthing. One thing we do know is what they eat. In order to maintain their enormous size, these sharks consume over 20 kilograms (44 pounds) of plankton each and every day.

I spent months studying the whale sharks of the Maldives, getting to know individuals and their behaviours. Just like humans, they all have different personalities, with some more curious than others. Their individuality is also a matter of scientific record, with each individual 'starry shark' having a unique spot pattern. By studying and documenting these patterns, we can identify the movements of

individuals within the Maldives as well as tracking their growth. With so little known about these animals, any small piece of information that we can procure is vital.

A keystone species, whale sharks are an excellent indicator of the health of reef ecosystems. Their appetite keeps the levels of plankton in the oceans under control, preventing an excess that would lead to algae blooms and a knock-on negative effect on the coral reefs. (Excessive or invasive algae can destroy coral-dominated environments, effectively 'smothering' the coral.)

Through my photography, I can tell the story of these elusive giants, and the efforts of the incredible team at the Maldives Whale Shark Research Programme (MWSRP) and other marine conservation organisations, who work hard to protect them. My experience in the Maldives shows us how tourism can be an important tool in conservation, but tourism can also pose a serious threat if not conducted in the proper manner. For example, their huge size unfortunately makes these sharks prone to becoming entangled in fishing nets, and their slow and lethargic nature means that they are often hit by marine vessels. Thankfully they have incredible healing capabilities, but now more than ever it is crucial that we help protect these gentle giants from the impacts of humanity on the oceans.

'Just like humans, they all have different personalities, with some more curious than others.'

An adolescent whale shark sunbathes in the shallow waters of the reef.

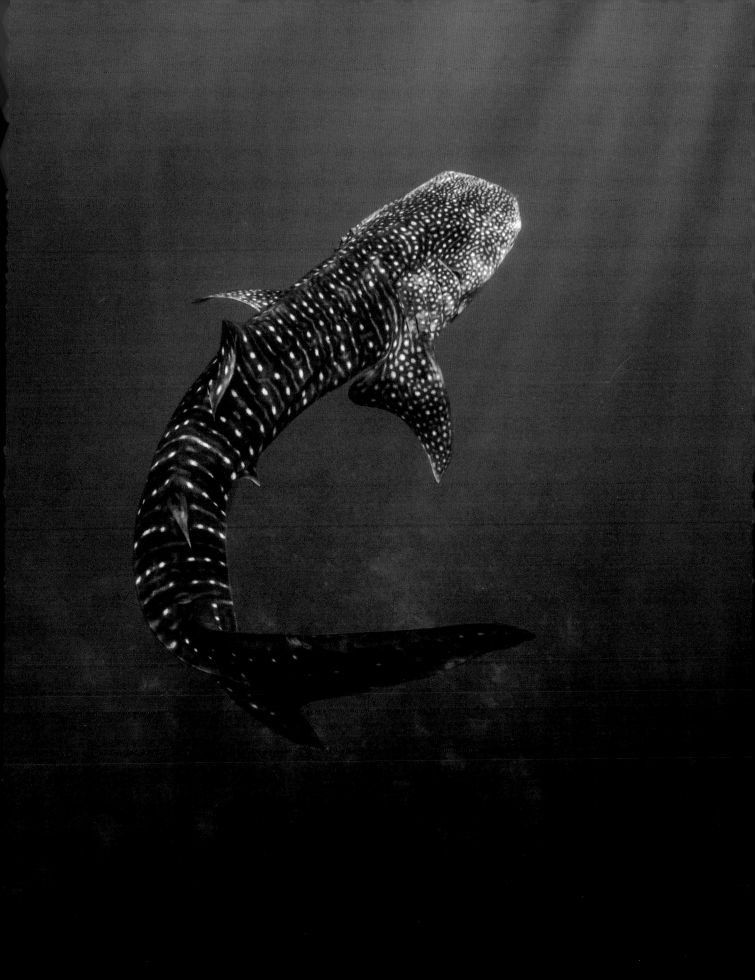

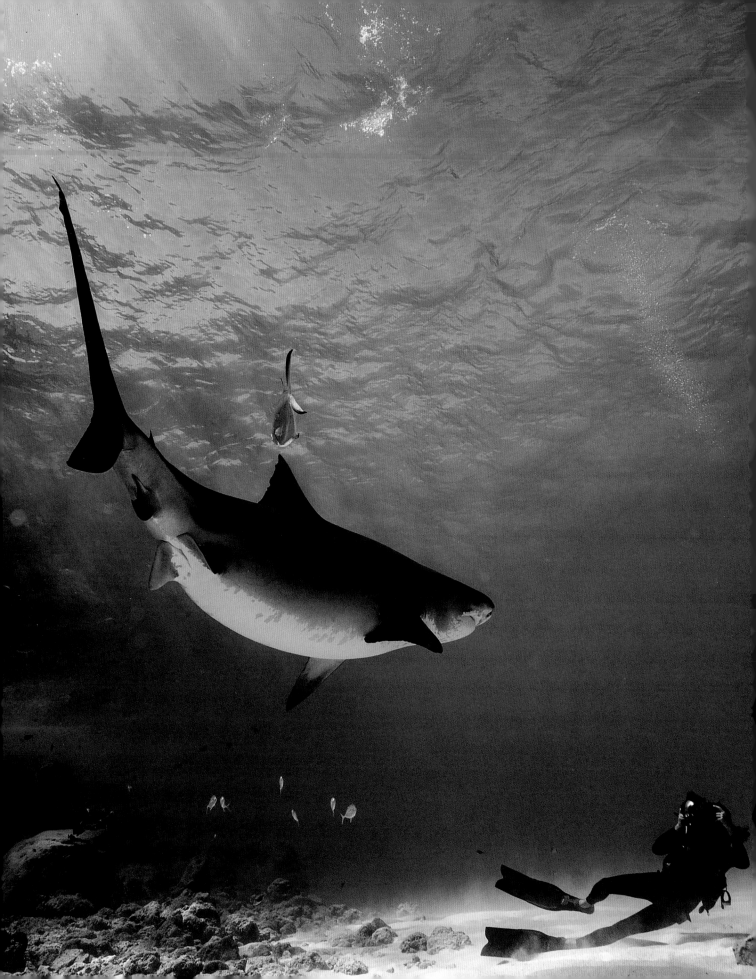

OCL Storyteller Jono Allen captures a large female tiger shark (*Galeocerdo cuvier*) from below.

OVERLEAF: A single frame showcasing the beautiful biodiversity of the ocean in Fuvahmulah.

Co-existing with Sharks in Fuvahmulah

FUVAHMULAH, THE MALDIVES

NASHEED LONU

PHOTOGRAPHS BY MATT PORTEOUS

A recently founded dive school and marine foundation on the island of Fuvahmulah aim to bring local people, as well as visitors, into the water, spreading knowledge about the world beneath the waves, especially the extraordinary population of sharks found here.

When I was a child my mother would always know if I had skipped school by licking her finger and tasting the dried salt on my skin as I returned home. The ocean has always been my playground, and it was where I earned my nickname, 'Lonu', which means 'salt water' in Dhivehi, the national language of the Maldives.

My home, the tiny island of Fuvahmulah, is unique even amid the outstanding natural beauty and biodiversity of the Maldives. Designated a UNESCO Biosphere Reserve in 2020, the atoll boasts unique coral sand beaches and the most diverse coral ecosystems in the country, with that same diversity reflected on land in its mangrove and wetland regions. An 'immensely significant' population of over 1,200 species of fish is found in the island's waters, and the reef systems are home to large populations of sharks: tiger sharks (*Galeocerdo cuvier*), threshers (*Alopias*), hammerheads (*Sphyrnidae*), white tips (*Carcharhinus*

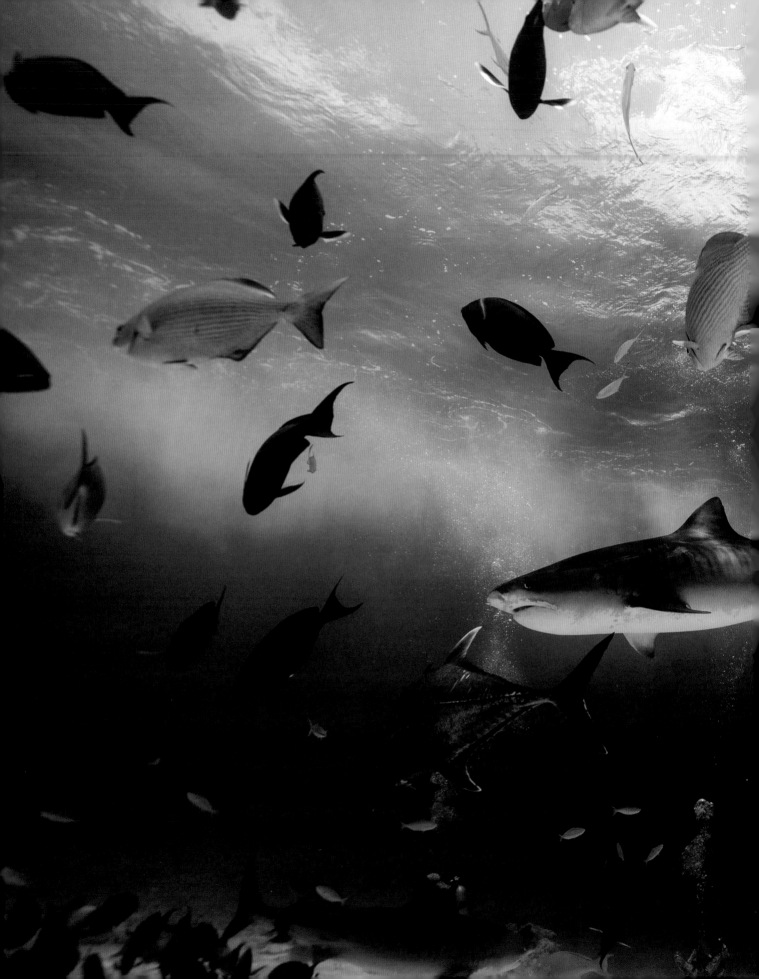

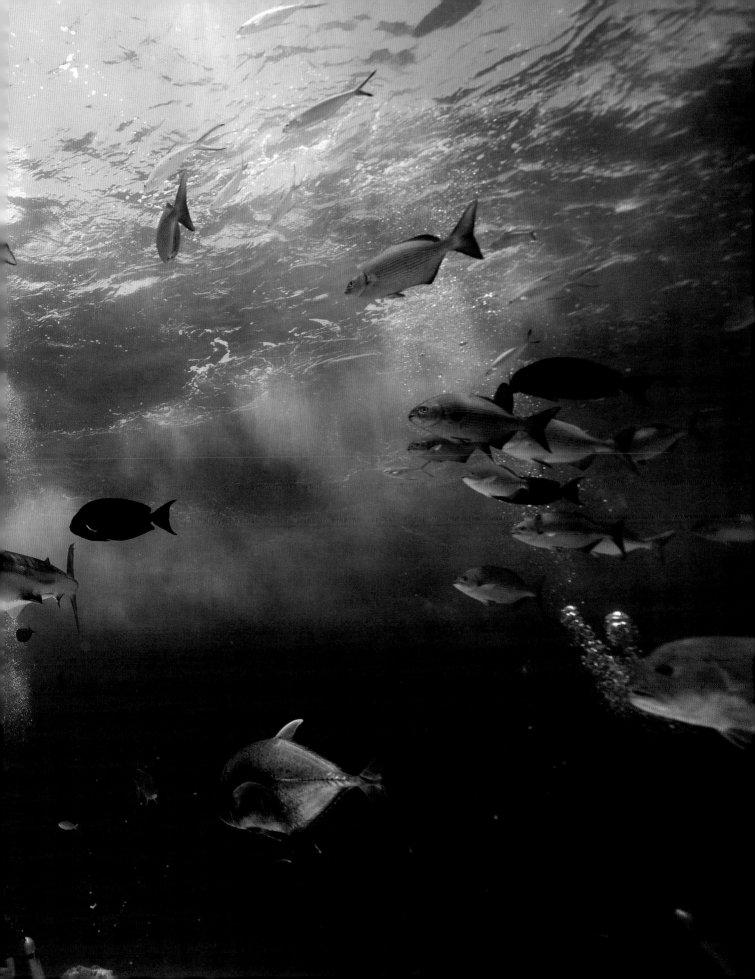

longimanus) and whale sharks (*Rhincodon typus*), among others. The unique geography of our island, with no other land masses nearby, and its ocean current patterns have created an ideal nursery for juvenile sharks, who thrive in the volcanic underwater landscapes with their steep drop-offs. The tiger shark population, in particular, is sizeable here.

I first encountered these sharks as a young child when snorkelling. Many in my community feared these creatures and local fisherman would hunt sharks, as it was widely believed they stood between them and their catch. However my fascination and curiosity to learn more about these animals drew me to explore the ocean every day. The fascination soon turned into an obsession and I learned how to scuba dive. The day I encountered an eight-foot female tiger shark was the day my life changed forever.

As I spent more time with the sharks I learned about their importance as indicators for ocean health. I wanted to share this knowledge with my community but very few would venture beneath the surface with me to see it for themselves. I knew I had to find a way of showing them how helping to protect sharks would bring benefits not only to the ecosystem but to our island's economy. In 2016 I set up the very first dive school in Fuvahmulah. My mission was to safely take others with me to experience the magic that lay beneath our waters. Word soon spread and began to attract visitors to our island.

Today, we introduce hundreds of guests every year to our pelagic residents, and have recently founded Fuvahmulah Marine Foundation to help further protect the marine life that gives us so much. I now work with my community to protect our shark residents.

'Many in my community feared these creatures and local fisherman would hunt sharks. However my fascination drew me to the ocean every day.'

A beautiful moment with these misunderstood apex predators, which have been with us for 450 million years.

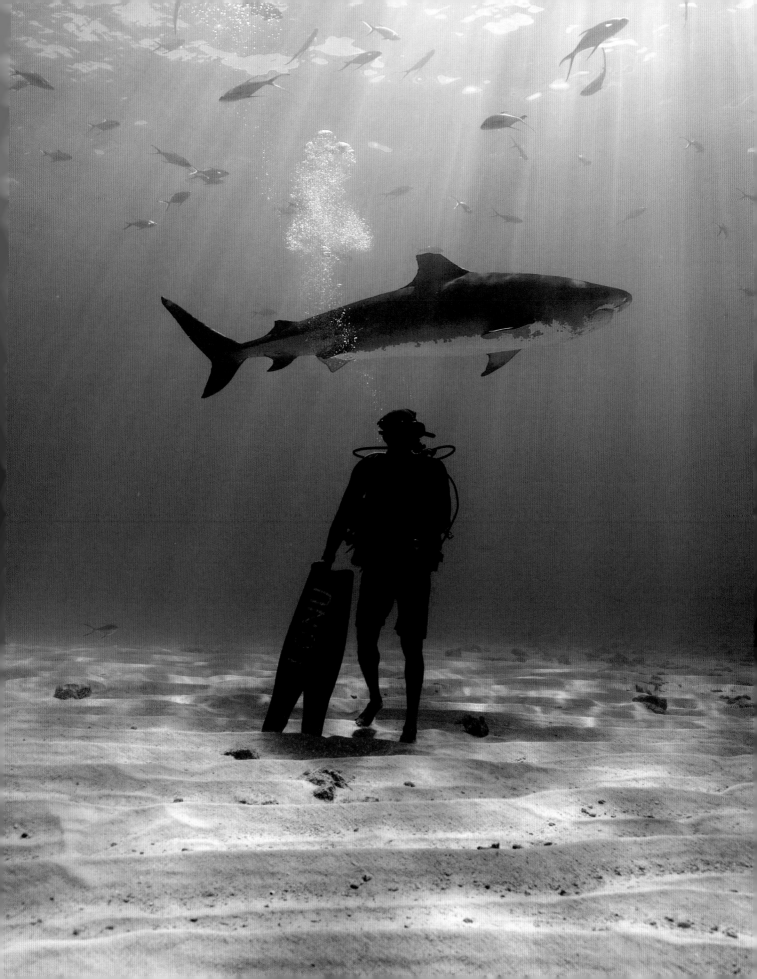

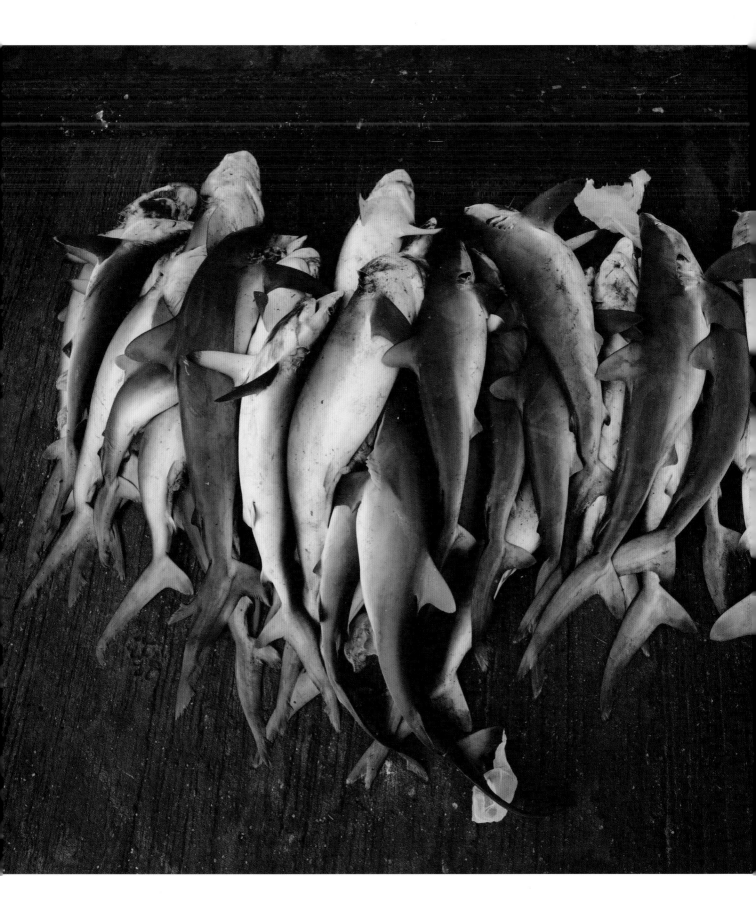

Sharks lie lifeless on the ground at the
fishery harbour of Negombo, Sri Lanka,
after being caught out at sea.

Shining a Light on the Shark Meat Trade

SRI LANKA

NOEMI MERZ

While the demand for shark-fin soup is a global and
ongoing threat to shark populations, the demand for shark
meat has also been steadily increasing. Awareness of this
demand and the tremendous trade network behind it lags
behind the urgency (and complexity) of the issue.

While we recently celebrated a huge success in shark conservation, with
the listing of almost 100 new shark species on CITES Appendix 2 –
which controls trade in specimens whose existence might be threatened
by human activity – this milestone only affects international trade.
Currently, very few countries have measures in place that protect
sharks within their borders, and sharks are therefore traded and
utilized without restrictions.

By monitoring landing sites across the country, the non-profit
organization Blue Resources Trust aims to identify caught shark
species in Sri Lanka, their abundance, and potential trends in shark
bycatch. Beyond this, there is a gap in knowledge regarding their
domestic value. In collaboration with Blue Resources, I spent four
months in Sri Lanka investigating the popularity of shark meat, trying
to identify the drivers behind its consumption and studying whether
there is a dependency on it as a food-securing protein source.

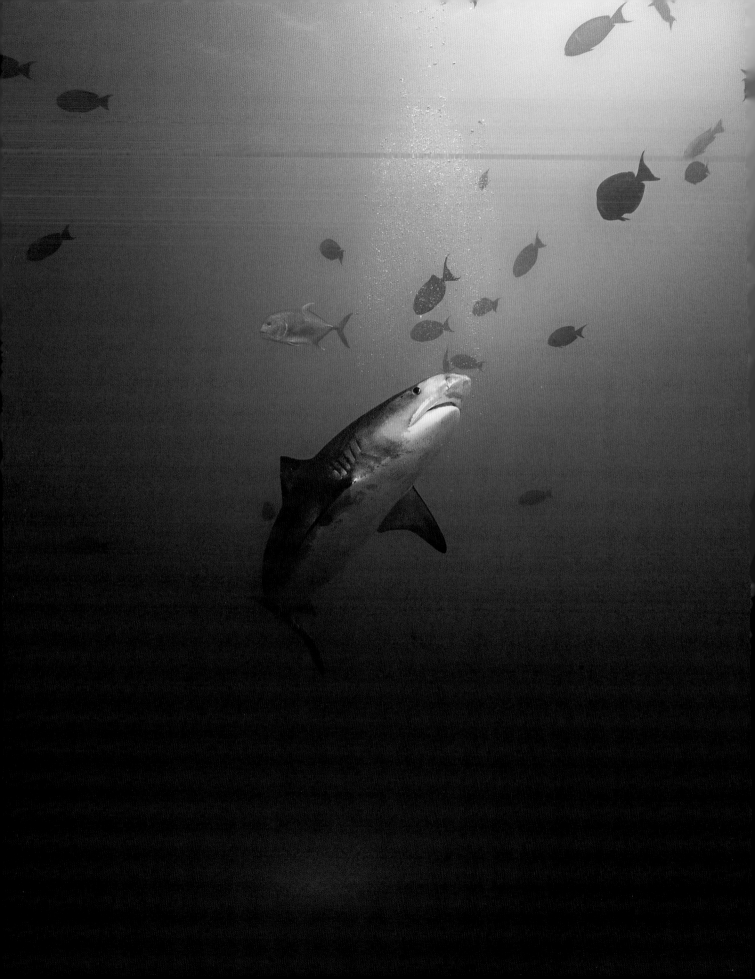

There are only a few targeted shark fisheries in Sri Lanka; the majority of sharks (and rays) are caught as bycatch in gillnets and longlines in the more profitable tuna and billfish industries. Finning – the practice of removing a shark's fins and discarding the rest of the creature – is also prohibited in Sri Lanka and therefore sharks are landed as a whole, with most of the shark being utilized and the meat sold domestically. The extent of the global meat trade is, to date, only partially understood, and domestic consumption is even less traced and acknowledged. Revealing the importance of shark meat to local communities and identifying the given circumstances under which financial income and sources of nutrition are potentially connected to it will allow conservationists to work on the mitigation of shark consumption.

Shark meat in Sri Lanka is sold either fresh at fish markets or dried and salted in supermarkets. There is little to no traceability for the consumer regarding what shark species are sold: shark is sold under generic labels and cut into small pieces, indicating that multiple shark species may potentially be within the same package. Whether these species are potentially threatened with extinction is not known unless DNA analysis is performed on the meat. Increasing transparency in this supply chain is another way in which a sustainable and regulated trade could be created within the country.

The interconnection between fisheries, domestic communities and the protection of endangered shark species is complex here. On the outside, it might often seem obvious how to initiate conservation efforts, but on the inside, it is rather complicated. On the one hand, we are trying to protect sharks, but on the other hand, we need to be aware of how conservation efforts potentially affect communities that could be dependent on sharks and are not privileged with alternatives to which they can turn. I want to give a voice to sharks but also to the people relying on them, aiming for a future where this dependency can be replaced by co-existence.

'The extent of the global meat trade is only partially understood and domestic consumption even less.'

A tiger shark (*Galeocerdo cuvier*) emerges from deep tropical waters off the coast of Fuvahmulah, an island in the Maldives.

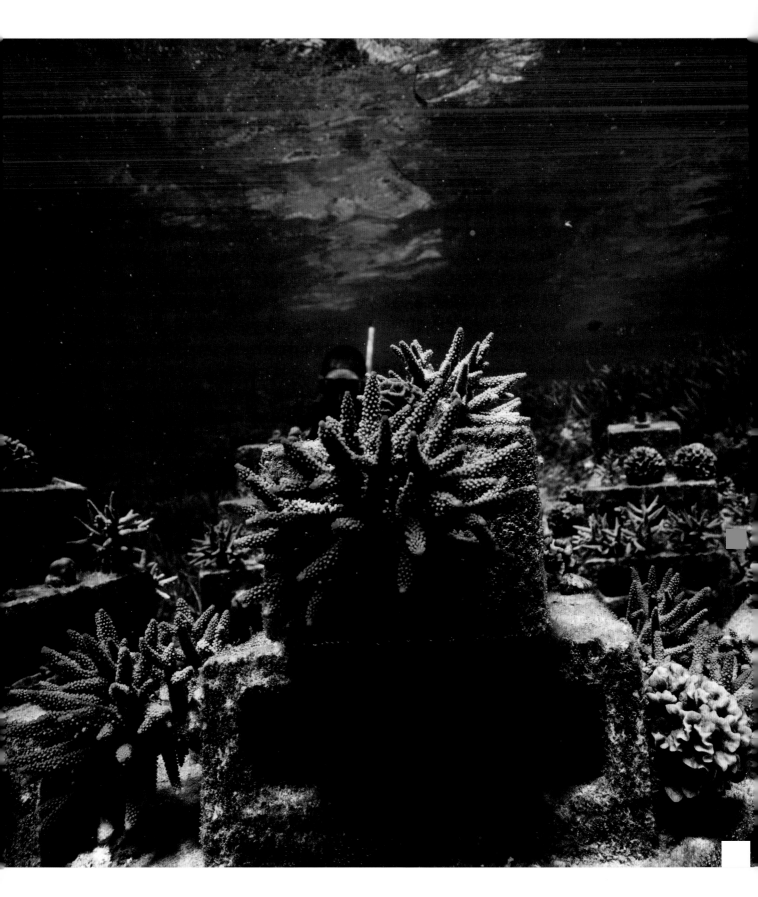

The thriving marine sanctuary at Kuruwitu is now a biodiversity hotspot.

The Kuruwitu Way

KENYA

OCEANS ALIVE TRUST

Imagine a place where palm-fringed sandy beaches lead down to coastal waters that teem with marine life. On shore, a close-knit community of traditional fishermen and their families live in harmony with the ocean. This is a snapshot of daily life at Kuruwitu, a coastal area north of Mombasa, Kenya.

Kenyan-born Des Bowden was fortunate enough to spend his childhood here; he spent family holidays learning to snorkel, losing himself in the underwater world. As an adult, however, Bowden saw the marine life he'd grown up alongside was not thriving and, in some cases, had disappeared entirely. A friend and local fisherman, Dickson Juma, began telling Bowden about the problems he increasingly saw. Fish catches declined in weight and size, and an unfamiliar note of desperation was heard in the voices of the usually laid-back fishermen.

The time-honoured fishing life that had sustained Kuruwitu for generations was shaken by a series of tragedies. An El Niño coral bleaching event in 1999 was made worse by the ever-growing population and more fishermen using increasingly small and unsustainable nets. Fishing as a way of life at Kuruwitu was on the brink of collapse and could no longer sustain the community. In this dark hour, the conversations between Bowden and Juma, and the village elders, fishermen and fishmongers, sparked an idea, which led to the birth of the Kuruwitu Conservation and Welfare Association

'The elders here told incredible stories of once-plentiful oceans and inspired the conservation team to act.'

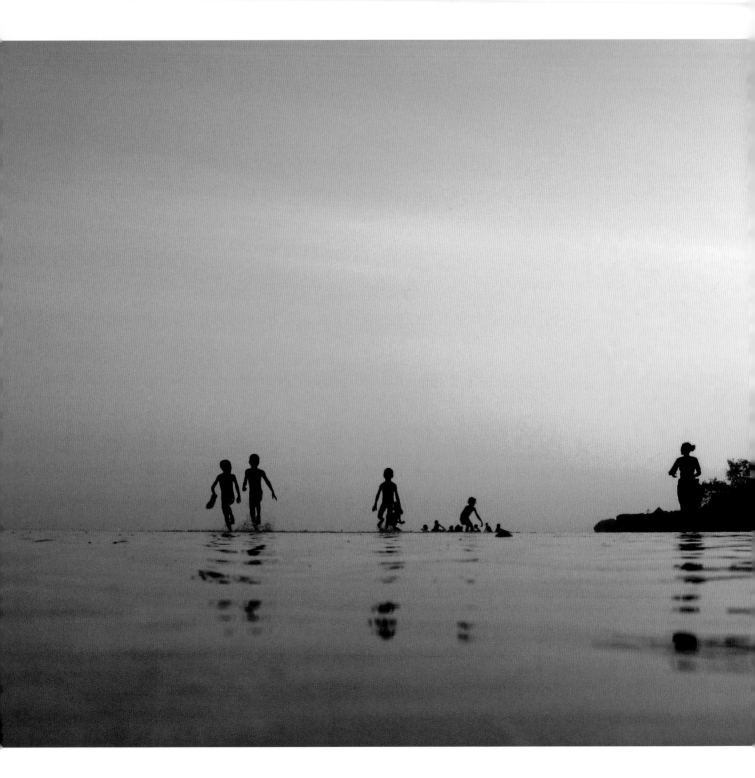

OPPOSITE: Indian Ocean sunsets are enjoyed by the whole community.

BELOW: Charles III at Kuruwitu in November 2023 with co-founders Des Bowden and Dickson Juma.

(now Kuruwitu-CBO); this community group charted a way forward by embracing traditional approaches to marine management, starting a community-run marine sanctuary, the first of its kind in the region. Within a couple of years, this led to a remarkable recovery: from a marine desert characterised by sea urchins, dead coral and very few fish, the sanctuary recovered some of its vibrancy, and life returned. The sanctuary ('tengefu' in Swahili) turned into a breeding ground, the community saw their nets full once again, and their livelihoods quickly improved.

Word spread, and the visible recovery at Kuruwitu inspired the start of Oceans Alive, created to support and scale the work at Kuruwitu and amplify its message along the Kenyan coast. We provide training, support and capacity building to place large areas of oceans under management. In 2021, Oceans Alive worked with stakeholders to upscale the original marine sanctuary to a 12,000-hectare Co-Managed Area. This is part of a program to put nearly 600,000 hectares – covering the majority of the Kenya coast – under community-led Joint Collaborative Management.

In November 2023, Charles III visited us and saw the impact and scope of our work. He launched a coral restoration structure bearing his cypher to illustrate his support. Oceans Alive is proud to serve as a conservation model that shows there is hope through working together.

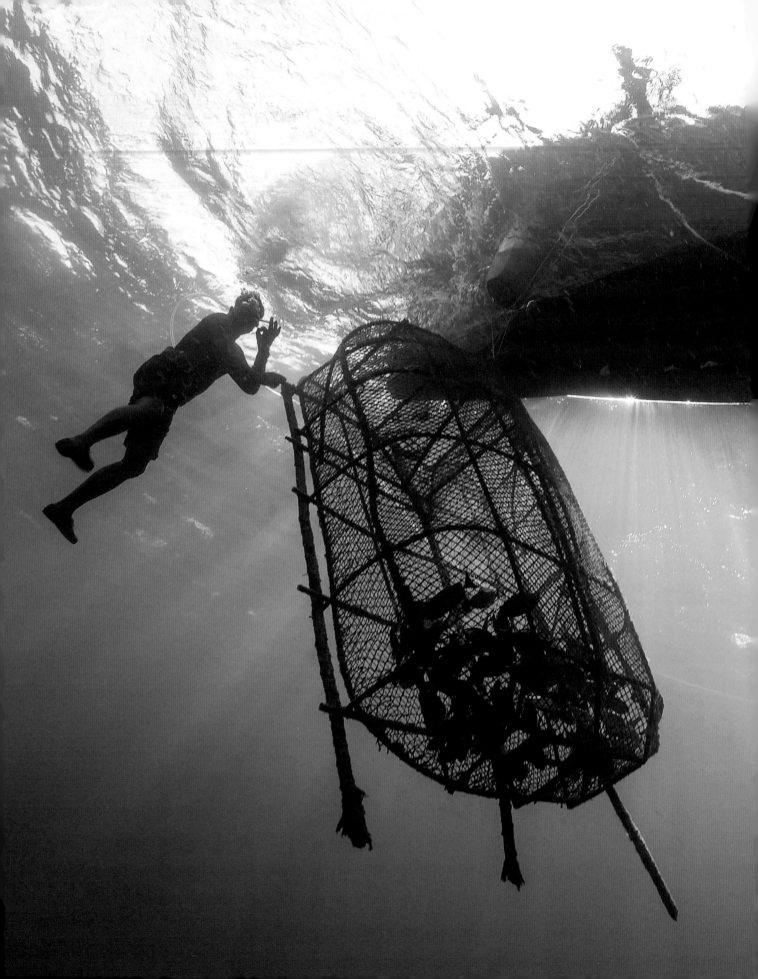

An Urak Lawoi fisherman lifts a fish trap to the boat with the help of a bucket filled with air.

Urak Lawoi

ANDAMAN SEA

MILOŠ PRELEVIĆ

The Urak Lawoi, the indigenous people of the Adang archipelago, preserve their traditions and help to care for their island homes. Those drawn to these gorgeous islands by the dive sites - the soft corals, whale sharks and rays - can learn from the local knowledge of these communities.

As the tourist season winds down, the Urak Lawoi rely on the sea for their livelihood. Walking the streets on the island of Koh Lipe, I saw fishermen making netting and wooden traps; trap fishing stands out for its low bycatch and use of biodegradable materials. While photographing this unusual method of fishing, I observed that unwanted fish are returned to the sea once the traps are full and released if caught in the traps. I noticed that the fishermen took a moment to pray before diving into the deep waters (the Urak Lawoi are animists, believing in the spirits of places and things). Through conversations with the locals, I learned about the Plajak ceremony (the Floating Boat ceremony), the Urak Lawoi's most significant tradition. The Urak Lawoi celebrate the Plajak ceremony twice a year, marking the beginning and end of the rainy season. It involves building a ceremonial boat to remove any bad luck or misfortune from the island. On the first day, the Urak Lawoi head to the local shrine to connect with the spirits and make a wish while lighting a candle. The following day, a group of locals set out for Koh Adang in search of a specific type of

TOP: People leave pieces of hair and fingernail on the ceremonial boat to represent misfortune to be taken away.

LEFT: A fisherman prays before diving for an abundance of fish and for safety.

ABOVE: An Urak Lawoi woman adorns the ceremonial boat with flowers.

wood that will be used to construct the boat. The boat must be finished by evening and adorned with flower decorations.

Then, in order to represent the bad luck that will be removed, people cut pieces of their hair and place them in the boat. As the first rays of the sun emerge on the third day, the ceremonial boat is loaded onto a longtail boat, taken far from the island, and left to the mercy of the sea. Upon their return, the community builds crosses that are placed around the island, offering protection against any bad luck that may return. Through this ancient ritual, the Urak Lawoi demonstrate a deep connection with their environment and traditions.

Many locals participate in island clean-ups, but, as in many places, their knowledge seems to be under-utilized. Through the years, these communities have gained a deep understanding of the intricacies of the island terrain, animal behaviour and the ocean's weather patterns. Such knowledge can be applied to conservation efforts, allowing us to better understand and manage our impact on marine ecosystems. Where jobs are available in conservation projects, these communities are also enabled to move away from over-reliance on fishing. Both oceans and local residents benefit from a community-driven approach to conservation.

ABOVE: A longtail boat zigzags through the coral patches while carrying a ceremonial boat far from the island.

Seagrass (*Posidonia australis*) meets seaweed (*Ecklonia radiata*) on the seabed.

The Symphony of Nature

CAPE ARID, AUSTRALIA

DIEGO LEANDRO GENNA

A wild dive in the pristine waters of Cape Arid brings this photographer face to face with some of the extraordinary marine creatures of the southern hemisphere, including its most famous predator.

Cape Arid National Park – 125 kilometres (78 miles) east of Esperance in Western Australia – is a gorgeous, wild place of broad, bright, untamed perspectives. I explored this remote landscape with a friend in 2020, navigating a succession of hills that gently slide into the ocean, rounded granite boulders, long stretches of milky sand and small bays next to the surging of the ocean.

One sunny winter morning we spotted the first southern right whale (*Eubalaena australis*) of the season, coming straight from its feeding season in Antarctica to breed in the warmer northern waters. It was resting in the bay, close to a rock, not far from the shore and we decided to jump into the water and try to get a bit closer. We swam to that rock through a shallow channel of turquoise water, with snow-white sand beneath, and dived in the open water. It was one of the best spots I have ever experienced, so pristine, and a glorious concert of living colours and shapes surrounded us: corals, sponges, seaweeds, ascidians and bryozoans, and all the creatures of the sea – busy crustaceans, idle

molluscs, alert cephalopods, indifferent jellyfishes, starfish looking as though dressed up for the party. In that unrivalled richness, innumerable species of all kinds thrived, many of which I was seeing for the first time. Not a single inch of rock, at the bottom, that wasn't covered with incredible life forms, sharing the same space in fierce and wonderful coexistence. A triumph of colours, a jubilation of shades, a rhapsody in blue, gold, purple, green. The ocean is in bloom. We couldn't have asked for better.

The whale we had spotted earlier from the shore was gone, disappeared. And after a while my friend wanted to get out of the water. I was taking the last pictures of a beautiful walking anemone on a kelp blade, so stayed a little longer. I was swimming back to the shore when a great white shark (*Carcharodon carcharias*) spotted me. The ocean suddenly became silent – even more transparent, with the shark's shape clear and sharp and coming slowly towards me, showing an inquisitive and disquieting smile of more than three hundred teeth. I couldn't believe my

eyes. I could hear my throbbing heart. The shark suddenly turned on its side, flashing in front of my eyes 3½ metres (maybe 4) of massive, untamed magnificence. It touched the tip of my flipper with its snout. And then it swam away, slowly vanishing into the wild ocean.

It had touched me, without bumping me, without hurting me, almost delicately, as with the conductor's baton. Still, today, when I think about that dive in Cape Arid, I can feel the symphony of Nature.

OPPOSITE: A baby wandering sea anemone (*Phlyctenactis tubercolosa*) begins to explore the ocean.

ABOVE: A solitary squid seems to reproduce the colour of the sunset at the water's surface.

RIGHT: A fan coral is reflected in a bubble trapped on the roof of this small cave.

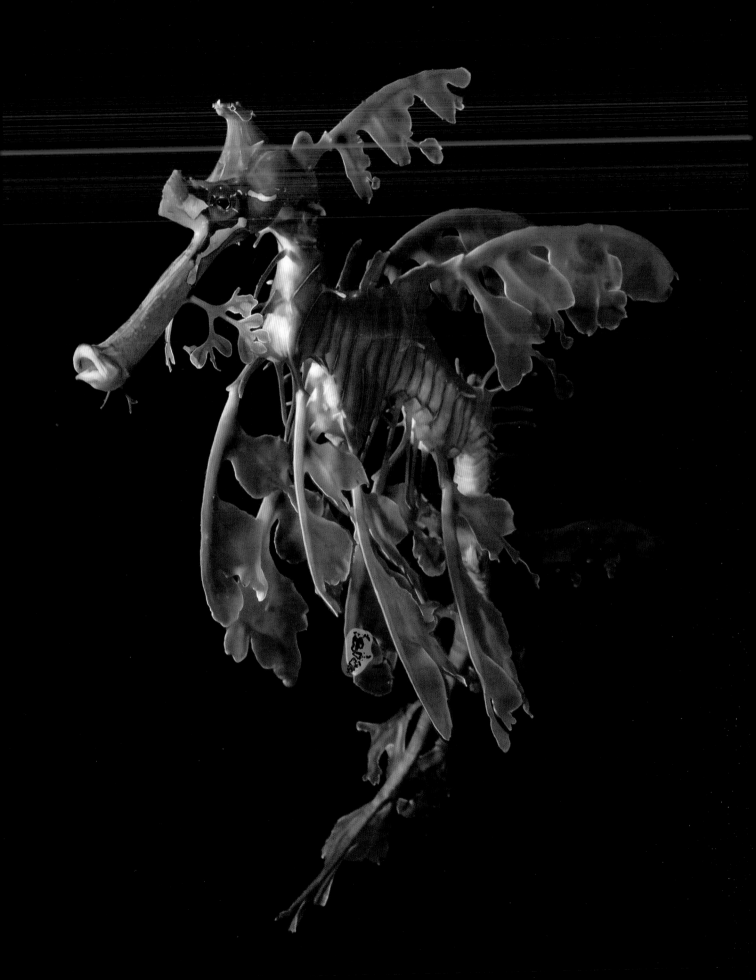

Australia's Reef-Dwelling Dragons

GREAT SOUTHERN REEF, AUSTRALIA

WENDY MITCHELL

Sailing less than 200 nautical miles in one week, I was lucky enough to swim with several pods of orcas, a blue shark, long-finned pilot whales and sperm whales. Yet what trumped all of them was finding this exquisite southern Australian species – the leafy seadragon (*Phycodurus eques*).

This incredibly beautiful species is found only in Australia's Great Southern Reef system, which lines the south coast, stretching from New South Wales to Western Australia and covering a massive 71,000 square kilometres (27,413 square miles). These waters are cold and sometimes hostile, as large Southern Ocean swells batter the coast in the winter months. In the summer the waters warm slightly but the prevailing southwesterly winds can make ocean conditions un-divable, or at least unpleasant.

Pulling on multiple layers of neoprene and strapping on a scuba tank quickly became the norm in my quest to find these ornate, endemic beauties. I checked my equipment and entered the water from the shore, and navigated my way out in search of the extensive kelp gardens. My eyes were scouring every section of the substrate and water column, as white sand changed into lush green seagrass beds

This leafy seadragon (*Phycodurus eques*), photographed after dark, makes its home in the cool southern Australian waters.

teeming with life; later, the rocky substrate changed into thick yellow kelp, moving with the motion of the rolling swell.

I swam past large blue groupers (*Epinephelus morrhua*) that would sit and stare at me with their beady eyes and bulging lips. Charismatic sea lions would occasionally zip past me with elegance, twisting and turning as they shot through the water and disappeared before my eyes. Finally, I found what I had been dreaming about for so long; at around 8 metres (26½ feet) under the surface I found my first leafy seadragon, gracefully bobbing around in the lush kelp, sun rays from the surface beaming down through the water column and amplifying the rich yellow colouration of its body.

Leafy seadragons are very easy to identify because of their unique body shape, with long, yellow, leaf-like appendages flowing off the body from head to tail. The seadragons will often spend several weeks or even months in one area and are sometimes only pushed out to sea during heavy weather or storms. Closely related to seahorses, the male leafy seadragon also carries and cares for the eggs when reproducing – they are carried on the underside of his tail, stuck onto a spongy surface until they are ready to hatch. When the babies are born they are totally self-sufficient and head off into the kelp to begin their life.

At times, looking so incredibly beautiful can come at a cost. As demand for these unusual-looking creatures in the aquarium trade spreads across the world, it opens doors for poachers to seek them out and remove these beautiful seadragons from their habitats across the south coast. Breeding leafy seadragons in captivity is difficult, so this puts pressure on the wild populations that are being harvested to keep up with demand. Captured leafy seadragons, if they survive the transportation process, will spending their remaining years in a glass tank, instead of their natural habitat.

'At times, looking so incredibly beautiful can come at a cost. Demand for these creatures in the aquarium trade is spreading across the world.'

These unique and beautiful creatures are endemic to this region alone.

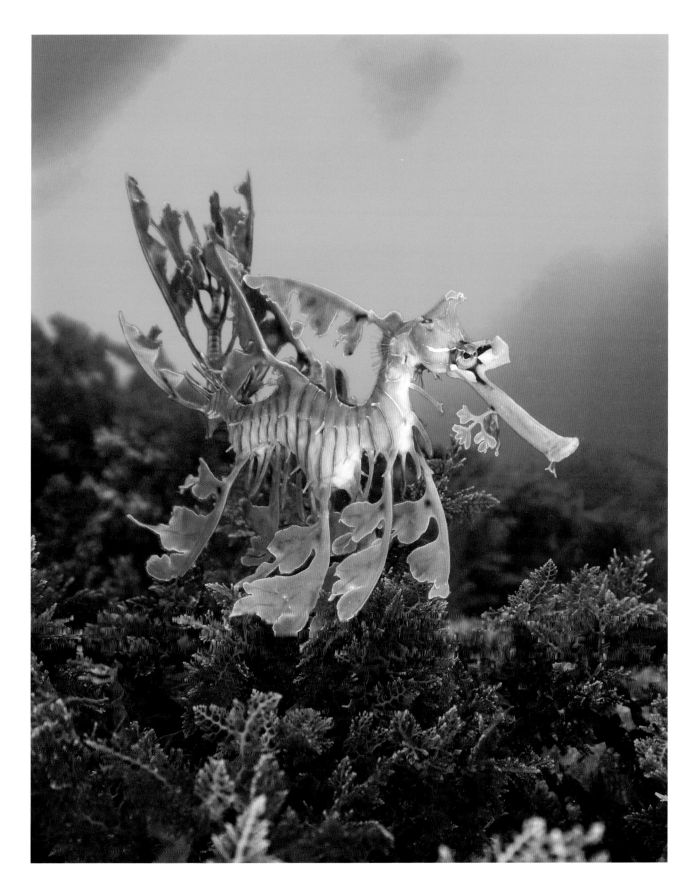

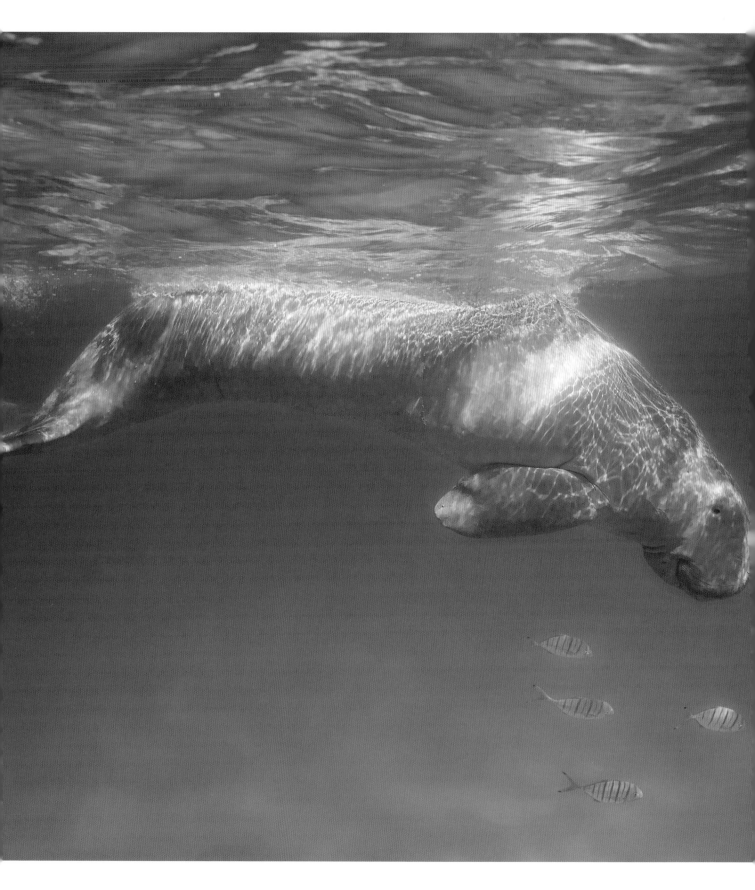

A serene and friendly dugong (*Dugong dugon*), captured in East Africa's underwater realm.

The Guardians of Bazaruto

BAZARUTO ARCHIPELAGO, MOZAMBIQUE

MIA STAWINSKI

Known for their elusive tendencies, dugongs are ocean mammals that have been driven to the brink of extinction in East Africa. These photographs document the last viable dugong population in the region, offering a glimpse into the threats they face.

During my recent photography collaboration with the NGO African Parks, I was fortunate enough to visit and photograph marine life in the Bazaruto Archipelago National Park in Mozambique. Protected since 1971, the Bazaruto Archipelago spans 1,430 square kilometres (approximately 552 square miles) of seascape and five islands along Mozambique's coast, encompassing terrestrial and marine habitats of ecological importance. Bazaruto is also home to a unique population of dugongs, the ocean's 'seagrass-community specialists'. Once abundant in East Africa, the dugong population has suffered a dramatic decline in recent decades and Bazaruto hosts the last known viable dugong population on the eastern coast of Africa. The loss of this subpopulation could lead to their extinction in the region, which would have devastating consequences for both the marine ecosystem and the local communities that depend on these waters.

Some of the area's biggest threats to dugongs are primarily linked to

human activities, with entanglement in gillnets and loss of seagrass, the dugong's primary food source, being of great concern. Protecting the dugongs in Bazaruto is not only crucial for their survival, but also for maintaining the overall ecological balance. By grazing on up to 40 kilograms (88 pounds) of seagrass daily, they play a vital role in promoting new growth, which fosters a healthier and more resilient marine habitat. Seagrass meadows also serve as important nursery areas for numerous fish species and are important in combating climate change, as they act as one of the most effective carbon sinks in the world. Additionally, the dugongs have significant socioeconomic importance; a healthy marine ecosystem draws tourists from around the world and provides employment opportunities for locals. Many locals also rely on the surrounding waters as a source of food and income through fishing.

Recognizing the urgency of the situation, African Parks researchers and partners have tirelessly worked to elevate the conservation status of East Africa's dugongs on the IUCN Red List of Threatened Species. In December 2022, their efforts yielded results and the IUCN officially listed East Africa's dugongs as 'Critically Endangered'. This has given the species the highest level of global protection, amplifying their conservation needs and paving the way for proactive conservation measures. The Bazaruto region stands as a beacon of hope for the dugong species, and local efforts are showing promise. Thanks to collaborations between the island communities, National Administration for Conservation Areas (ANAC) and African Parks, no dugong has been killed by nets inside the archipelago since 2017. However, much work is still left to be done. Continued collaboration between local communities, governments and stakeholders will be necessary to ensure that these majestic creatures continue to grace our oceans for generations to come.

The extinction of the dugong (*Dugong dugon*) would have disastrous consequences.

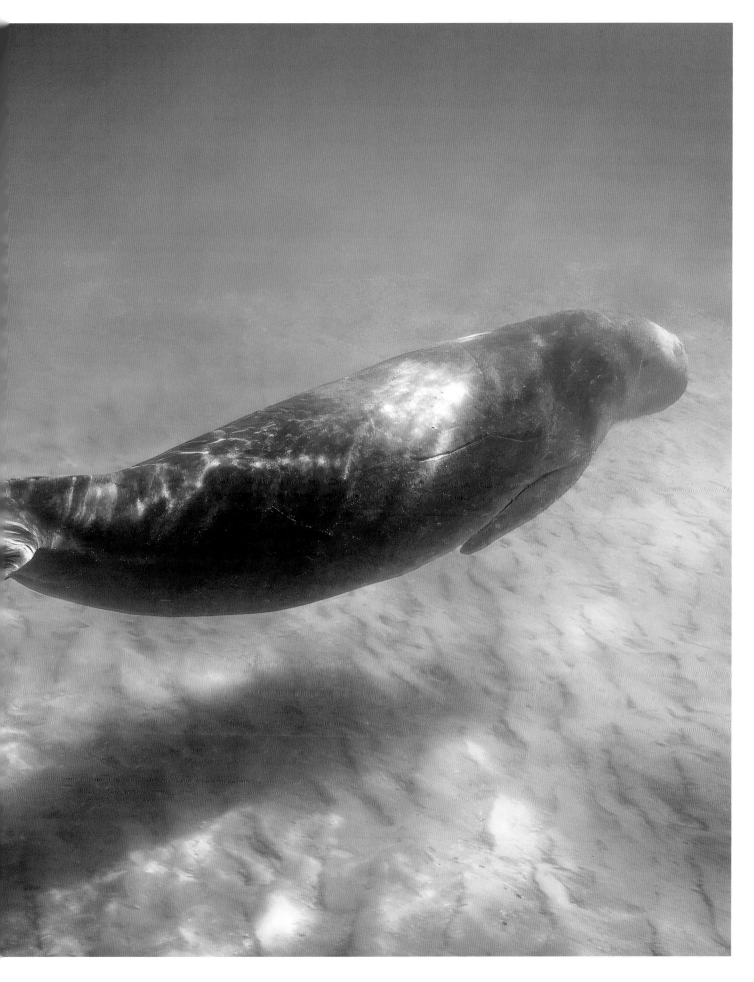

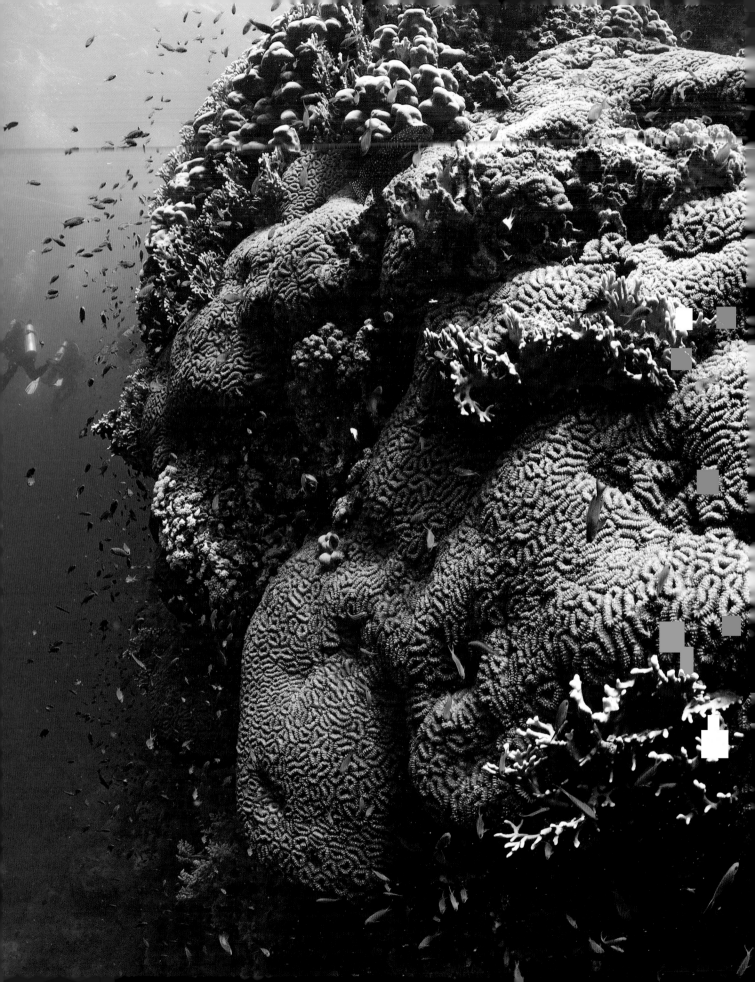

Super Corals of the Red Sea

RED SEA, EGYPT

MARCUS DE LA HAYE

A sentimental journey back to this dive site revealed a thriving and spectacularly beautiful underwater world – a reminder of the need to protect coral reefs and the ecosystems that depend on them globally.

The Red Sea is a semi-enclosed extension of the Indian Ocean between the continents of Africa and Asia, and is among the richest and most productive marine ecosystems, particularly in its southern regions. Ten per cent of the species found here are found nowhere else in the world. I first dived here with my dad at the age of eight, and earlier this year I was able to return, spending a week on a liveaboard in the southern region of the Red Sea. Departing from Marsa Alam, we headed south towards St Johns, an area not too far from the Sudanese border known for exceptional underwater biodiversity. Having not dived in the Red Sea for well over a decade, I was worried that perhaps the underwater landscape might have deteriorated. However, under the water, the Red Sea was bursting with colour, with coral of every colour and pattern you could possibly imagine, just as I had remembered it.

Seeing healthy coral reefs – a rarity these days – was a breath of

Divers float beside an enormous coral reef wall covered in a sprawling bed of brain coral (*Lobophyllia corymbose*).

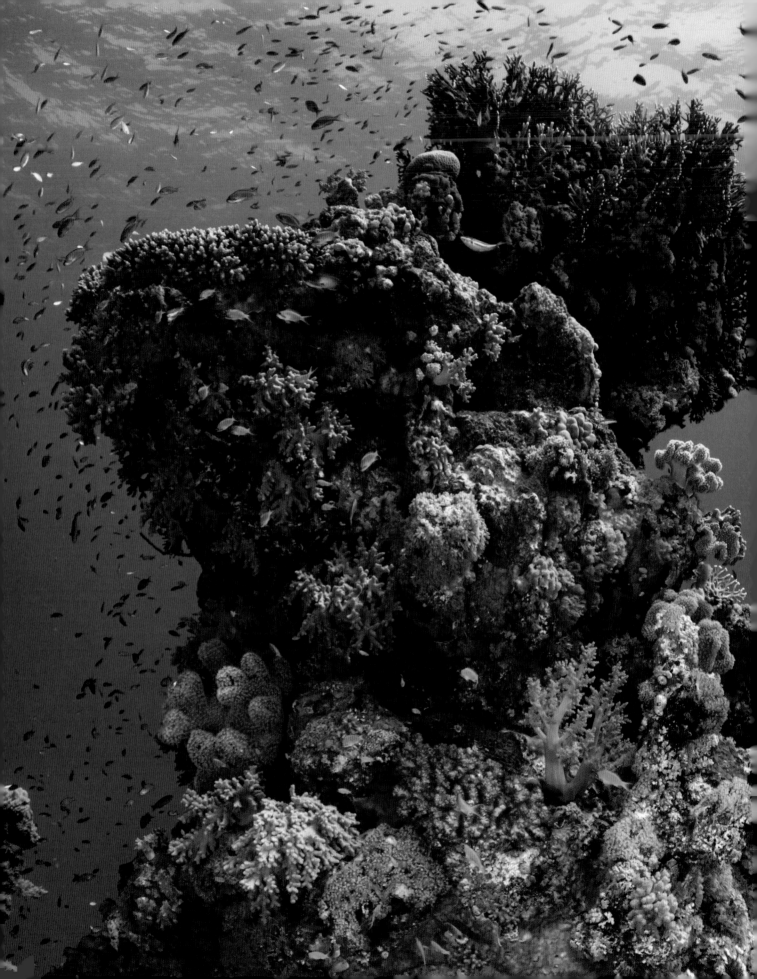

fresh air. Coral bleaching is a natural phenomenon that occurs due to environmental stressors, such as pollution and increasing water temperatures. Corals evict their energy-producing symbiont partners, zooxanthellae algae, lose their colour and appear white, and, over time, if the conditions not reversed, the corals eventually die. Once the corals die, entire reef ecosystems, on which both wildlife and humans depend, deteriorate. With the majority of the world's coral reefs being predicted to die by the end of the century, what hope is there? Coral reefs in the Red Sea are special in this respect, aside from being beautiful. While scenes of ghostly white skeletal coral reefs are becoming a more common sight across the world, this is not so much the case here.

Despite sea temperatures rising quicker than the global average in this region, there are yet to be any documented mass bleaching events in the Red Sea. Scientific work looking specifically at these corals has found that some Red Sea species actually function better in warmer water. As ocean temperatures continue to rise due to global warming, Red Sea reefs could act as a refuge for corals, potentially becoming one of the last remaining functioning coral-reef ecosystems in the world. However, this will require an effort to protect the Red Sea from other stressors, such as overfishing and pollution, with one of the key obstacles being the need to persuade Middle Eastern governments to collaborate and work in unison.

A pinnacle of coral, swarmed by orange anthias fish (*Pseudanthias squamipinnis*), towers over the reef.

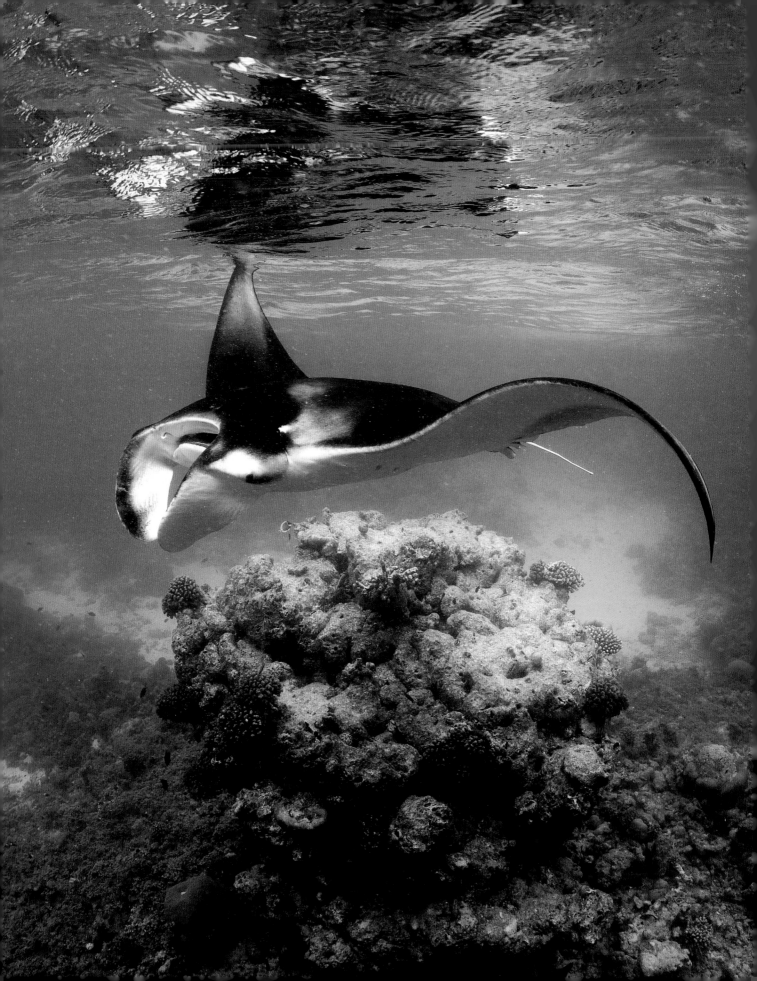

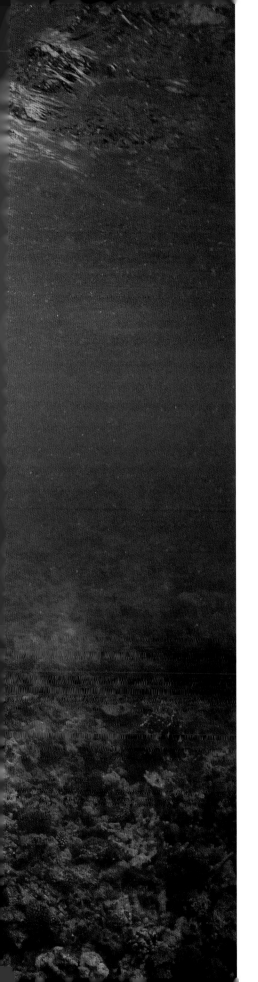

A reef manta ray (*Mobula alfredi*) cruises
through the lagoon of Makunudhoo,
which is the largest in the Maldives.

The Mantas of Makunudhoo

HAA DHAALU ATOLL, THE MALDIVES

JASMINE CORBETT

A month spent on this remote island yielded incredible
encounters with a previously undocumented manta ray
population and introduced the researchers of the Manta
Trust to a human community living in harmony with the
marine environment.

Our team of seven manta ray researchers, educators and media makers
from the Manta Trust came to record and explore Makunudhoo, a
remote island in Haa Dhaalu Atoll, in response to an invite from local
fishermen. They had informed us on a previous research trip that it's
common to see mantas (or 'mobula') in their lagoon – which is the
Maldive's largest – every day, and reported seeing huge aggregations of
mantas there in the northeast monsoon season. We spent one month
on a fishing boat, searching for these rays and mapping the reefs of
Makunudhoo. With the help of a local fisherman and captain Alha, we
pinpointed manta ray cleaning stations, at which the mantas stop to be
rid of waterborne parasites by species of 'cleaner' fish, and discovered
what conditions would determine manta ray aggregations. We collected
identification photographs, conducted aerial surveys, deployed remote
underwater video and time-lapse cameras and interviewed fishermen
to learn from their local historical knowledge of this species.

This project was like no other that the Trust had run before. Having little to no knowledge of this region's reefs and rays, we had no idea what to expect. During this short time, we encountered an incredible number of manta rays and identified more than 150 new individuals to be added to the Maldives database. We saw courtship behaviour, met pregnant females and pups and discovered active manta ray cleaning stations.

However, the most rewarding part of our trip was working so closely with the Makunudhoo community. We ran outreach and education sessions with local stakeholders such as council members, police and the women's development committee. We conducted marine education classes in the island's school and took the students to study the reefs first-hand. The majority of Makunudhoo's population have never swum with a manta ray before, and many have never been swimming at all. We took community members swimming with mantas for the first time and trained them on our research techniques, to help them to understand why we were on Makunudhoo.

We are so grateful to this community for their hospitality, kindness and wealth of local knowledge, without which our work would not be possible. We are so inspired by the collective desire of the people of Makunudhoo to protect their environment, retain their culture and traditions, and ensure that any development of their beautiful island occurs sustainably, and look forward to continuing work with them to ensure that the manta rays that call this incredible place home remain safe and protected. Having researched manta rays in many locations around the world, in many of which the rays are increasingly threatened, it was inspiring to witness the healthy, flourishing population of manta rays that are safeguarded by the people here. The coral reefs are teeming with life, yet any fishing that occurs here is non-destructive and selective, ensuring that fish populations continue to thrive.

This remote island in the middle of the Indian Ocean offers encouragement as to how humans can still live peaceably with nature. There are few examples of pristine marine environments left on our fast-developing planet, so we can look to places like Makunudhoo to find hope and motivation.

Reef manta rays (*Mobula alfredi*) feast on plankton along the outer reef of Makunudhoo, in the north of the Maldives.

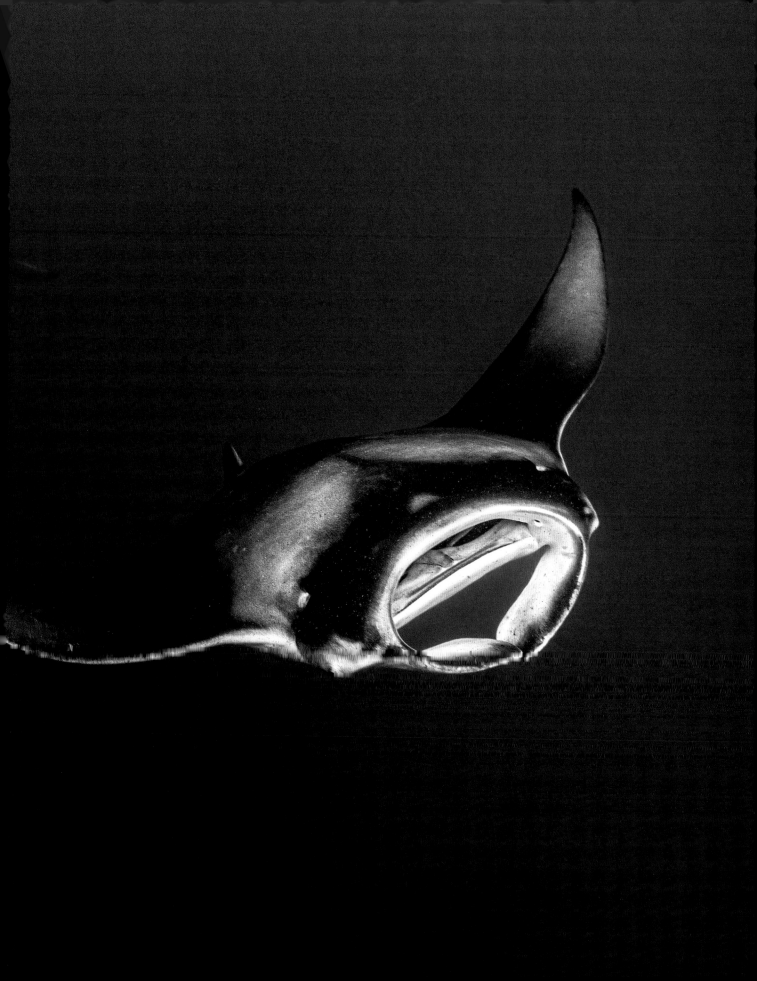

THE
PACIFIC
OCEAN

Journey across the Pacific Ocean, where every ripple holds a story. Here the majestic Guadalupe Island rises from the depths, offering sanctuary to hundreds of majestic great white sharks. In the South Pacific, we explore encounters between humans and humpback whales. Raja Ampat, an ecological marvel celebrated as 'the last paradise on Earth', demonstrates the transformative potential of conservation. Finally, we confront the looming challenges of deep-sea mining, where the pursuit of clean energy presents a formidable threat to the entire ocean.

A reef shark (*Carcharhinus amblyrhynchos*) looking for its next meal at Waikīkī, Oʻahu ('Shark Ecotourism', pp.210-15).

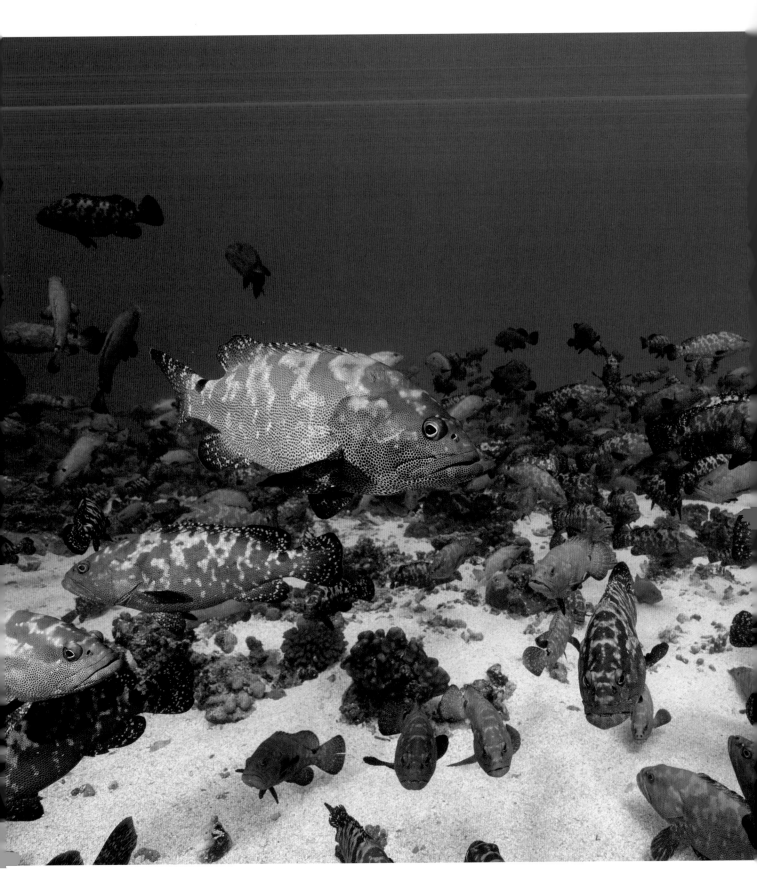

THE PACIFIC OCEAN

OPPOSITE: Camouflage groupers (*Epinephelus polyphekadion*) aggregate along the bottom of a channel at Fakarava Atoll.

OVERLEAF, LEFT AND RIGHT: Grey reef sharks (*Carcharhinus amblyrhynchos*) hunting along the reef; the sharks fight over prey in a feeding frenzy.

Spectacle and Survival

FAKARAVA ATOLL, FRENCH POLYNESIA

RICK MISKIV

Each year around June, approaching the full moon, camouflage groupers (*Epinephelus polyphekadion*) aggregate in the tens of thousands for a massive spawning event in a channel located in Fakarava South Pass (Tumakohua), French Polynesia. This incredible natural spectacle plays a significant role in the survival of the fish from generation to generation.

The aggregation also has an element of mystery: how do all the individual groupers know exactly where and when to meet? What are the specific criteria that provoke the primary spawning event? Time of day, light, lunar cycle and direction of the current are among the factors thought to play a role in the timing of spawning. A better understanding of the role and characteristics of the aggregations can not only inspire us to protect the ocean, but also inform and improve conservation efforts.

Female groupers tend to hide under the coral when their bellies are filled with hydrated eggs, and male groupers will flutter, push and encourage the females to ascend for spawning. The aggregation, however, attracts hundreds of predators, such as grey reef sharks (*Carcharhinus amblyrhynchos*) and oceanic blacktip sharks (*Carcharhinus limbatus*). The sharks will try to take advantage of the situation to hunt the groupers, darting and cutting through the large mass of fish, looking to make a strike. The sharks drift and patrol the channel, and

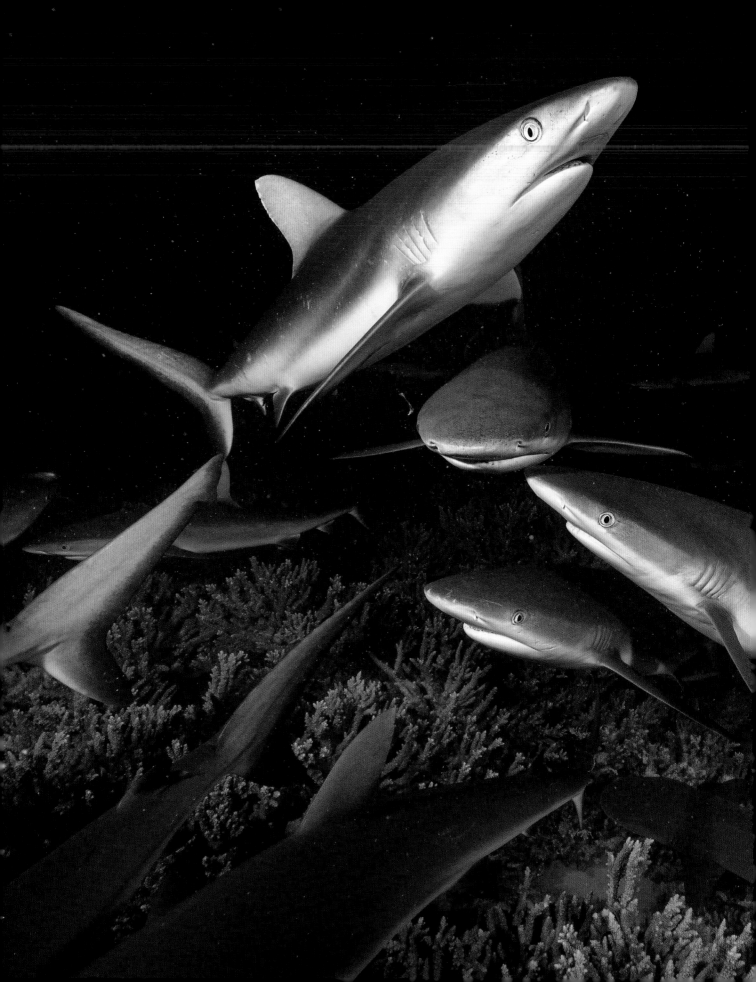

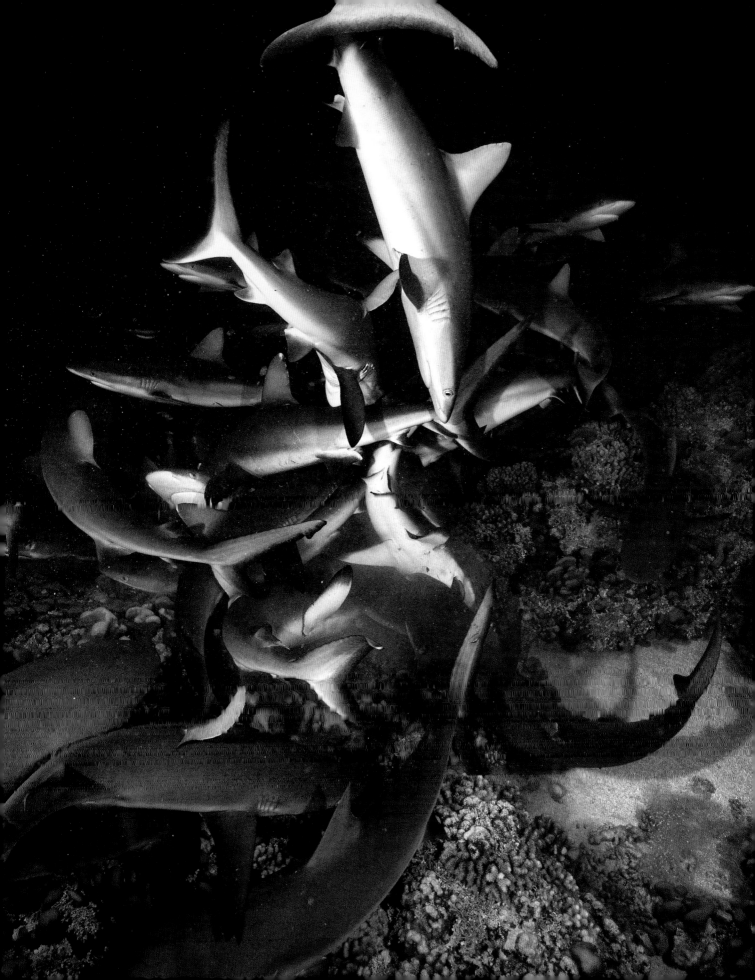

the groupers appear to use a strategy of non-movement to avoid detection.

Groupers that maintain a zen-like stillness are unharmed by sharks that pass directly over them; however, if bumped or pushed into a situation of flight, the sharks attack with speed and precision. At the height of the spawning event there are fish as far as the eye can see, spanning the entire channel. The night dives I took were filled with the frenetic energy of 100 or more sharks on the hunt and fighting over their prey right in front of us.

Sharks swam directly into me on these dives, once bumping into my head, and a few times quite forcefully into my legs. All the instances were non-aggressive – we were sharing a crowded space – and it was an electric experience, but also created a sense of humility and respect for nature. In my personal experience, sharks are not indiscriminately aggressive or violent animals; their effortless grace and power are awe-inspiring to see up close. You are witnessing about 450 million years of evolution in action at moments such as these.

The spawning aggregations of camouflage groupers, and the associated wildlife, form an incredibly rare ocean event, encountering which highlights an important aspect of the cycle of life for fisheries. The nature of spawning aggregations shows us the connections between the moon phases, tides, currents, birth, survival strategies and predation, the rhythmic nature and balance of which were set in motion centuries ago. A story of science, poetry, grace and drama.

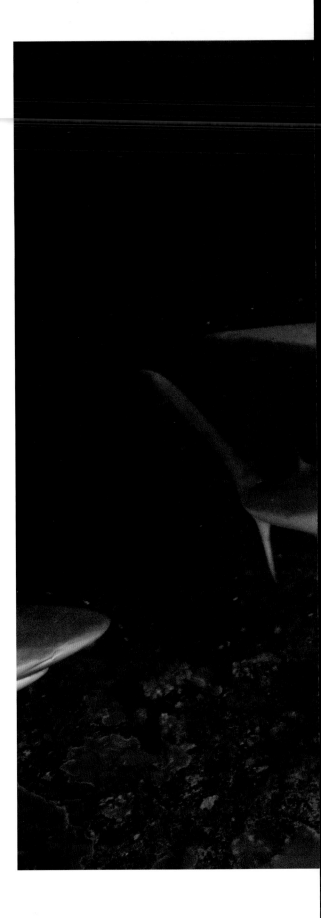

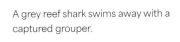
A grey reef shark swims away with a captured grouper.

Mutual curiosity: a shark and human face each other.

A Fallen Paradise

GUADALUPE ISLAND, MEXICO

YARA LAUFER

Rising from the sea 241 kilometres (approximately 150 miles) from the west coast of Baja California Peninsula, the volcanic peak of Guadalupe Island is surrounded by an incredible underwater world, which provides a home for around 400 identified great white sharks (*Carcharodon carcharias*).

This island, which until recently was known for the best cage diving in the world, has a dramatic history of exploitation and hope. Human settlement of the island in the mid-nineteenth century led to a drastic depletion of native plants and creatures. The hunting of northern elephant and Guadalupe fur seals (*Mirounga angustirostris* and *Arctocephalus townsendi*) nearly wiped out these species, except for a small colony of eight northern elephant seals, which are known to be the ancestors of the present-day population. At the same time hunters and fishermen brought herds of goats and cows – the population of the former at one point reaching nearly 100,000 – which destroyed the entire vegetation of the island. In 2005, after years of research, Mexico finally declared Guadalupe, its islets and its surrounding waters a Biosphere Reserve, and two years later, in 2007, the last goats were removed. Nowadays, except for a few scientists, the island is once again uninhabited, giving the ecosystem a chance to recover.

This unique habitat attracts many dive tourists and filmmakers every year. Until recently, several liveaboards operated in the waters and conducted cage diving and research, but in January 2023, after emerging criticism of these practices, the Mexican government implemented an indefinite ban on shark watching and sport fishing activities in the area. The justification was to avoid altering the behaviour, habitat and feeding sites of great whites and thereby preserve and conserve the species. However, what seems like a step in the right direction for the conservation of the oceans raises some doubts with regard to the protection of the animals. As one local conservationist puts it: 'While ecotourism is banned, commercial fishing is inexplicably allowed to continue in the waters around the island?'

Mexico is the sixth-largest nation exporter of shark fins in the world, with the industry's epicentre in Baja California, not far from these vulnerable creatures. The fact that Guadalupe Island is largely uninhabited and only liveaboards have been on site at any time to report illegal fishing gives us an idea of what could happen if these boats disappear. Worth 20,000 USD on the black market, a great white is a lucrative target. Illegal fishing in these waters could lead to a drastic reduction (up to 16 per cent) in this species, which is considered 'vulnerable' by the World Wide Fund for Nature, and have a huge impact on its reproduction. 'This is not about cage diving, it's about finding solutions to keep an ecological treasure safe,' says one filmmaker who works in the area.

Thanks to years of behavioural research and awareness campaigns in social media, the image of these creatures has finally slightly changed. Nevertheless, these advances can only be sustained – and our unanswered questions about the behaviour and habitats of these animals addressed – if expeditions and interaction continue to be possible. Research is just as important as sustainable conservation. To truly protect and conserve this species, protective measures should be implemented carefully and with an eye on their potential and ongoing impact.

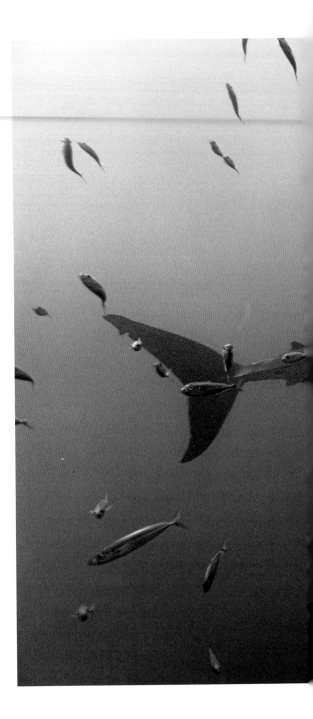

It is not uncommon to see several great white sharks at the same time around Guadalupe Island.

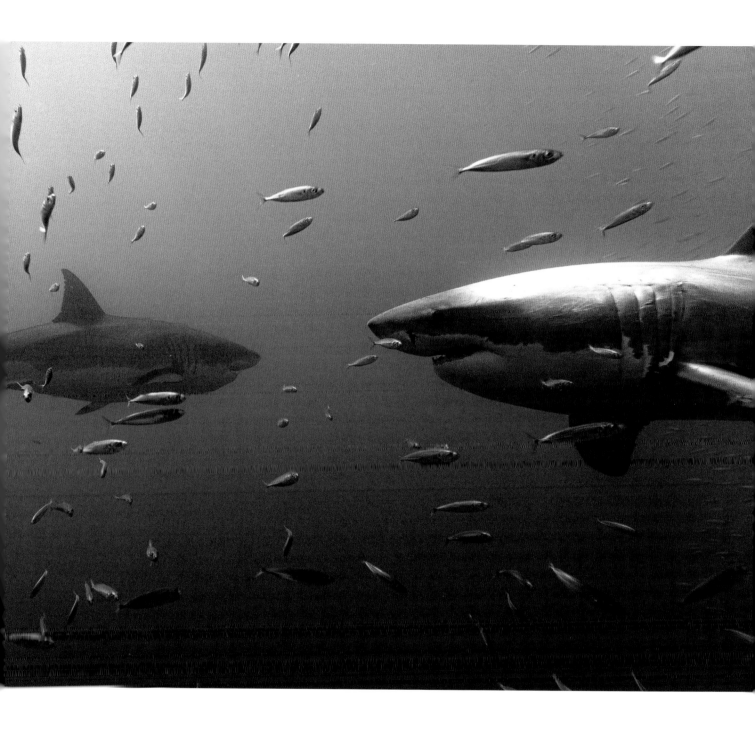

'The island is once again uninhabited, giving the ecosystem a chance to recover.'

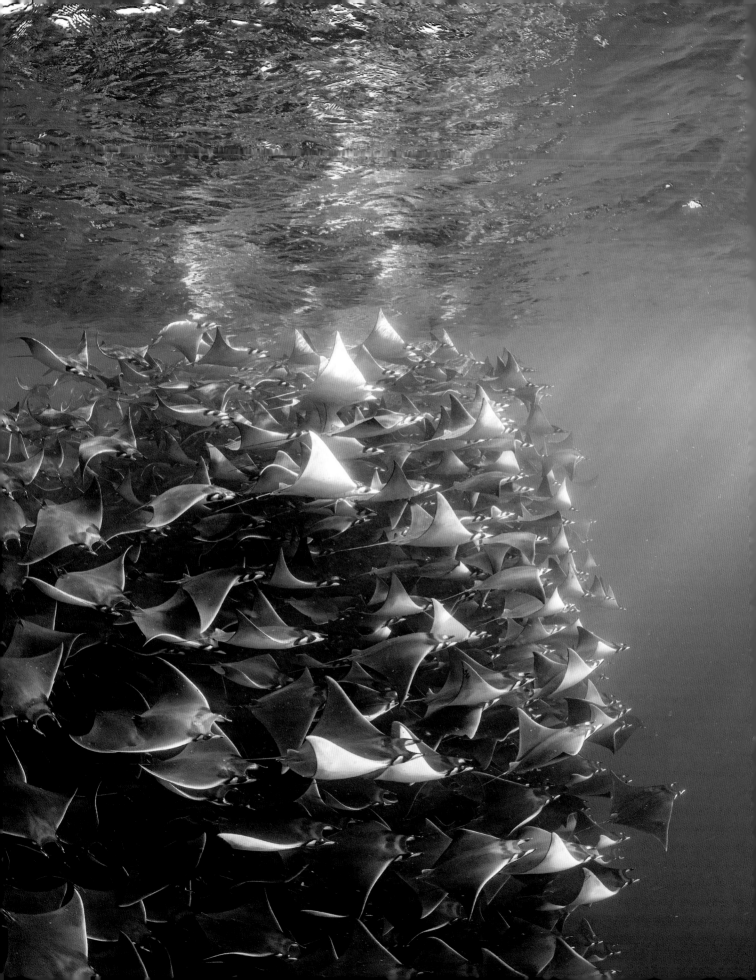

The Devils of Baja

SEA OF CORTEZ

JAY CLUE

Years ago, on a calm autumn morning in Los Cabos, at the southern tip of Mexico's Baja California peninsula, the ocean would unknowingly shift my life's trajectory, showing me its wonders and inspiring me on a lifelong journey to preserve the 'devils of Baja'.

The warm Baja sun had just begun to peek over the horizon, setting the desert landscape afire. I can still remember my excitement as our skiff slowly motored offshore. I had heard only stories up until now: legends of thousands of Munk's devil rays (*Mobula munkiana*) schooling off the coasts of Baja, creating a breathtakingly beautiful choreography of the largest aggregation of any ray species on our blue planet. Within moments the symphony began, as hundreds of rays leaped from the water one by one. I could not believe my eyes as I slipped into the water.

In awe, I completely forgot I was even holding my camera and walked away from the experience with only one, very poor image of the encounter. But that moment would ignite a passion inside me to preserve these remarkable creatures. My thirst for knowledge would lead me to a brilliant marine scientist, Marta Palacios. She had been working with the rays of Baja – other species as well as Munk's devil rays – for a few years and had recently discovered the first mobula nursery in the world. We met for a coffee one afternoon to discuss an idea: could we partner up to create a platform that mixes science and tourism? Something that helps to further research into and

OPPOSITE: Thousands of Munk's devil rays (*Mobula munkiana*) come together off the coast of Baja California to form the largest schools of any ray species on earth.

OVERLEAF: Aggregations form massive, compacted groups of rays just below the surface.

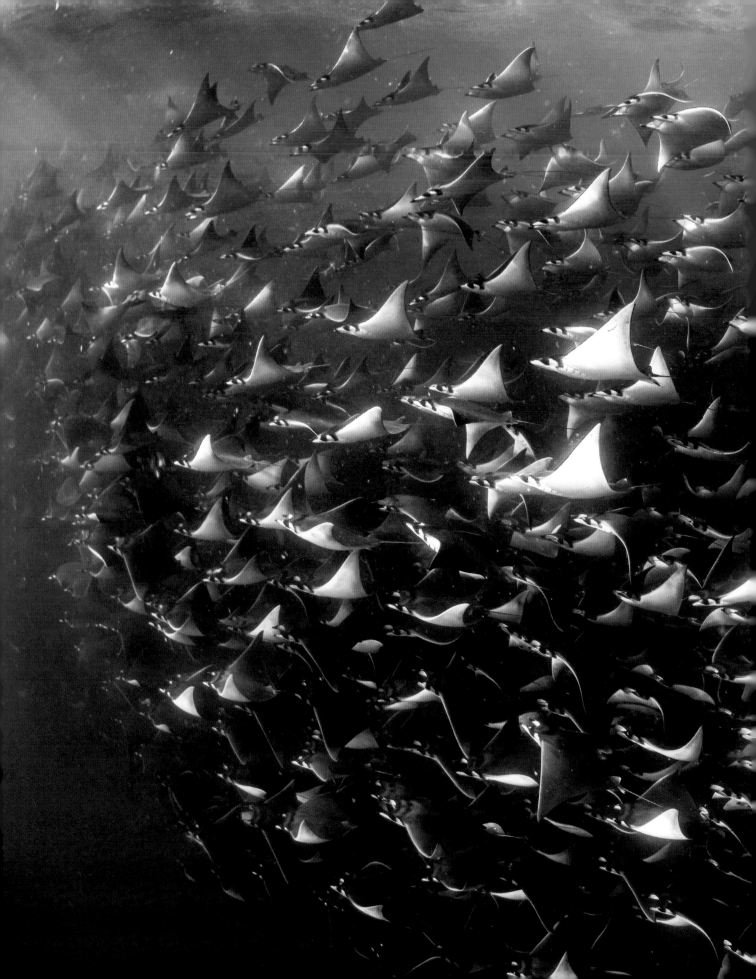

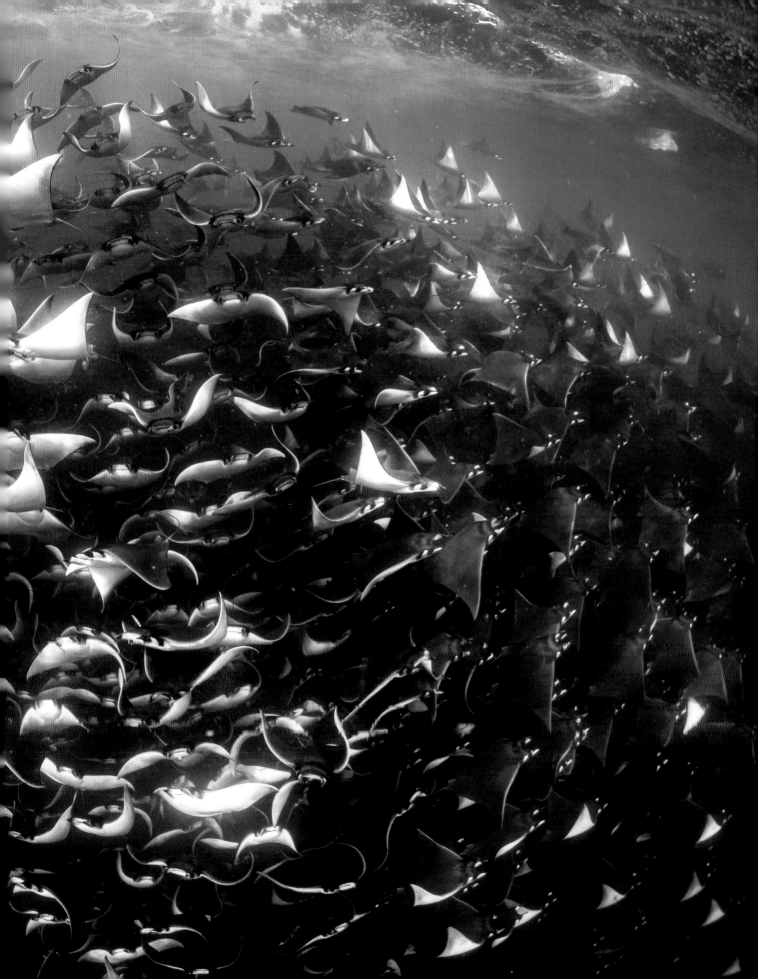

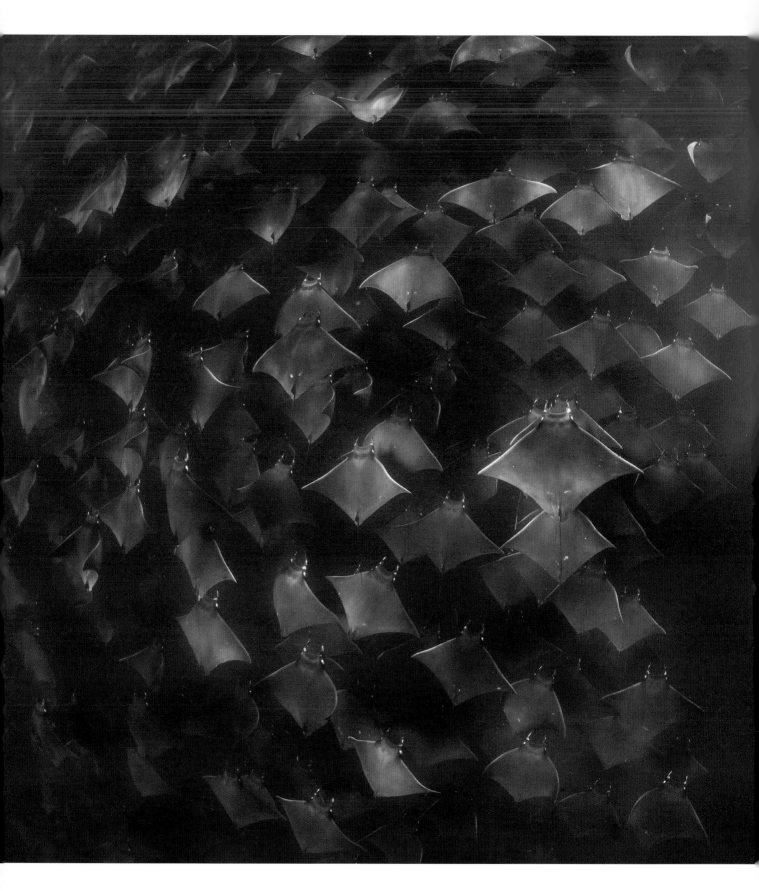

conservation of Baja's devil rays, while introducing more humans to this awe-inspiring spectacle.

Palacios explained, 'Although mobulas are protected under Mexican law, they are not given the same strict rules as other megafauna such as whale sharks. This is due to the knowledge gap on their critical habitats, ecology and vulnerability to fisheries.' Together we began creating citizen-science-style expeditions. We started out by running small trips only twice per year. Since then the project has grown, so that now we run back-to-back trips throughout the entire four-month aggregation season, exposing hundreds of guests to mobula science and conservation.

Since their inception, these expeditions have raised over 25,000 USD to help fund Palacio's research. They have helped create a platform for capturing population and census data on mobula rays, as well as providing a template for mobula ray tourism guidelines and best practices globally. Most importantly, they have inspired humans to fall in love with the devils of Baja and take action to protect them. Early on, Palacio and two other incredibly talented female marine scientists, Melissa Cronin and Nerea Lezama-Ochoa, formed the Mobula Conservation Project, a research program that grew substantially over the next few years. They work on many fronts, from developing responsible tourism guidelines to studying conservation genetics to mitigating bycatch in fisheries. They also partner with local fishermen to understand the impact of fishing and to help mentor them on transitioning to ecotourism, while at the same time drawing on their wealth of local knowledge on mobula ray history, ecology and behaviour.

Someone once told me that marine conservation is like a long-distance marathon. You put all of your heart, passion and energy into trying to push forward, yet at times it feels like you are going nowhere fast. That is, until you look behind to see the long journey you've completed. One foot in front of the other, our marathon continues on; striding forward, we push to preserve the magic created by the devils of Baja.

Looking down from the surface as morning light dances across a school of mobula rays (*Mobula mobular*).

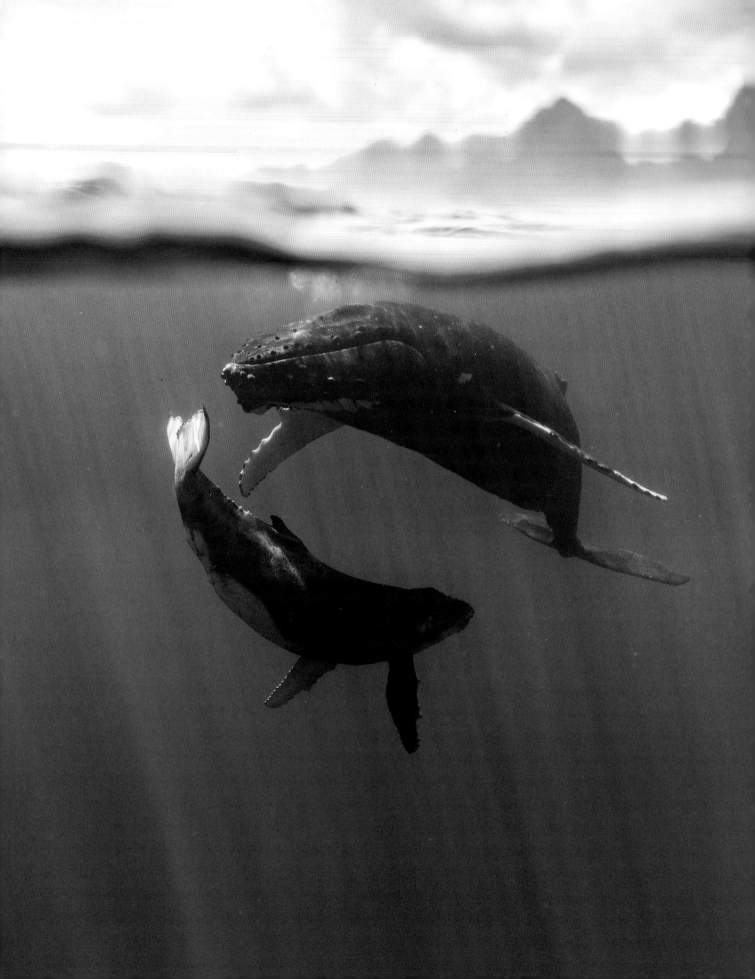

A Whale Connection

MO'OREA, FRENCH POLYNESIA

KELSEY WILLIAMSON

In the South Pacific, encounters between humans and humpback whales are becoming more common, as these creatures become accustomed to human presence and seem to seek out interaction.

For the past four years, the majority of my time has been spent in the captivating realm of French Polynesia, where I have had the opportunity to embark on immersive swims with humpback whales (*Megaptera novaeangliae*). For three months of the year – starting in late June or July – these majestic beings can be seen in the waters here, having migrated north from the depths of Antarctica to meet, mate and breed. The island of Mo'orea, where I am based, may have particular appeal, as there are two large bays where the whales can rest, hidden from predators. I have been a first-hand witness to the incredible bonds formed between humans and humpback whales here, and have had the chance to capture the inherent beauty of these profound connections.

Beyond their ecological importance, humpback whales hold deep cultural and spiritual value for many coastal communities. From an economic perspective, the revenue generated from nature tourism, including whale watching and whale swimming in particular, supports local economies, creating employment opportunities and fostering incentives for humpback whale conservation and habitat protection.

In my own experience, I have observed a notable increase in close encounters between humans and whales. While I acknowledge that

A humpback whale (*Megaptera novaeangliae*) mother and her calf rest together in the warmer waters of French Polynesia.

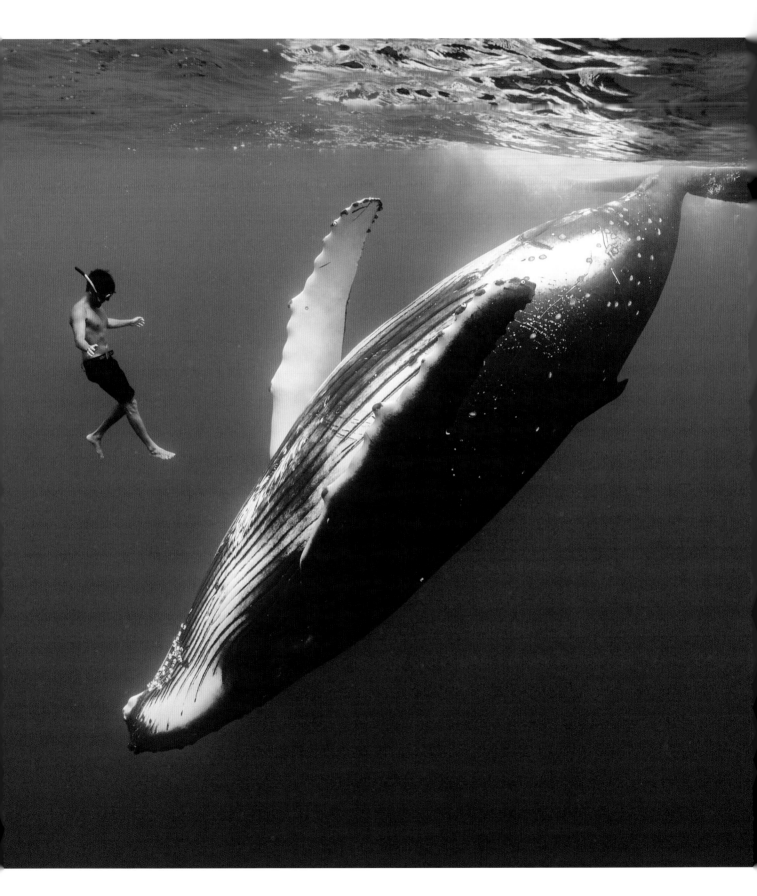

THE PACIFIC OCEAN

such encounters may have occurred for years, in this region, in particular, I have noticed a unique phenomenon unfolding. It appears that these magnificent creatures are becoming increasingly accustomed to human presence, perhaps acting on memories of the connections they once forged as calves when they return to the same coastal areas as juveniles. Similar phenomena seem to be unfolding worldwide – see, for example, the remarkable behaviour of grey whales, approaching boats in Mexico and exemplifying the potential for profound connections between humans and marine life.

On the positive side, it's fascinating to witness these majestic creatures up close, and the opportunity for human-whale interaction can be truly magical. Such encounters can, however, potentially disrupt the whales' natural behaviours, particularly when they are in a resting state or engaged in important mating rituals. Complicating matters further are the increasing number of boats venturing into these waters each year. While these provide more people with the opportunity to connect with nature,

they also introduce more disruptive noise into the marine environment. Additionally, there's an elevated risk of boats accidentally colliding with whales that are not easily visible.

Although there are established rules and guidelines in place to govern whale swimming, enforcing these regulations effectively is becoming increasingly challenging, especially as new companies enter the industry on a yearly basis. Finding a balance between offering this remarkable experience and ensuring responsible and considerate interactions with these magnificent creatures remains an ongoing challenge.

OPPOSITE: A local guide encounters an extremely curious humpback whale.

BELOW LEFT: The underbelly of a southern humpback has more white colour compared to the darker northern humpback.

BELOW RIGHT: A whale looks us in the eye.

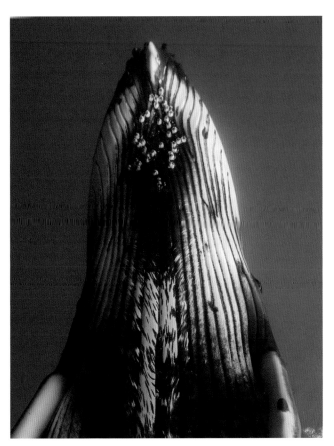

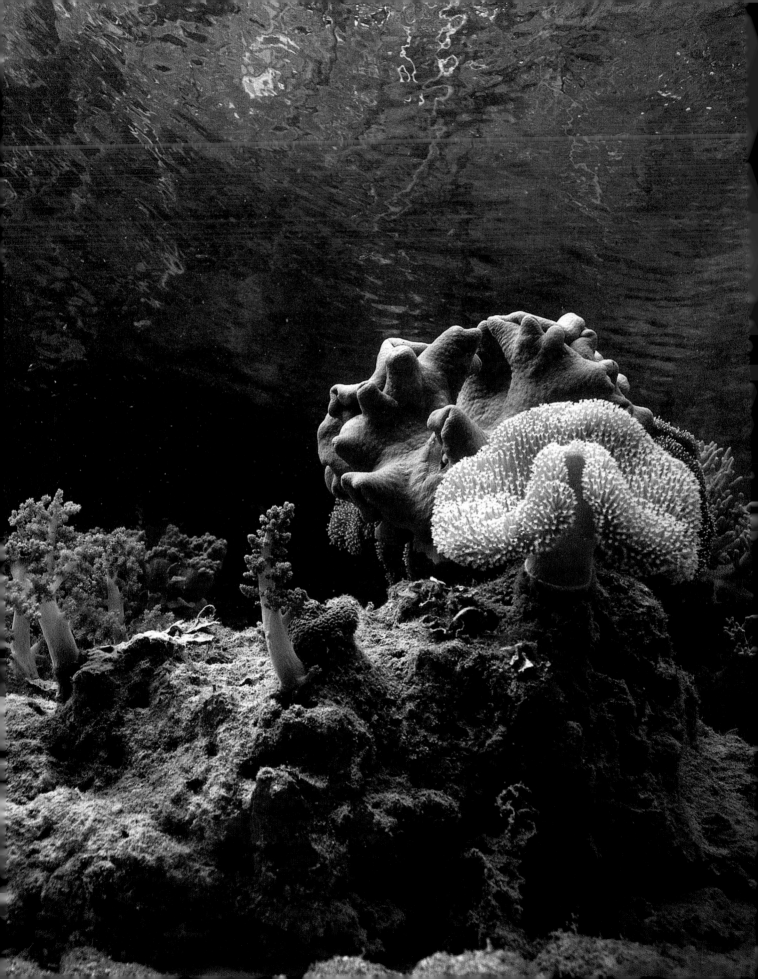

The brilliant colours from a shallow coral reef reflect at the surface in Raja Ampat's nutrient-rich waters.

The Last Paradise

RAJA AMPAT, INDONESIA

MEAGHAN OGILVIE

Located in the 'Coral Triangle', a global centre of marine biodiversity between the Indian and Pacific Oceans, Raja Ampat has been described as 'the last paradise on Earth'. While it hasn't always been a conservation success story, it is evidence that real change is possible with the right approach.

In April 2023, I travelled to central Raja Ampat, an archipelago comprising 4 main islands and over 1,500 smaller islands and shoals located in Southwest Papua province, Indonesia, and experienced firsthand the abundant, thriving coral reefs. Its remote location has, historically, allowed this archipelago to escape mass tourism and it is known as the location of one of the most successful conservation projects on Earth. Its waters contain 1,600 fish species and 75 per cent of all the coral species that are known to the world. Having already dived in other marine conservation areas around the world, such as Palau, I was amazed at the biomass of fish and the abundance of hard and soft corals I saw on every dive here. At times, it was almost overwhelmingly promising, given our current climate crisis. The beauty and marine health here should inspire further conservation around the world, as new imminent threats are looming.

Twenty years ago, Raja Ampat's communities and ecosystem were in decline because of unsustainable practices and unregulated commercial fishing. In 2004, Raja Ampat was added to West Papua's Bird's Head

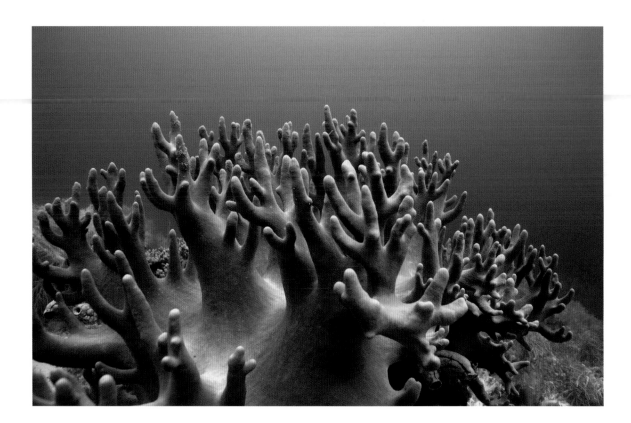

ABOVE: Finger coral (*Porites porites*) stands tall like an underwater forest.

OPPOSITE, ABOVE: A jellyfish bobs at the surface in the shallow waters around Gam island, Raja Ampat.

OPPOSITE, BELOW: A school of jack fish (*Carangidae*) swim above a shallow reef.

Seascape initiative, a project created to form a network of marine protected areas with the support of local authorities and international conservators. Since its foundation, fish populations have rebounded, coral is recovering and long-term livelihood security for local communities has improved.

Today, Raja Ampat faces new threats and challenges, as tourism numbers have increased tenfold in a short period of time. In 2008, there were two to three liveaboards operating. By 2019, there were hundreds, with a growing number of additional vessels frequenting the area. There is a lag between this rapidly escalating industry and the infrastructure and systems necessary to provide protection to the reefs. During my recent visit, I saw an alarming amount of plastic in the ocean, as well as unregulated liveaboards and boats at dive locations. The reefs of Raja Ampat now face coral degradation, increased plastic pollution and the threat of anchor damage and boat strikes. Locals believe that the government is working on building faster, larger ferries to accommodate greater numbers of tourists from Sorong to Raja Ampat islands, which will only exacerbate the situation. My photographs show evidence of plastic pollution in contrast with the healthy marine life that still exists and can still be conserved. As a witness, I feel a responsibility to share both the beauty and the impending threats to the reefs, to inspire viewers to learn more, to take action and to travel responsibly. Raja Ampat is known as a conservation success story and is marketed to tourists as 'nature's last frontier' and 'the last paradise'. Although this is true, most people are unaware of the impending threats the corals face through a lack of sustainable tourism, and attention is needed on this overlooked issue.

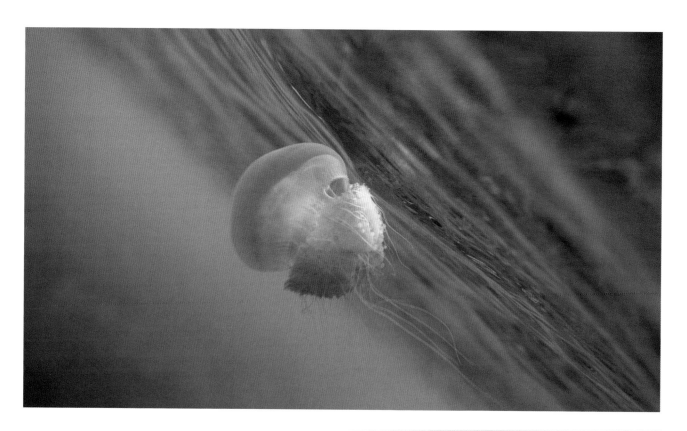

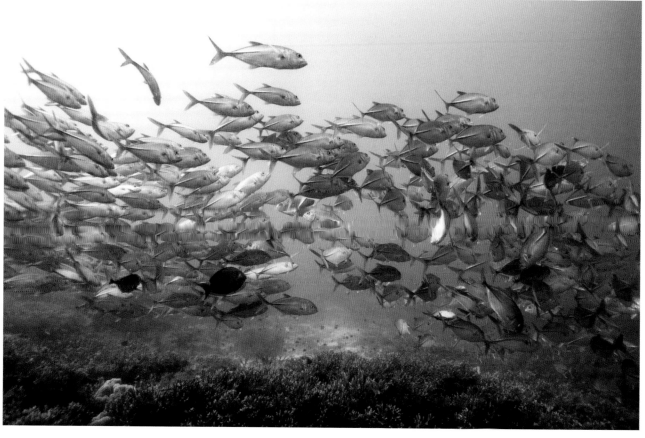

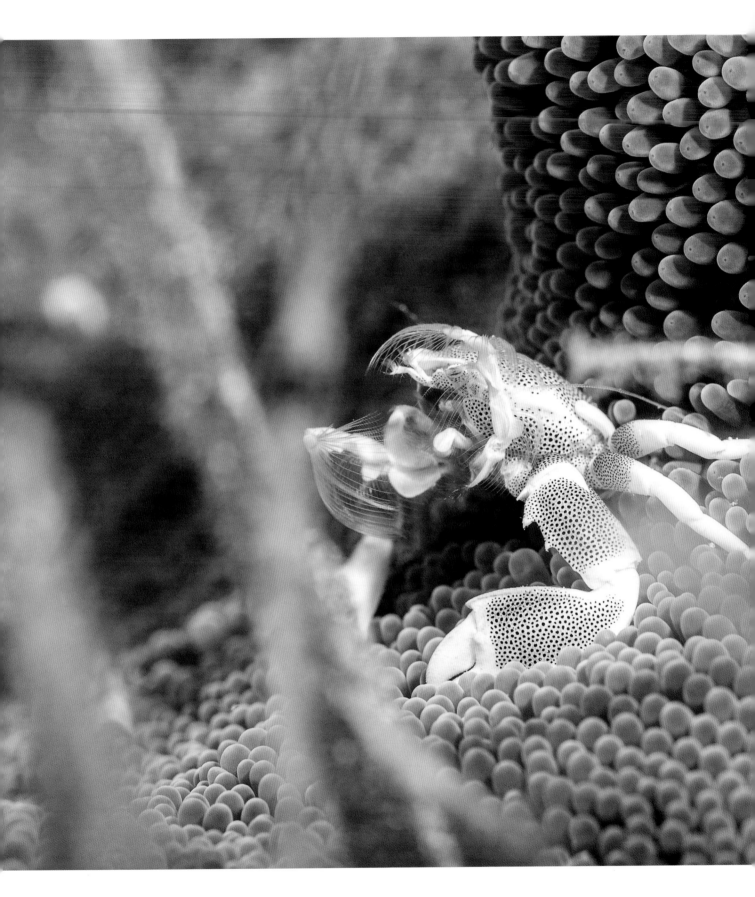

A porcelain crab (in the family *Porcellanidae*) catching nutrients from the water column in hair-like filaments on the ends of its claws.

Tiny Secrets of the Coral Reef

WAKATOBI BIOSPHERE RESERVE, SULAWESI, INDONESIA

ADRIENNE GITTUS

While larger species such as sharks and marine mammals are less common in Wakatobi, there is massive biodiversity of 'macro' life (so called because of the lenses required to capture the details of these smaller species), and it is of immense importance.

It is commonly accepted that everything in the ocean has its place in the food chain, with a great deal of media coverage going to apex predators and their importance. But what about the creatures at the other end of the scale? They are equally necessary for maintaining balance in the ecosystem: from cleaner wrasse (*Labroides*), who clean other fish, to the crustaceans and tiny invertebrates that form the basis of the food supply for other species. These creatures go overlooked, but are also a beautiful and fascinating part of our incredible oceans.

The National Oceanic and Atmospheric Administration (NOAA) of the US says that 'despite their critical role in ecosystems, the economy, and our food supply chain, mid-trophic level organisms [those occupying a middle position in the ocean food web] like zooplankton, small fish and invertebrates are rarely granted most valuable player status in the ocean ... Small but mighty, these organisms are a linchpin

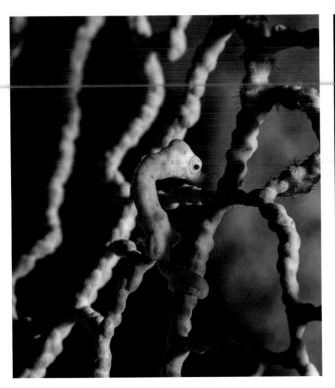

ABOVE LEFT: The pygmy seahorse (*Hippocampus denise*) spends its entire life on one sea fan coral.

ABOVE RIGHT: The orangutan crab (*Achaeus japonica*) lives in bubble coral (*Plerogyra sinuosa*) or mushroom corals (*Fungiidae*) and covers itself with algae to hide from predators.

OPPOSITE: Coral hermit crabs (*Paguritta harmsi*) make their homes in abandoned holes made by tube worms.

for healthy oceans; declines in their population could trigger bottom-up trophic cascades that negatively affect organisms in higher tropics levels like large fish, sharks and marine mammals.'

In 2012 the Wakatobi National Park was designated a UNESCO Biosphere Reserve, and the protection of the park – achieved in cooperation with local villages – has resulted in incredibly healthy coral growth and an abundance of marine life. The innovative Wakatobi Dive Resort Collaborative Reef Conservation Program creates a mutual relationship between the underwater occupants of the park, the tourists who want to experience them and the local communities who depend on the natural resources here to live. Under a 'lease' agreement, for example, the Wakatobi Dive Resort makes payments to local villages, in return for their honoring 'no take' fishing zones; the resort also sponsors conservation initiatives led by local people. One result of this approach is that the reefs here are nearly pristine.

The UNESCO listing for this area notes that there are 590 fish species and 396 coral reef species alone within the reserve. Maintaining the health of these reefs and the variety and density of smaller species in the marine park is essential to support the biomass of large schools of fish resident here. There is hope that the conservation work going on here will only encourage the proliferation of apex predators in the region.

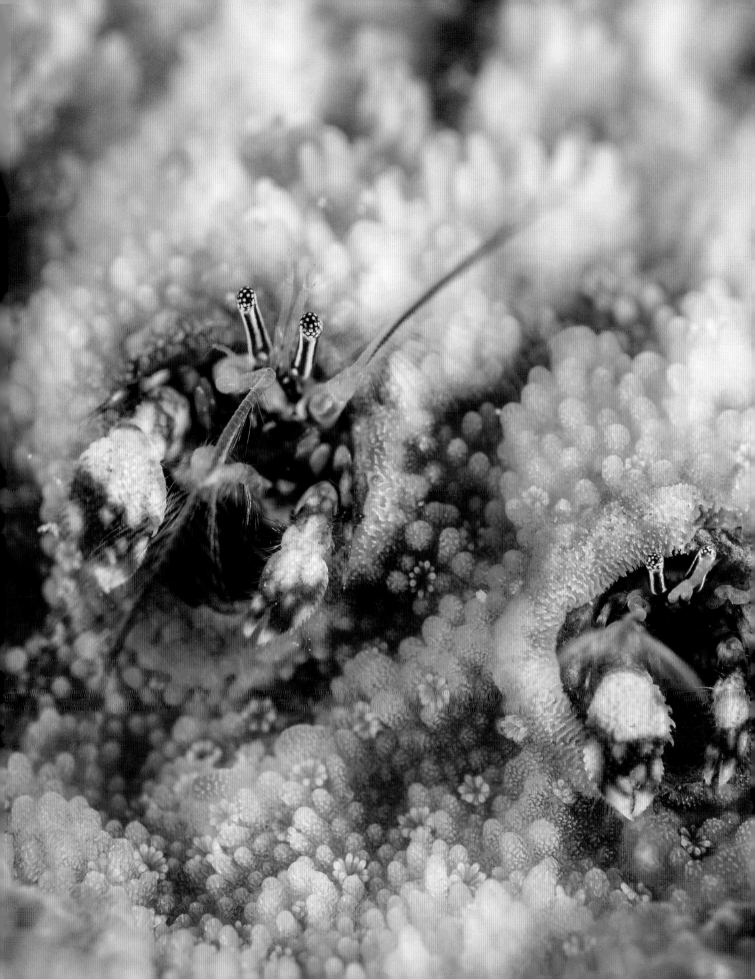

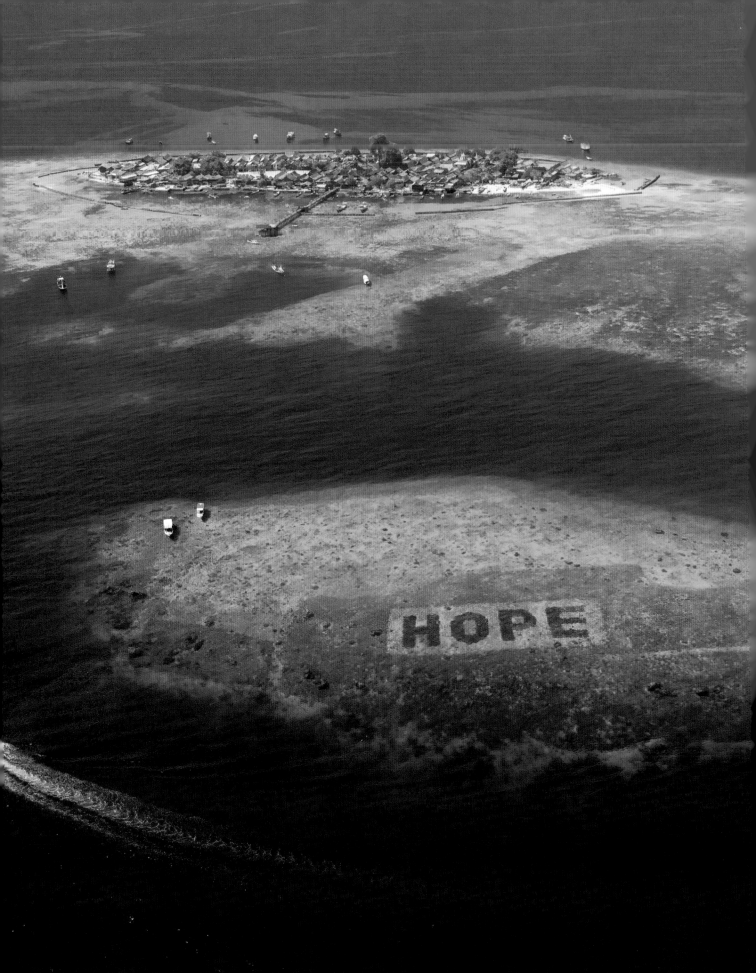

Sheba Hope Reef, a 14-metre- (46-foot-) high restored coral reef, located off the coast of southwest Sulawesi, Indonesia.

Growing Hope

SULAWESI, INDONESIA

BUILDING CORAL
PHOTOGRAPHS BY MIA STAWINSKI
AND MADELINE ST CLAIR

For over a decade, MARS Sustainable Solutions, in partnership with local communities, scientists, businesses, NGOs and governments, has been developing and implementing a simple, community-led solution to help restore damaged coral reefs globally.

Over 50 per cent of the world's coral reefs have been lost over the last 30 years, and many reefs around the world have now lost their ability to recover on their own. If we do nothing, up to 90 per cent of coral reefs, globally, may die by 2050. The outcome would be catastrophic, as 25 per cent of all marine species make their home in these reefs, which also protect our coastlines by forming a barrier against wave action.

But there is hope. The Mars Assisted Reef Restoration System (MARRS) is a holistic approach to reef restoration and is centred around the Reef Star, a hexagonal steel structure coated in coral sand to mimic the natural environment. Reef Stars are deployed in extensive webs to stabilize loose, dead coral and provide a platform on which coral can grow. This creates new habitat for fish and invertebrates and encourages the settlement of additional native corals. As natural ecological processes kick into motion, the whole reef comes back to life.

At its most effective, the MARRS method can transform heavily

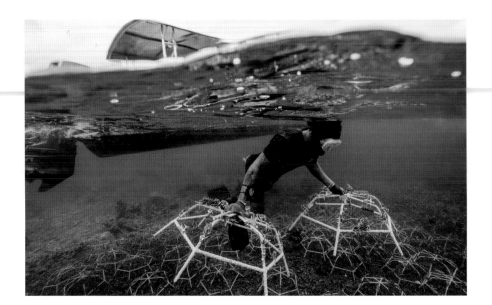

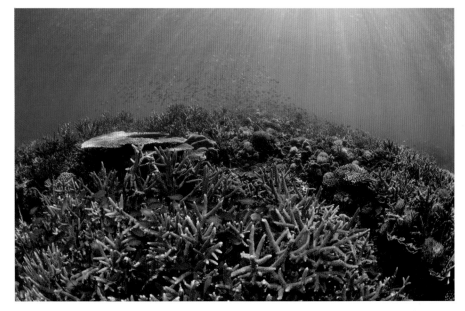

degraded coral rubble fields into healthy, vibrant, coral-dominated ecosystems within a few years, with coral cover increasing from less than 5 per cent to over 70 per cent, with a 64 per cent rise in the number of fish species. Since the first Reef Star was installed, the Building Coral team have trained and supported a global community of reef builders and advocates, involving more than 500 people from Indonesia, Australia, Mexico, the Maldives, the US Virgin Islands, Costa Rica, Hawaii, Kenya, Colombia and Aruba. Members of local communities are trained to build the hexagonal Reef Stars using local materials, then to prepare and install them. Collectively, the team and partners have installed over 90,000 Reef Stars, planting over 1,300,000 coral fragments across 40 reef sites in 10 countries, spanning 5 continents.

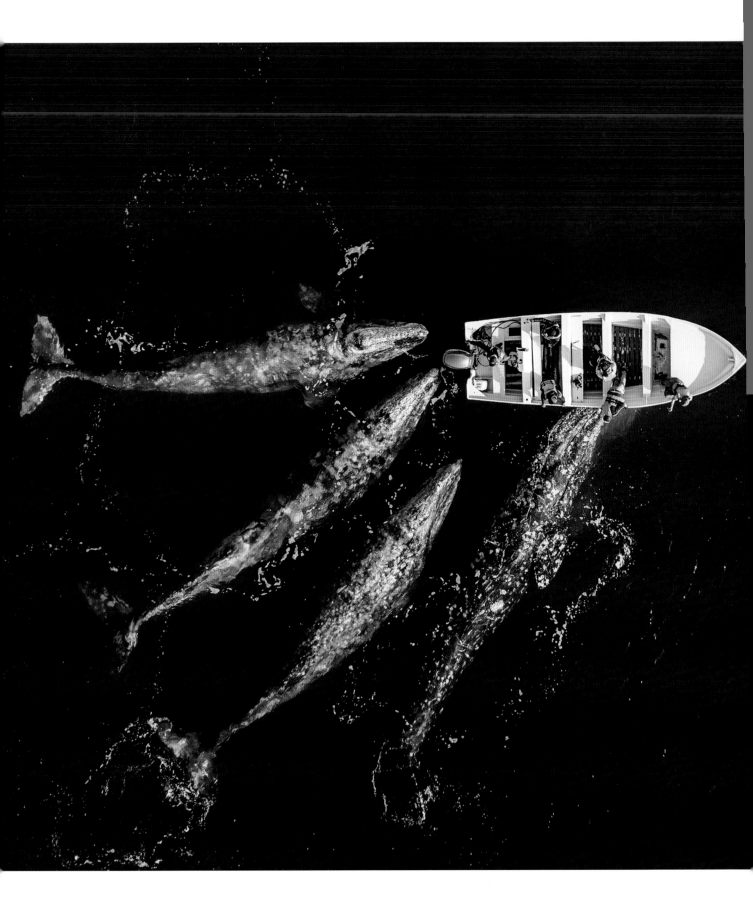

THE PACIFIC OCEAN

A group of curious grey whales (*Eschrichtius robustus*) investigates our boat. Usually, once one individual shows interest, it causes a ripple effect.

The Lagoon

BAJA CALIFORNIA SUR, MEXICO

KAUSHIIK SUBRAMANIAM

In the secluded lagoons of central Baja California, safe from predators, grey whales exhibit behaviours unlike those seen anywhere else on the planet, seeking out interaction with the few humans who visit this remote area.

The lagoons of central Baja California are a unique place, where one of nature's giants comes face to face with humans, in a story of true connection between species. Grey whales (*Eschrichtius robustus*) migrate from the icy waters of Alaska – the Chukchi, Beaufort and Bering Seas – to locations including San Ignacio Lagoon and Magdalena Bay to mate and give birth, in one of the largest migration journeys of any mammal in the world. They show an incredible curiosity towards the humans they encounter, often flocking towards the small local boats in search of attention from the people aboard. The whales spy-hop out of the water, taking a better look at the faces on the vessels, before coming closer and even allowing the passengers to scratch and pet them.

This kind of behaviour – in which a wild animal searches out people for interaction – is truly unique and humbling to witness. You cannot help but feel awe when you are surrounded by multiple 40-foot giants, all vying for your attention. The level of trust shown by the whales is breathtaking. Mothers can even be seen encouraging their calves to interact with humans, shattering all common theories about human–wildlife interactions. As grey whale populations increase, there are

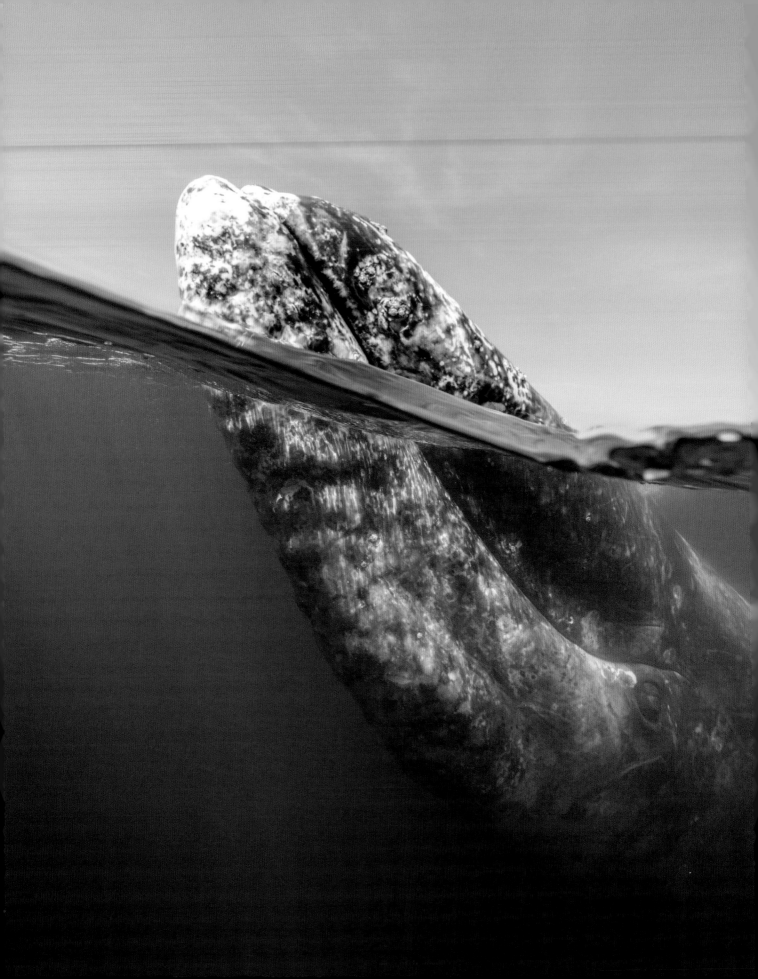

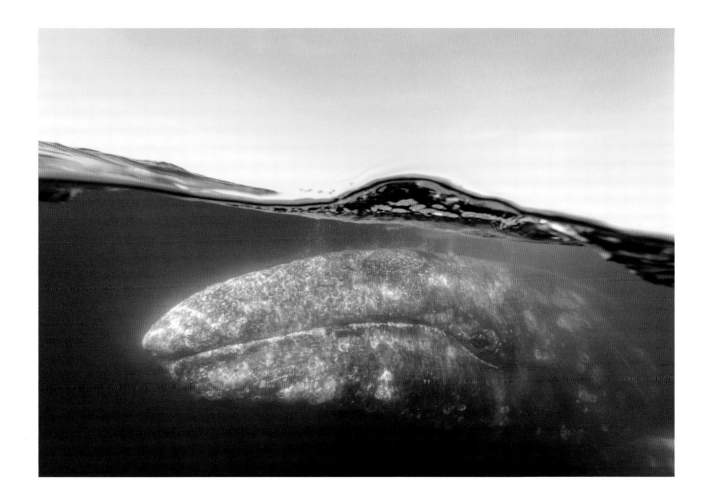

some concerns about too many people visiting the bays, but it is pretty well controlled. Outside of the lagoons the whales don't seem to show any interest in people or vessels.

The remoteness of this location – deep in the El Vizcaino Biosphere Reserve (a UNESCO Heritage Site), on the Pacific side of the Baja California peninsula – means only a handful of people are able to see these magical moments for themselves. I hope that by documenting this incredible story, I can share these powerful moments with those unable to make the gruelling journey to the lagoon.

Moments of connection like these are what fuel conservation, and empower people to make changes to protect the oceans.

Grey whales were hunted to the brink of extinction by humans in the very bays where they now share life-changing experiences. Since the 1982 worldwide ban on commercial whaling was put in place, their numbers have increased dramatically, with more and more Mexican whales being born each year in these lagoons. When plans were announced to drain San Ignacio lagoon to create commercial salt flats – a joint venture of the Mitsubishi corporation and Mexican government, mooted in the early 2000s – a coalition of more than 50 environmental groups from the US and Mexico campaigned to stop the development, arguing that these whales (and other species in the area) might be at risk. No doubt the incredible interactions with whales that take place in this area were key in preventing this incredible habitat from being decimated as a result of human greed.

OPPOSITE: Like a living iceberg, this whale was vertical in the water, periodically popping its head up to see what we were doing on the boat.

ABOVE: A moment of connection with one of these incredible animals.

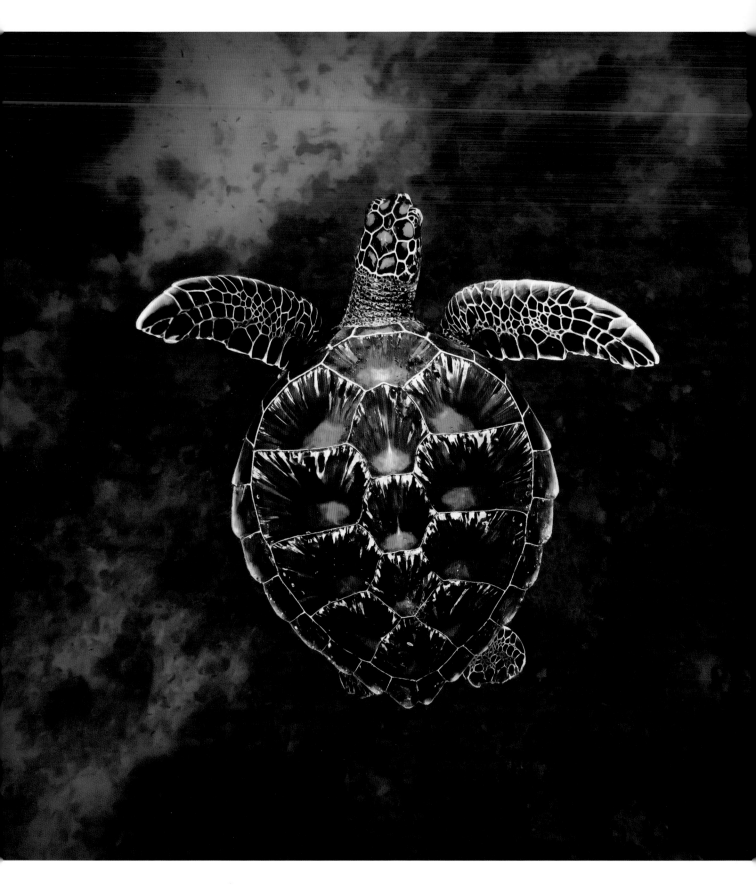

THE PACIFIC OCEAN

View from above, discovering the
intricate patterns of a hawksbill turtle's
shell (*Eretmochelys imbricata*).

Encounters with
Sea Turtles

LADY MUSGRAVE ISLAND, GREAT
BARRIER REEF, AUSTRALIA

STEPHEN LARDER

Turtles are pivotal players in maintaining ecological
balance within their habitats, but today six out of seven
species of sea turtle (all of the species found in Australia)
are recognized as under threat by the International Union
for Conservation of Nature.

As both predators and prey, sea turtles help control populations of
insects, molluscs, crustaceans and small vertebrates in the marine
ecosystem. By regulating these populations, turtles prevent outbreaks
and maintain the delicate equilibrium within the food chain. They also
contribute to nutrient cycling within their ecosystems; their excrement
and decaying carcasses release valuable nutrients into the environment,
which nourish algae and aquatic plants, providing sustenance in turn
for a variety of organisms within the food web.

Sea turtles exert an influence on their habitats through their unique
behaviours. Their movements, foraging activities and interactions with
the environment can impact the distribution and abundance of aquatic
plants and invertebrates. Even when they nest, turtles have a part to
play. At Lady Musgrave Island, and surrounding islands on the
Southern Great Barrier Reef, turtles return to lay eggs in their

thousands during nesting season. During the turtle nesting season, Lady Musgrave restricts access to campers to allow the turtles full access to the beach and natural environment, and as female turtles dig nests in the sand to lay their eggs, they inadvertently contribute to preventing beach erosion. By disturbing the sand and creating depressions, they stabilize the beaches, helping retain the integrity of coastal ecosystems.

There are only a few large nesting populations of the green (*Chelonia mydas*), hawksbill (*Eretmochelys imbricata*) and loggerhead (*Caretta caretta*) turtles left in the world. Mon Repos Turtle Centre – located in the Bundaberg region, just a short boat ride from Lady Musgrave Island – is a conservation park for turtles that supports one of the largest concentrations of nesting marine turtles on the East Australian mainland and has a significant loggerhead turtle (*Caretta caretta*) nesting population. The success of this population at Mon Repos is critical for the survival of the endangered loggerhead turtle.

While poaching, over-exploitation and bycatch are key threats to these ancient reptiles, they are also especially vulnerable to pollution and changes to their habitats, including nesting beaches, where even changes in sand temperature can threaten hatchlings. In Australia, all six species of marine turtle are protected by law and they are a priority for conservation under a Recovery Act passed in 2017.

In my own experience as a photographer, I have been struck by the beauty of these creatures – their intricate patterning and graceful, seemingly effortless movement through the water. The younger turtles, especially standoffish, can swim away at such a speed that, even with fins on, I am no match. While turtles are generally solitary animals, some species display social behaviours and I find this to be a perfect time to capture them, as they gather in groups, bask together or graze at the surface, concentrating on everything but me.

Capturing the slow and steady charm of a turtle's world; pictured here, a green turtle (*Chelonia mydas*).

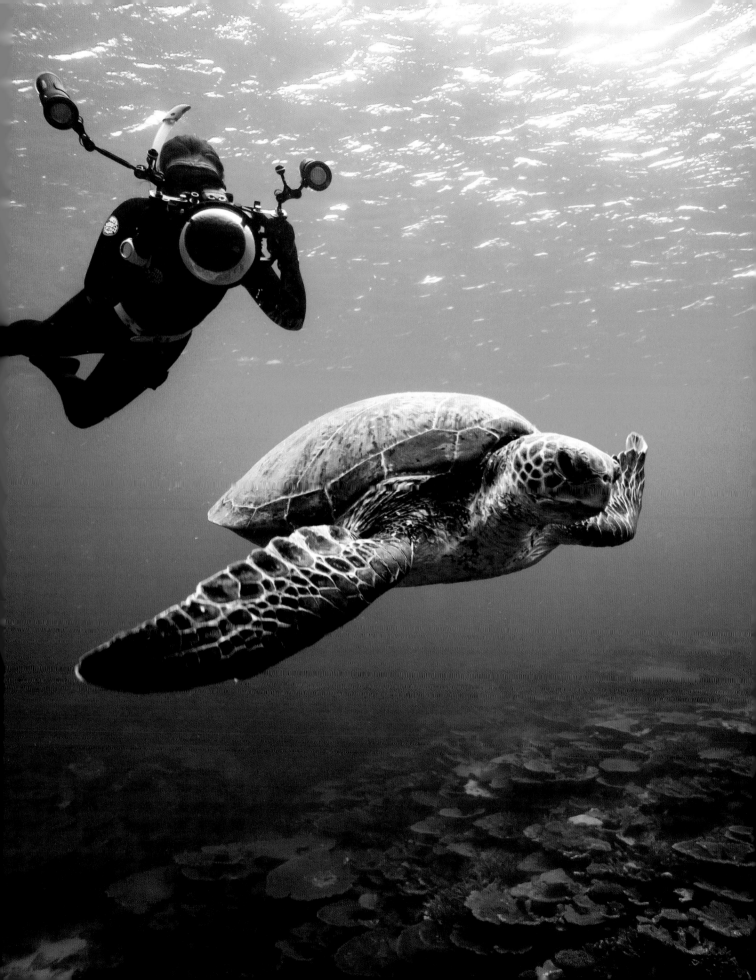

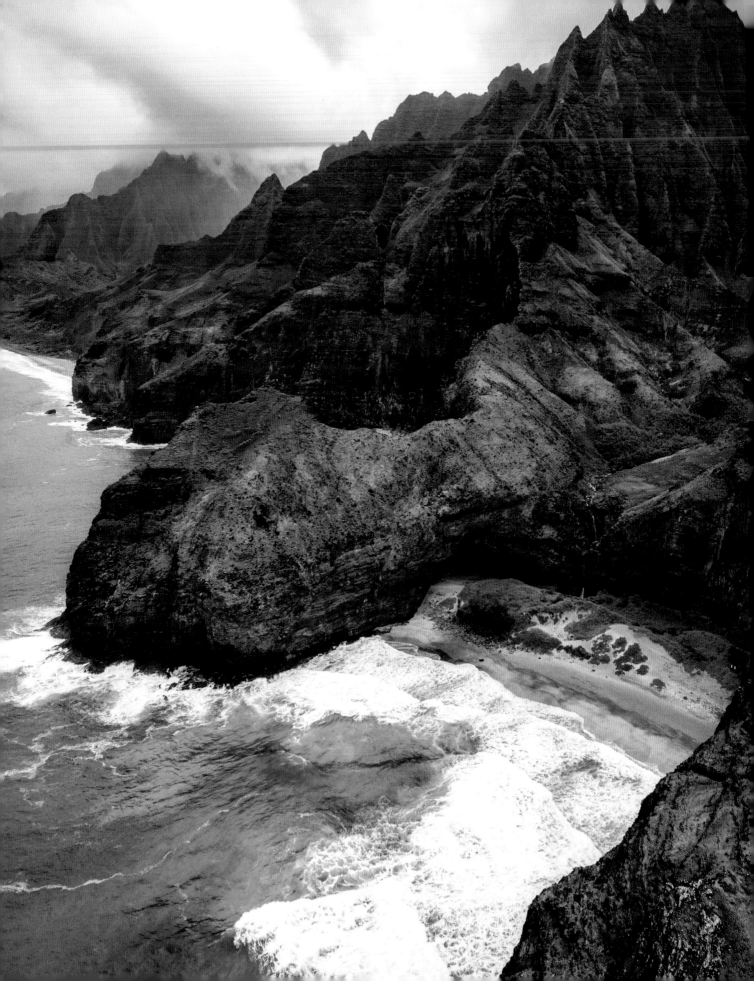

'Mauka to Makai'

HAWAII, UNITED STATES

KARYLE SOTO

Denoting direction, 'Mauka to Makai' is a common saying in Hawaii (*mauka* means 'to the mountains' and *makai*, 'to the ocean'), but it's also a lifestyle, and a statement of the synergistic flow between these two parts of the natural world.

Growing up in Hawaii, I used to take it all for granted: fresh air, clean water, seemingly pristine forests, beautiful beaches and abundant sea life. It seemed so 'everyday', I couldn't imagine anything disturbing its almost infinite existence. Of course, I learned I was wrong and have spent my life nurturing an ever deepening *kuleana* (responsibility) for my island home.

Here, the *Āinu* (land) is connected to the *Wai/Kai* (freshwater/ocean); what affects one, affects the other. While they may seem unrelated, efforts to ensure a healthy, thriving native forest – of 'ōhi'a trees, *Metrosideros polymorpha*, in particular – will directly ensure healthier Hawaiian reefs. On the island of Kaua'i, the 'wettest spot in the world', heavy rains cause landslides and erosion in the depleted canyons and valleys, with silt and debris flushed out to the ocean, where it coats the reefs. This deprives corals of sunlight, the fish disappear, and the *Honū* (Hawaiian green sea turtle, or *Chelonia mydas*) loses its food supply (of limu, an edible underwater plant that grows on coral and rocks). This is just one example of the domino effect caused by an unbalanced native forest.

Helicopter view of Honopū and Kalalau beaches, Kaua'i.

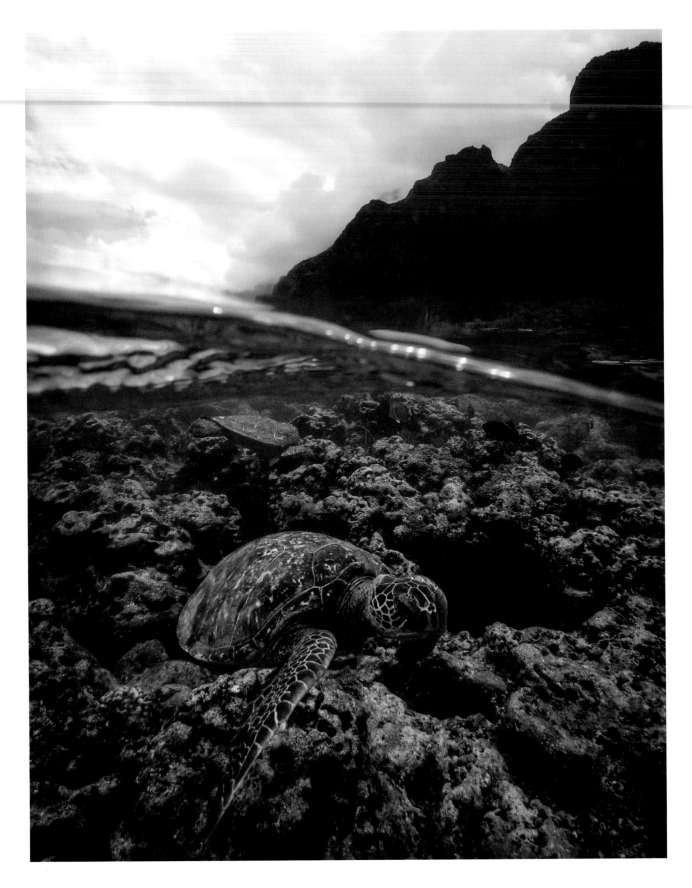

THE PACIFIC OCEAN

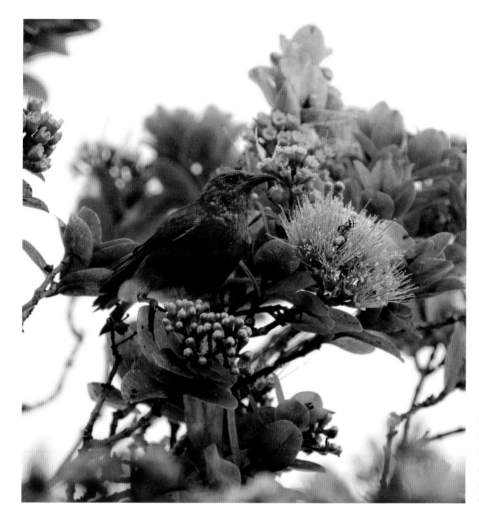

LEFT: *An'apapane* (*Himatione sanguinea*), one of our native honeycreepers, enjoying its favourite flower, '*ōhi'a lehua alani* (*Metrosideros polymorpha*).

OPPOSITE: Hawaiian *Honū* (*Chelonia mydas*) at Nualolo-Kai reef along Nā Pali coast.

Hawai'i and '*Ōhi'a* trees are being hit hard by Rapid '*Ōhi'a* Death (ROD), a fungus that has targeted these endemic trees and is devastating our already-sensitive forest ecosystem, which contains critically endangered native birds, snails and flora, all of which depend upon this keystone tree. Efforts by local government and communities to manage and combat ROD have been established in the last five years: bio-sanitation stations at major trailheads, new fencing to keep out invasive grazing mammals, and a grassroots campaign promoting reforestation as well as the planting of native species only (a message sent both to locals and to the resorts and developers on the island).

This idea – that what's happening on land can affect the surrounding ocean – is often overlooked. I've travelled a fair amount outside of my Hawai'i home, and nowhere else in the world is this concept, of how interconnected the land, ocean and people are, as prominent as in Polynesia. The islands there were 'born' from the ocean, which surrounds them and is highly culturally significant. There's a lot being done directly for the ocean/reefs around the world: coral restorations, beach clean-ups, using only reef-safe sunscreens, regulations on over-fishing, marine protected areas, and so on. However the importance of protecting native forests and wetland areas in the quest to ensure healthy oceans should not be understated.

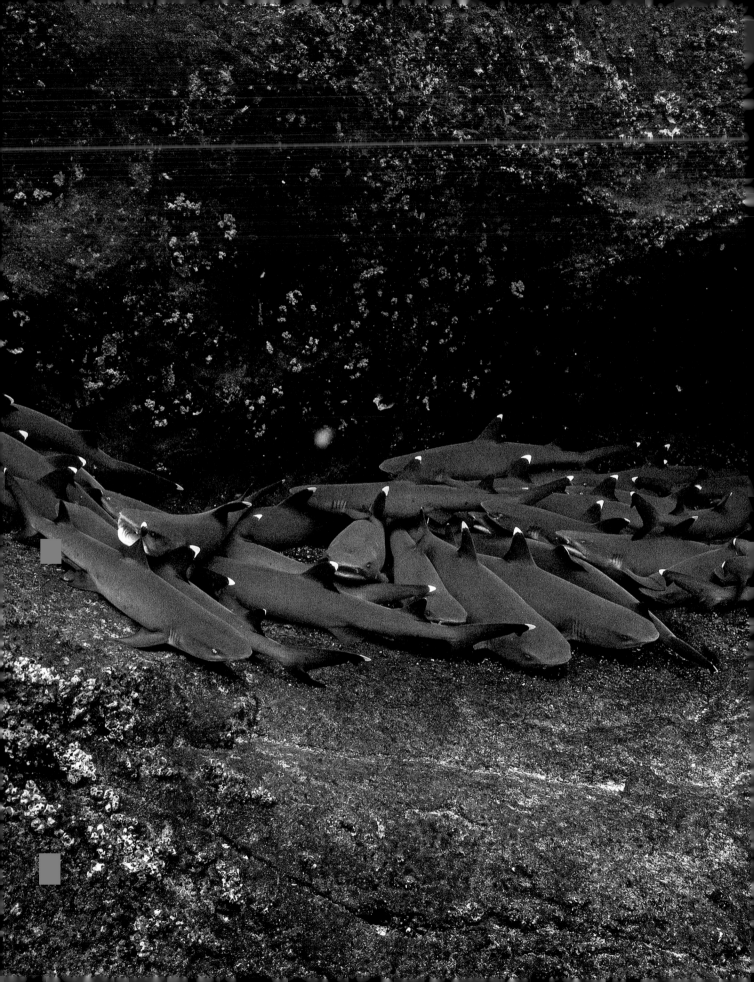

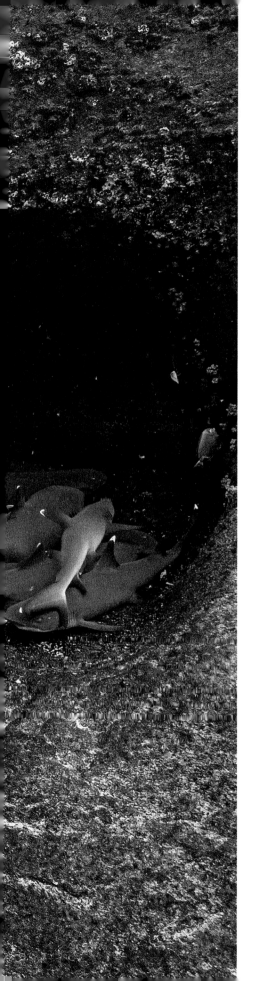

The erosion of the rock column at Roca Partida has created 'balconies' where whitetip reef sharks (*Triaenodon obesus*) can be found.

Citizen Action in the North Pacific

REVILLAGIGEDO ARCHIPELAGO

FERNANDA CORTINA

Ocean explorers, including divers and photographers, have both a privilege and a responsibility in Revillagigedo, where they form an unofficial patrol for the national park. On the island of Clarión, their absence is keenly felt.

The Revillagigedo Archipelago is one of the most diverse ecosystems and biosphere reserves in the Tropical Eastern Pacific. Located nearly 400 kilometres (249 miles) southwest of the southern tip of the Baja California Peninsula, on the 'Ring of Fire' – the volcanically active zone encircling much of the Pacific Ocean – the archipelago consists of four volcanic islands, the furthest and least explored of which is the mysterious Clarión. The underwater landscape, from shield volcanoes to shallow coral reefs and deep-sea hydrothermal vents, is a haven for pelagic marine life and one of the richest insular shark habitats in the world.

 The archipelago was made a UNESCO World Heritage Site in 2016, and, in 2017, it was declared a national park and marine reserve – the largest such reserve in North America, spanning 150,000 square kilometres (57,000 square miles). As such, development and fishing are entirely banned in the region, but this has not kept the illegal poachers and sport fishers away. Although the archipelago houses two small

naval bases, much of the work of keeping this marine area protected is done by the captains and scuba divers who travel to the islands on the liveaboards. These boats serve as an unofficial patrol in the national park, reporting any suspicious activity to Mexican authorities, and liveaboard diving expeditions have contributed to the preservation of marine life on San Benedicto, Socorro and Roca Partida.

At the island of Clarión, which usually does not make it on to diving itineraries because of the added two days of sailing time, a stark contrast is very evident. Because of the lack of divers here, it is largely unpatrolled save for a small naval base. Sport fishers and tuna boats are a frequent threat to the area, some of them sailing down from the United States to poach the rich waters around the island. Although still teeming with life, the dive sites here exhibit the impact of these illegal activities when compared to the rest of the archipelago.

It is because of the collective action of seafaring communities – be it sailors, divers or fishermen – that a great part of the marine protected areas that now exist in the world and remain healthy are kept safe. These images reflect the positive impact humans can have on an ecosystem when we approach it with respect and wonder.

Although policies such as the enforcement of no-fishing zones are a great step towards its health, the positive impact of sustainable human presence in protected ecosystems goes largely unnoticed. My photography aims to showcase the beauty and diversity of the archipelago, while emphasizing the importance of continued conservation efforts. I want to inspire people to recognize the value of citizen science and action to protect the ocean for future generations.

'Although still teeming with life, the dive sites [at Clarión] exhibit the impact of illegal activities.'

The oceanic manta (*Mobula birostris*) can be found in most of the dive sites on the archipelago. They appear to be almost curious about divers in their vicinity.

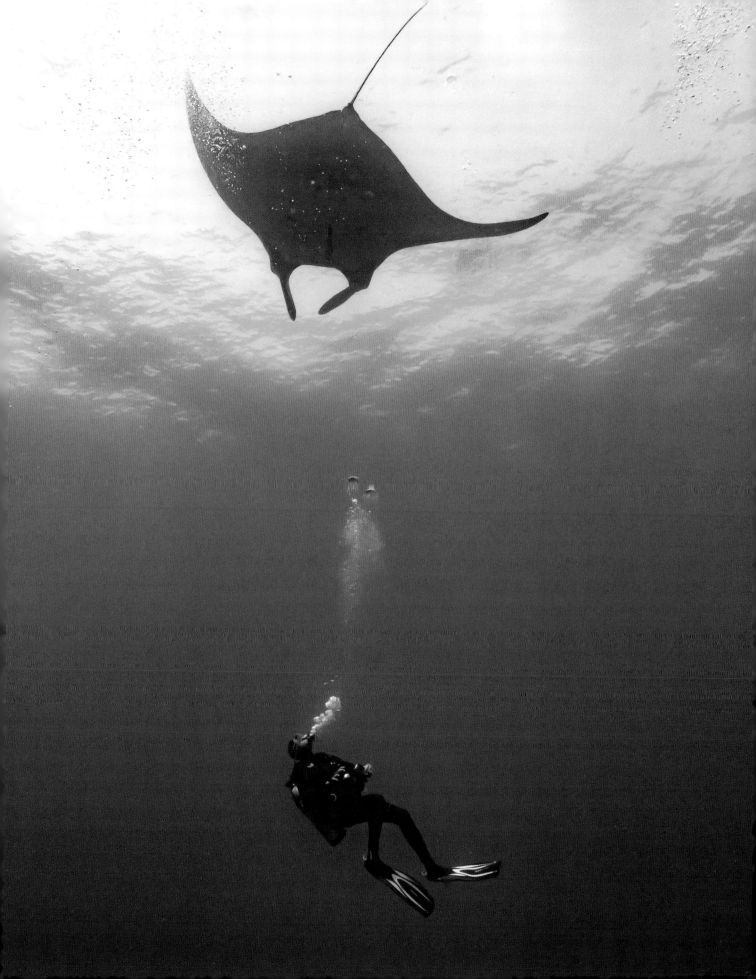

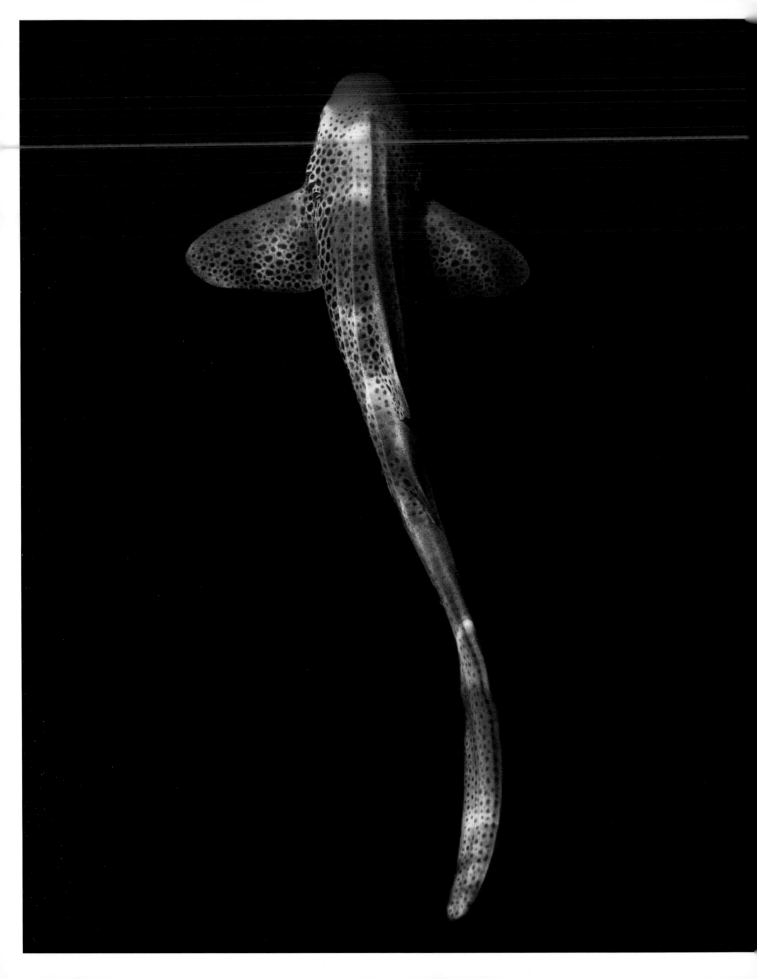

Low evening light refracts through ripples on the water's surface, casting a rainbow pattern onto a leopard shark's (*Triakis semifasciata*) dappled skin.

Hope in the East

AUSTRALIA

LEO BELLIS-JONES

Perched right on the most easterly point of Australia sits an unassuming rock, jutting out of the ocean, just off the coast of Byron Bay. From the land you wouldn't think much of it, but below the surface lies one of most biodiverse places in Australia.

Julian Rocks – or Nguthungulli (pronounced Nuth-un-gully) – sits in the spot where warm tropical water from the East Australian Current mixes with cold temperate water sweeping up from Tasmania. This confluence brings an incredible range of marine life from north and south, including the largest aggregation of leopard sharks (*Triakis semifasciata*) anywhere in the world. During the summer months, these critically endangered creatures glide through the water alongside dancing manta rays, eagle rays, Indo-Pacific bottlenose dolphins (*Tursiops aduncus*), bronze whaler sharks (*Carcharhinus brachyurus*), and often too many turtles to count. Then when winter comes around, grey nurse sharks (*Carcharias taurus*) move in and humpback whales (*Megaptera novaeangliae*) pass by. But it's not just the mixing of the currents we have to thank for this underwater melting pot – Julian Rocks–Nguthungulli is the perfect example of why Marine Parks are such an important feature of the Australian coastline. This area is classed as a Sanctuary Zone, giving it the highest level of protection for a delicate ecosystem, and without which the site would be a shadow of its current self.

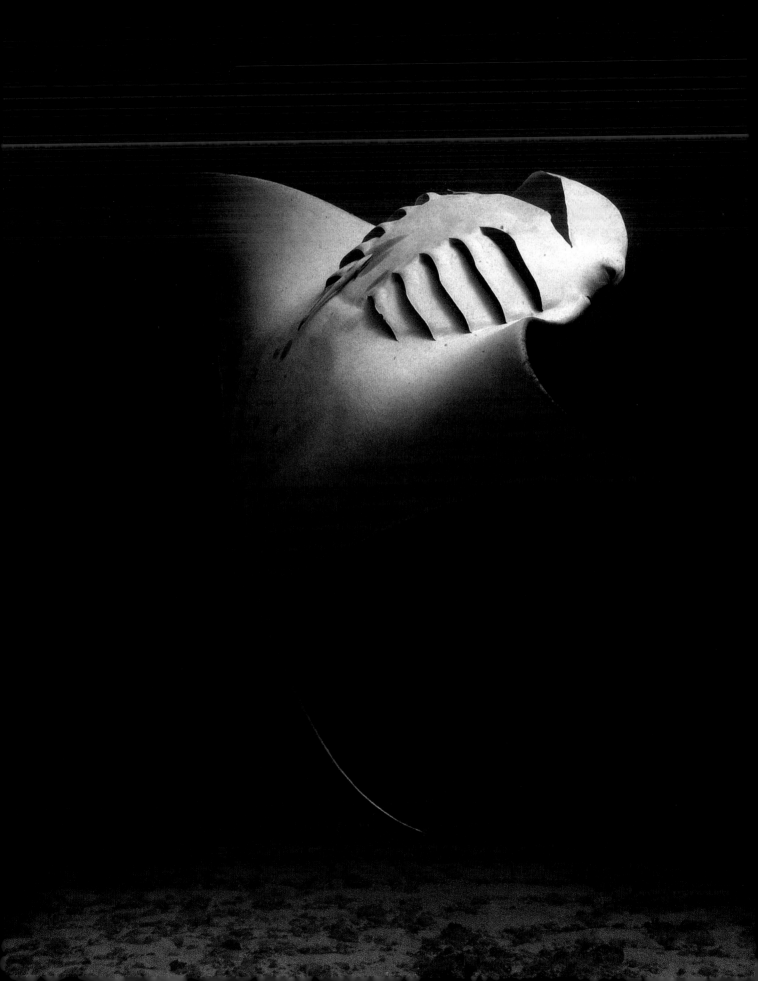

This is especially important because of Nguthungulli's cultural significance for the Arakwal people of Byron Bay – the Aboriginal traditional custodians, who have lived on these shores for at least 22,000 years. In the Aboriginal Dreamtime, Nguthungulli (which means 'Father of the World') was the creator of land, water, animals and plants, and came to rest at Julian Rocks. When the water level here was much lower and the rocks were accessible by land, this was an important ceremonial site for local people. Community Elders have instructed the generations that Nguthungulli be protected from misuse.

OPPOSITE: A manta ray 'barrel roll'-feeding in a dense patch of plankton, illuminated by a bright pool of light.

ABOVE: Nguthungulli captured at sunrise on a calm summer morning. Photograph by Alexander Roeterink.

With so many threats facing our oceans, it's reassuring to see what can happen when communities come together and fight for special places like this. So much so that the the Mission Blue ocean advocacy organization recently designated Julian Rocks Nguthungulli Nature Reserve one of their 'Hope Spots' – a collection of places around the world critical to the health of the ocean. And to me, that's exactly what it signifies – the hope that there's a way back from the damage that's being done. On a personal level, it was here – happily stranded in Byron Bay during the Covid lockdowns – that I rediscovered life underwater after years of moving away from the shore. In 2009, fresh out of school and about to embark on a round-the-world trip, I was swimming out to a reef in Fiji when I was run over by a speedboat and hit by the propeller. Several operations and a stint in intensive care later, I was lucky to be alive, but the years that followed took me further and further inland: first to a hospital bed, then to university, and on to work in London. Now, thanks to that rocky little island, I'm back underwater doing what I love.

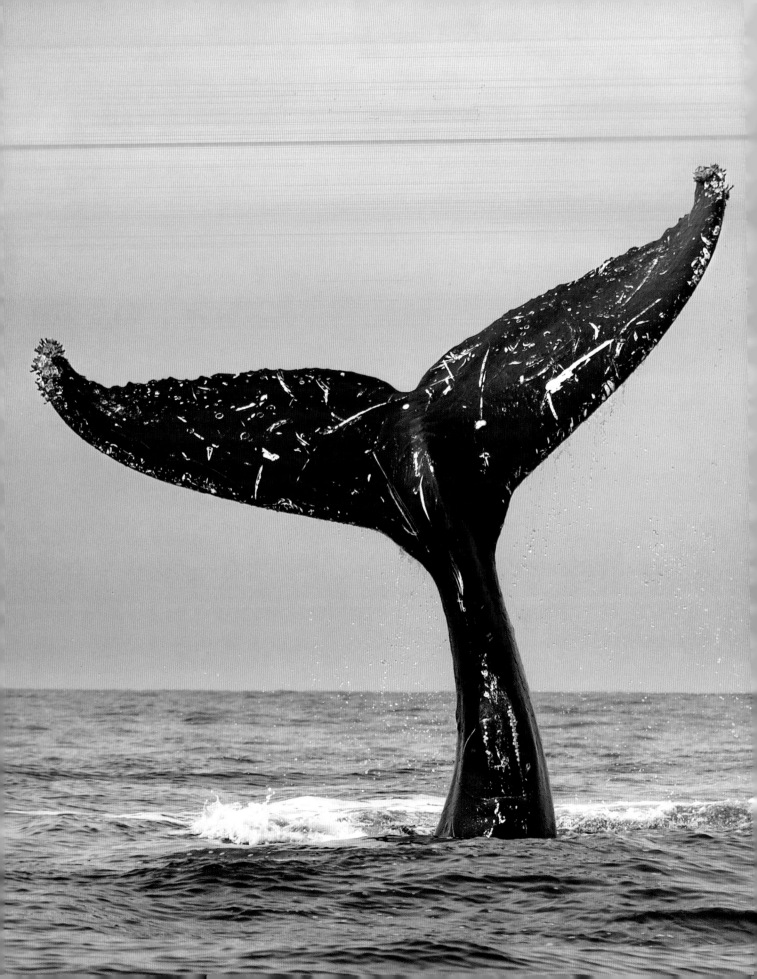

A humpback whale (*Megaptera novaeangliae*) at sunset, surprising us with several tail flips.

The Trees of the Ocean

SEA OF CORTEZ

MICHELE ROUX

The conservation of whale species such as the humpback is vital; these extraordinary creatures are important components of healthy ecosystems, help promote biodiversity and mitigate climate change through their capacity to capture, or 'sink' carbon.

The Sea of Cortez, also known as the Gulf of California, was once referred to by Jacques Cousteau as the 'the world's aquarium'. This sea, which sits between the Mexican mainland and the Baja California peninsula, is home to 39 per cent of the world's known marine mammals and one third of its cetaceans, as well as around 900 types of fish, of which 90 are endemic, such as the whale shark (*Rhincodon typus*) and the totoaba (*Totoaba macdonaldi*), which is endangered.

Among the most popular mammals here, attracting thousands of tourists, are humpback whales (*Megaptera novaeangliae*), which migrate thousands of kilometres from the Gulf of Alaska to the peninsula every winter to mate and give birth. They can grow up to 15 metres (49 feet) in length and weigh between 22 and 36 tonnes. They communicate through vocalizations, and these 'songs' can last between 10 and 20 minutes. They lack teeth, so their diet is based on krill – tiny crustaceans – and plankton, as well as small fish such as herring or

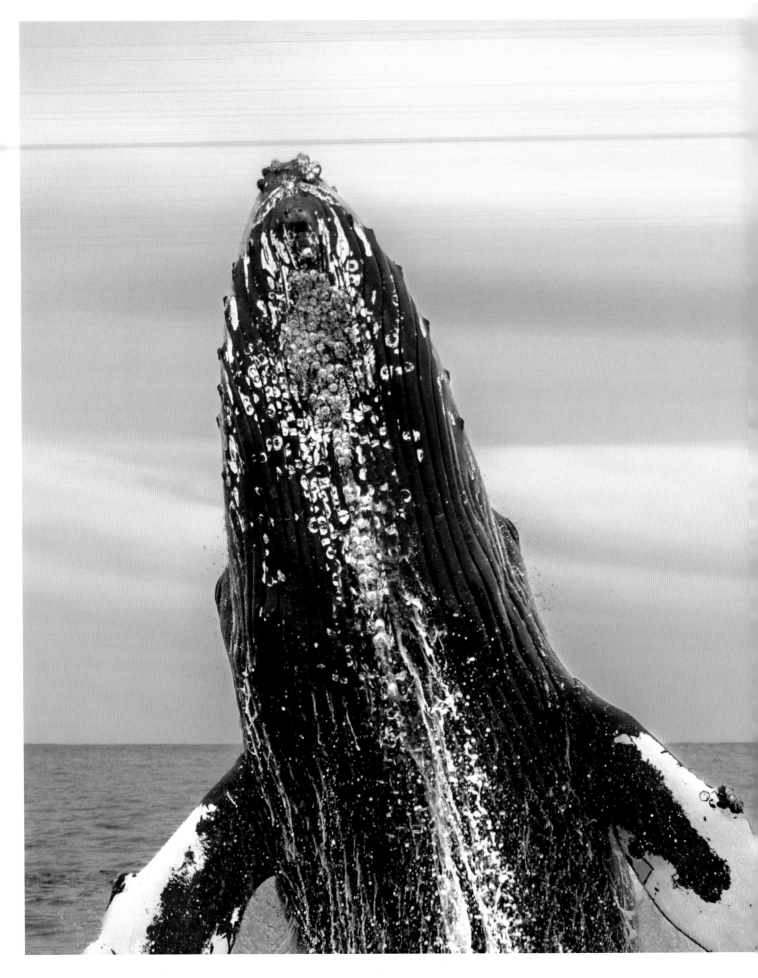

mackerel. This photography project was made out of my enormous love and passion for documenting humpback whales, with the intention of promoting the importance of their protection as a species.

Whales play a very important role in the ocean ecosystem, as each animal can capture, or 'sink', the same amount of carbon annually as a thousand trees. Their faeces are rich in iron, nitrogen and other nutrients, which act as oceanic fertilizer, increasing the productivity of small algae known as phytoplankton, which in turn sequester thousands of tons of carbon from the atmosphere annually. (When whale populations declined after intense hunting in the 1900s, plankton populations also rapidly decreased.)

These single-celled organisms are the main food for small crustaceans known as krill, which support the lives of hundreds of species of fish, birds and marine mammals, including whales. By promoting the emergence of new life, whales create more organisms capable of capturing carbon from the atmosphere; they then feed on these organisms in enormous quantities, blocking that carbon in their bodies for decades. Finally, when they die, their huge bodies fall to the ocean floor, where the carbon remains and is capable of supporting a succession of macrofaunal communities for several decades. So the disappearance of a single whale causes a huge deficit in the oceanic ecosystem.

My passion for the sea and photography led me to become a dive guide, with the purpose of speaking up for those species that can't speak for themselves, through conservation and activism. During the whale-watching season that I witness every year, I have noticed that there are many people who are unaware of these cetaceans and the vital role they play in sustaining the oceans. Through photography, I try to convey an educational message, so that more people can understand what it truly means to feel empathy towards those marine animals and towards the oceans themselves.

A whale appears in front of the boat
a few centimetres away from us,
impressing us with its large size.

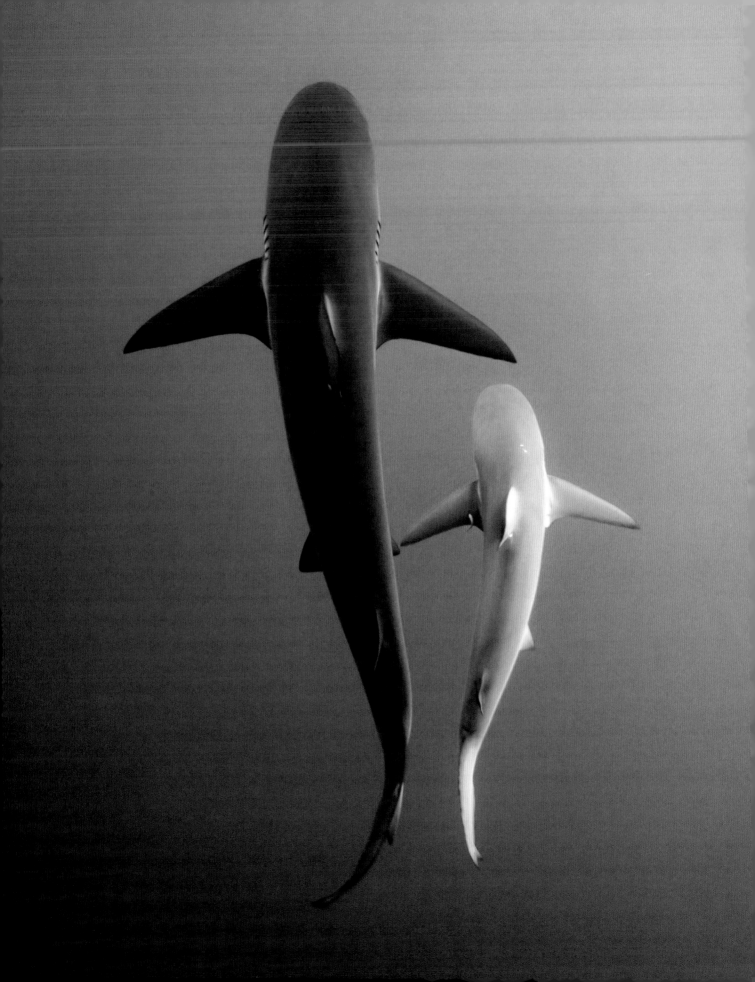

Shark Ecotourism: Surviving and Thriving

HAWAII, USA

PHILLIP VU

Oahu, Hawaii, is one of the few places in the world where sharks enjoy legal protections; shark fishing is illegal here. Shark-diving ecotourism on the island, meanwhile, brings in revenue for locals and allows us to get close to these beautiful creatures, whose existence is threatened in other parts of the world.

I'm currently working on a short documentary about the importance of sharks in our world and the value they bring to economics as living animals rather than dead catch. The film explores the various beautiful experiences to be had when interacting with live sharks in their natural habitats. It also takes a look at the dark side of human interaction with sharks, including the practices of shark-finning and shark-fishing. With the support of the team at Project Hiu (the brainchild of shark conservationist Madison Stewart), the film explores the dichotomy that exists between shark fishing as a means to support and provide for families (as in fishing communities in Indonesia) and shark fishing as a sport, with the bragging rights and competition that go along with it (as in locations such as Florida). The kind of ecotourism practised on the island of Oahu, Hawaii, where these images were made, presents yet another vision of human-shark interaction – one in which the

OPPOSITE: A Galapagos shark (left; *Carcharhinus galapagensis*) and sandbar shark (right; *Carcharhinus plumbeus*) swimming together peacefully.

OVERLEAF: Galapagos and sandbar sharks cruising through the northshore of O'ahu.

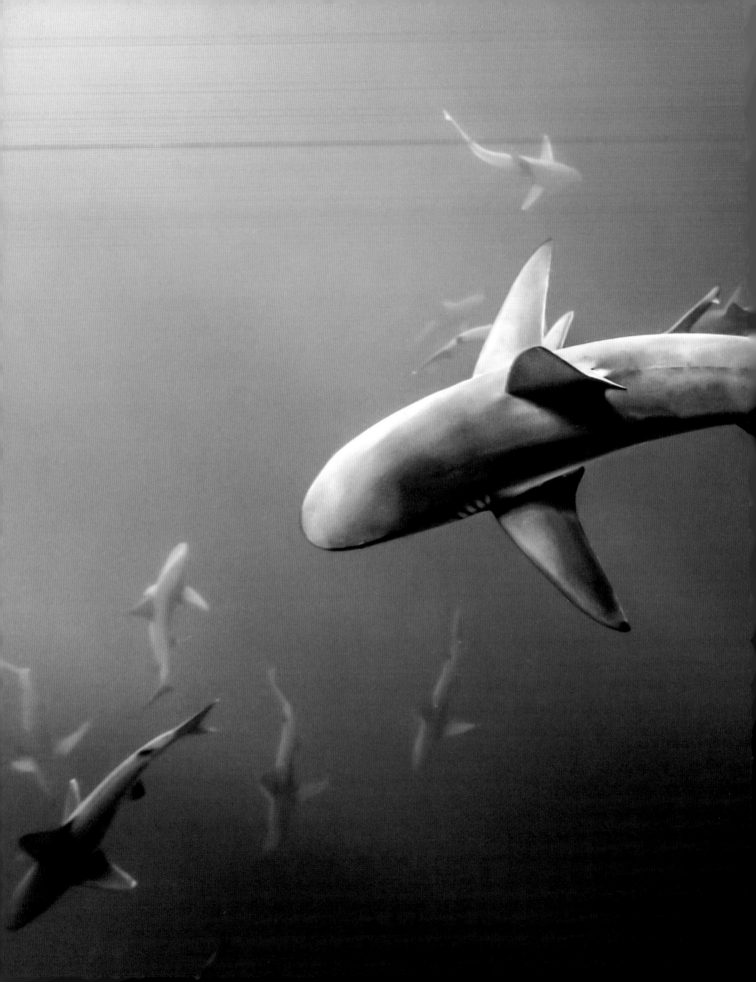

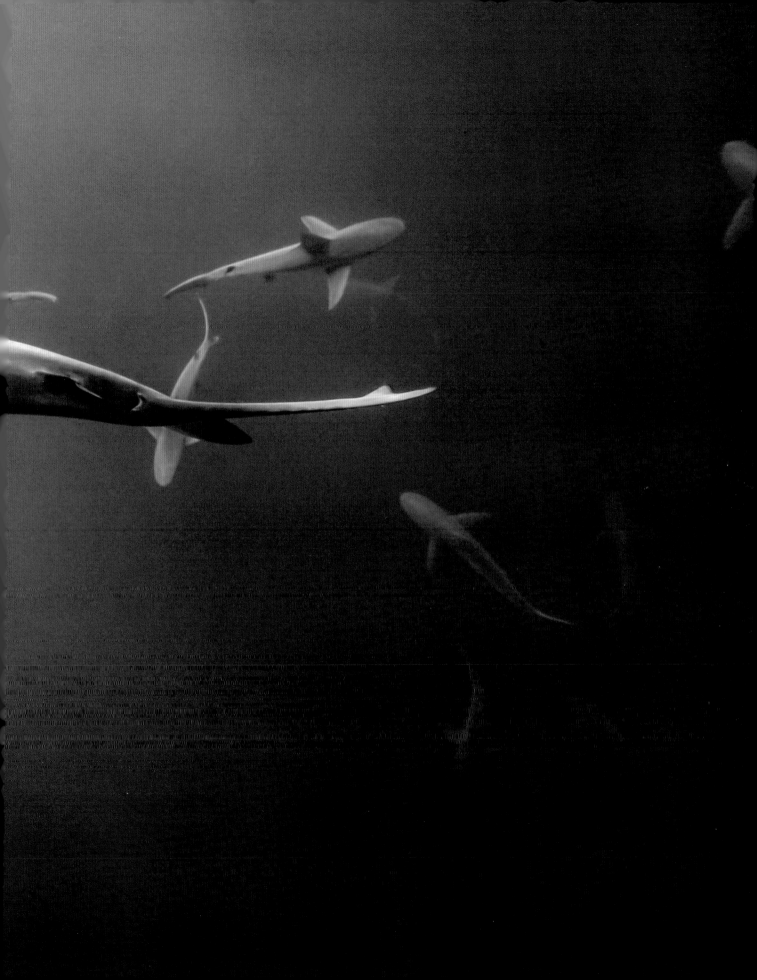

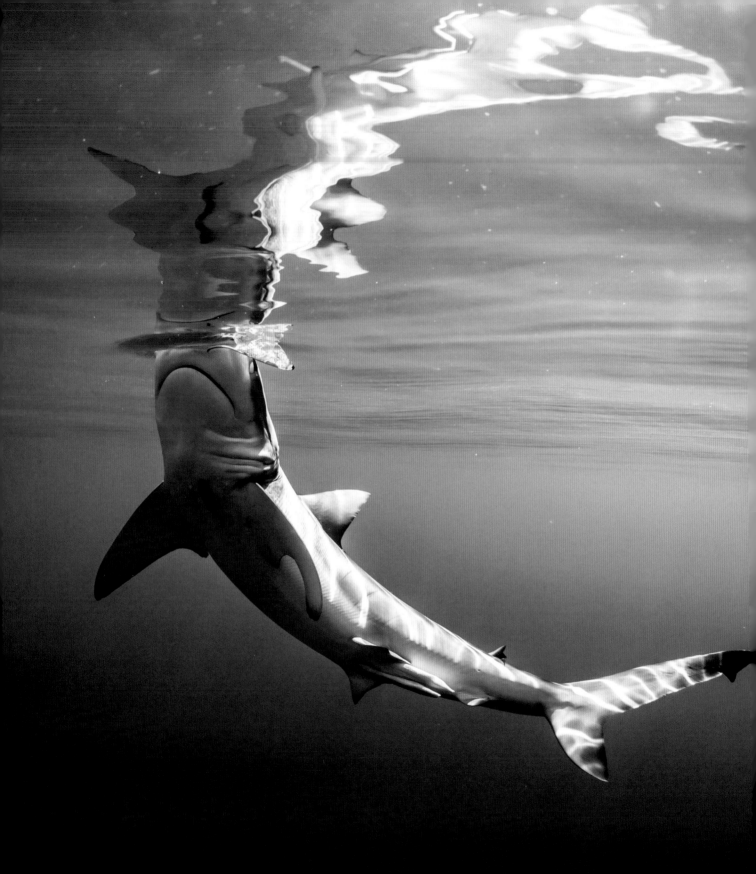

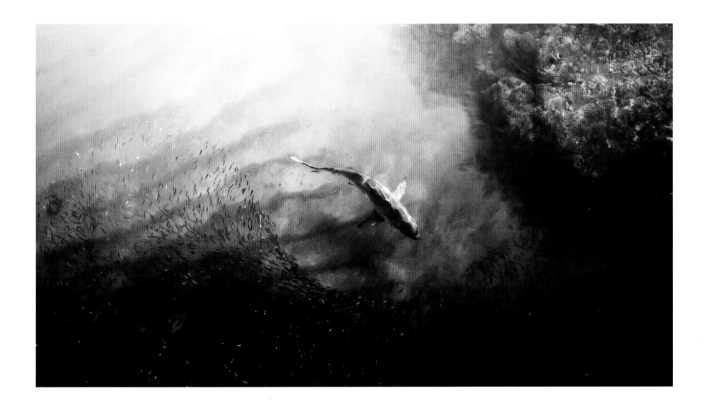

preservation of these creatures is central and where there is opportunity to shift the public perspective of sharks, often thought of as threatening or dangerous.

Florida is an epicentre of shark-fishing tournaments and many people there are committed to this variety of sport fishing. In July 2022, a tournament in the state drew the attention of activists after reports that participants had killed an individual from a protected species, as well as using illegal hooks to catch sharks. The National Oceanic and Atmospheric Administration (NOAA) oversees tournaments such as these, though it does not recognize the majority of the IUCN's listings for protected sharks. This government agency has also funded research exploring the possibility of culling sharks to reduce 'depredation' (or 'bite-off', where sharks take or damage fishermen's catch before it is landed), despite the fact that many experts in the field argue that it is overfishing that drives this behaviour in the first place, with sharks increasingly desperate to find and feed on injured fish, given the wider decline in their prey species.

Contrast this situation with the culture of shark fishing in Indonesia, where shark fisherman are often villainized, though they are arguably fishing for survival rather than sport. Stewart and Project Hiu have recently been the first to tag tiger sharks in Indonesia, and there are plans afoot to use the data on these sharks to help intentionally hire out shark-fishing vessels, in months where the tigers most frequent the area. Shark fishermen here have the opportunity to transition into the kind of tourism that is thriving on Oahu, or even research and shark tagging. As more people begin to realize the revenue they can bring in by running shark-diving tours, the better it is for economies, as well as for the sharks.

OPPOSITE: A Galapagos shark swimming up to check out a floating leaf.

ABOVE: A reef shark (*Carcharhinus amblyrhynchos*) looking for its next meal at Waikīkī, Oʻahu.

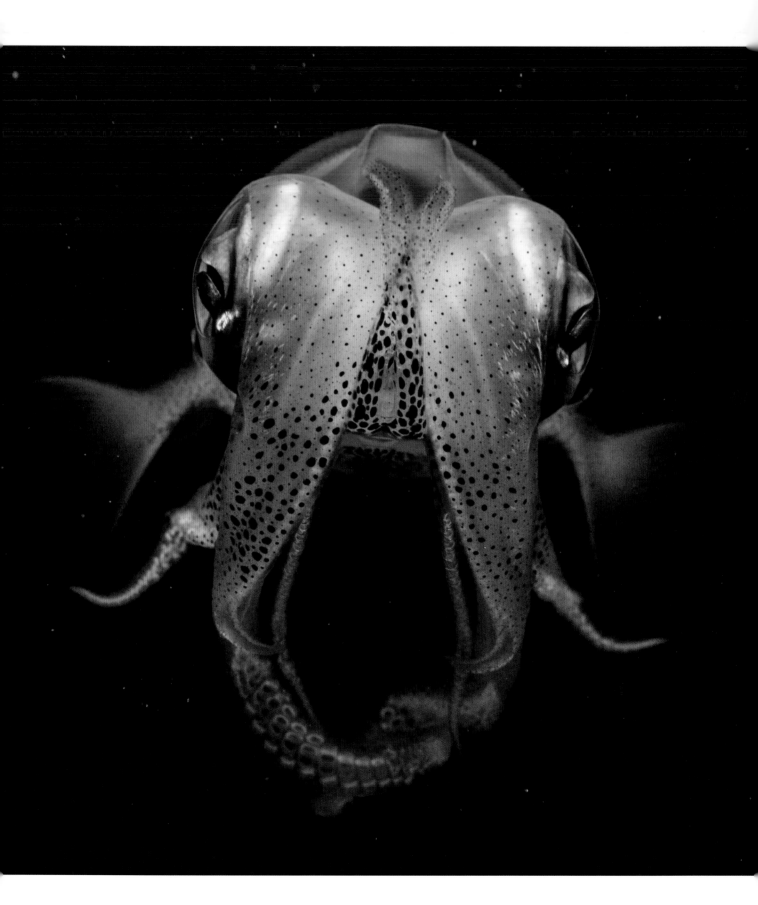

A Caribbean reef squid (*Sepioteuthis sepioidea*) hunts in the darkness in the Bahamas.

Defend the Deep

WORLDWIDE

CARISSA CABRERA

PHOTOGRAPHS BY SHANE GROSS

As we accelerate towards a clean-energy grid, the demand for minerals such as manganese, nickel and cobalt is prompting mining companies to look to the deep seabed. But one climate solution is another planetary problem, with mining posing an existential threat not just to deep-sea ecosystems, but to the entire ocean.

The deep sea is at risk of destruction from deep seabed mining, despite our lack of understanding of the ecosystem as a whole. Countries around the world are currently deciding their stance on deep-sea mining, with many nations coming out for a 10 year moratorium, but commercial and industrial pressure is mounting due to a growing demand for minerals that can be used in the production of, for example, electric cars. The International Seabed Authority (ISA) has, at the time of writing, granted 31 contracts for exploring opportunities, mostly in the Pacific Ocean. The deep sea cannot speak for itself. It is an environment so inhospitable to human life that our only images of it come from robots and rovers sent to the deep. Yet its stories must be told, so that we can act now to preserve it.

The deep sea is the largest habitat on the planet. It is home to 8.7 million species, and makes up 90 per cent of our ocean environment, yet the National Oceanic and Atmospheric Administration estimates

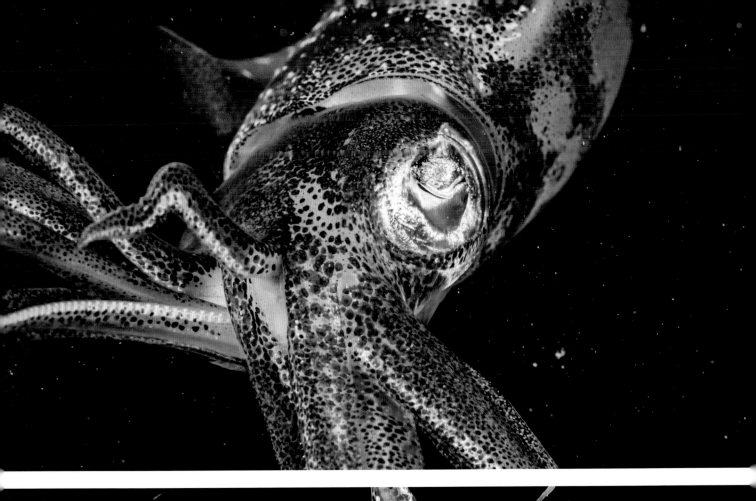
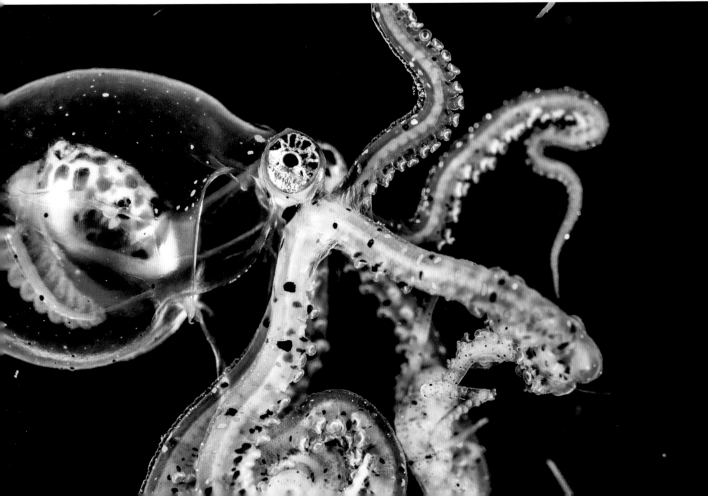

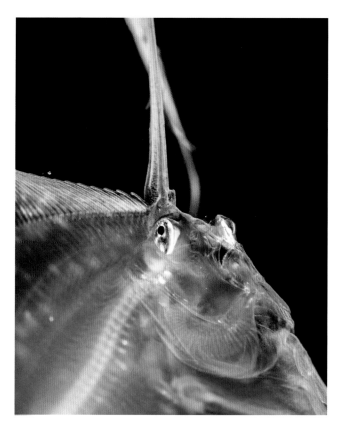

LEFT: A larval-stage flounder in the deep ocean of the Philippines.

BELOW: A sea butterfly (Thecosomata) in the deep of the Sargasso Sea in the middle of the Atlantic ocean.

over 80 per cent of our ocean is unmapped, unobserved and unexplored. It is also the largest carbon sink on the planet, absorbing approximately 38 per cent of the carbon dioxide produced by humanity. A complex marine ecosystem, it is covered in mounts and hydrothermal vents and home to creatures – living fossils – from millions of years ago. Humans do not understand the deep sea, but we know that it is a force of nature, where all life began and where answers to the future of life on earth may lie.

The minerals at the heart of the deep sea mining debate exist as potato-sized nodules scattered across the seabed. These deposits have built up over millions of years at the site of deep sea vents, where pressure, heat and the combination of magma with cold saltwater have created complex mineral 'knobs'. These deposits coexist with rich, little-understood forms of deep sea life, in ecosystems that have developed over millions of years. Once destroyed, these may never recover and the impact on the ocean as a whole could be seismic.

Deep seabed mining involves the use of large, loud robotic machines scraping the seafloor and destroying everything in their path. These machines dump wastewater, sediment and chemical in their wake – the equivalent, in one scientist's words, of 'vacuuming your rug, rescuing a lost earring from the canister, and then dumping all the collected debris back on to the rug and into the air in the room'. This is the last pristine place on our planet.

The deep ocean is a vast resource – a home to incredible biodiversity, the potential source of new medicines and materials, the engine of ocean life. But it is fragile and vulnerable to human exploitation. Can its voice, and the voices of communities who depend on it for life and livelihood, be heard in time to save it?

OPPOSITE ABOVE: A Caribbean reef squid flashes gold as it hunts the deep in the Bahamas.

OPPOSITE BELOW: A larval-stage wonderpus octopus (*Wunderpus photogenicus*) with transparent skin in the deep ocean of the Philippines.

THE POLAR OCEANS

In the icy embrace of the Polar Oceans, we embark on a journey to encounter ethereal wonders, from the intriguing aggregation of moon jellies feasting on the elusive salmon shark's eggs in the untamed waters of Alaska, to the distant, fastest-warming place on our planet – Greenland – where the profound loss of sea ice is transforming some of Earth's most resilient creatures into the most fragile. Time is slipping away as we witness the changing landscapes and delicate ecosystems of the Polar Oceans, reminding us of the urgent need for preservation and understanding in these remote and captivating waters.

Vibrant shades of glacial meltwater
flowing through a fjord in Greenland
('Shapeshifting Glaciers', pp. 222-7).

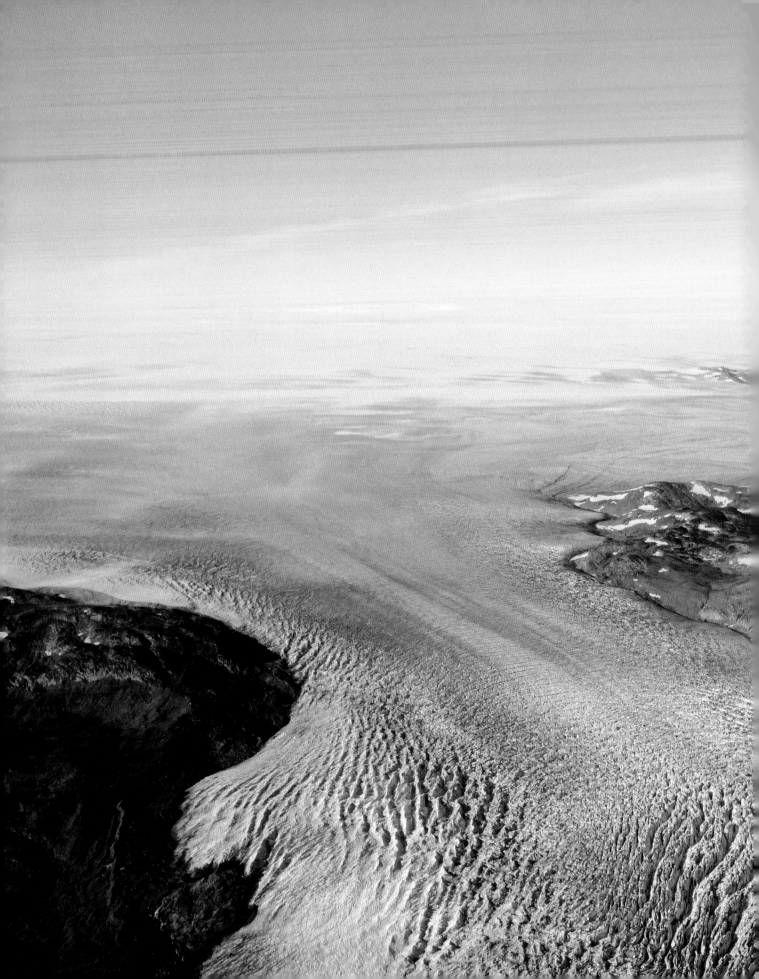

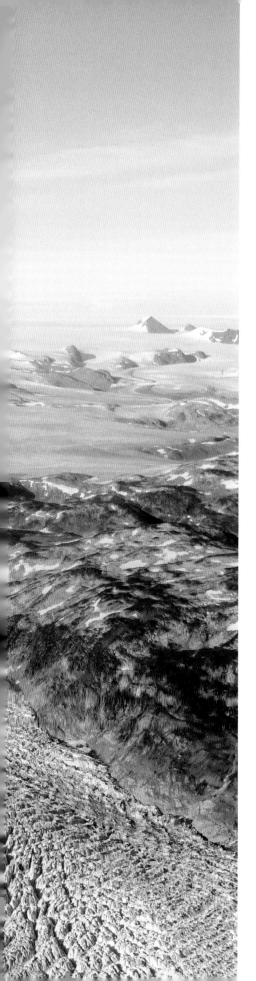

OPPOSITE: Greenland's ice sheet twists and ruptures across the rugged landscape as it moves into its glacial form.

OVERLEAF: An iceberg lies grounded in shallow water within the fjord system.

Shapeshifting Glaciers

GREENLAND

MADELINE ST CLAIR

In 2021 I was asked to join a project in Arctic Greenland documenting plastic pollution and climate change. As a tropical marine biologist, I was intrigued to see how these issues, the devastating effects of which I had experienced in equatorial ecosystems, would manifest in this part of the world.

Greenland is covered by an ice sheet nearly the size of Mexico, which in some places is almost 3.2 kilometres (2 miles) thick with ice. For an ecosystem so different to that with which I'm familiar (the tropics), the parallels were everywhere: the almost tropical hues of the fjord water, the remoteness, the lack of people, the stunning wilderness. The ice sheet even sounds like coral reefs – snapping, crackling and popping as thousand-year-old compressed air, trapped within tiny bubbles, escapes the ice. And much like my beloved coral reefs, this is an ecosystem that's in transition.

Climate change is amplifying the thawing of permafrost, the loss of seasonal snow cover, the loss of summer Arctic sea ice, and the melting of glaciers and ice sheets. In the summer months, a single glacier we visited calves about 200,000 tonnes of ice a day into the fjord. For Greenland as a whole that's one million tonnes a minute, and around 250 billion tonnes each year. In fact, the entirety of Greenland contains enough freshwater locked up in ice to raise global sea levels by 7 metres (23 feet). That doesn't feel like much, perhaps, until you're standing on

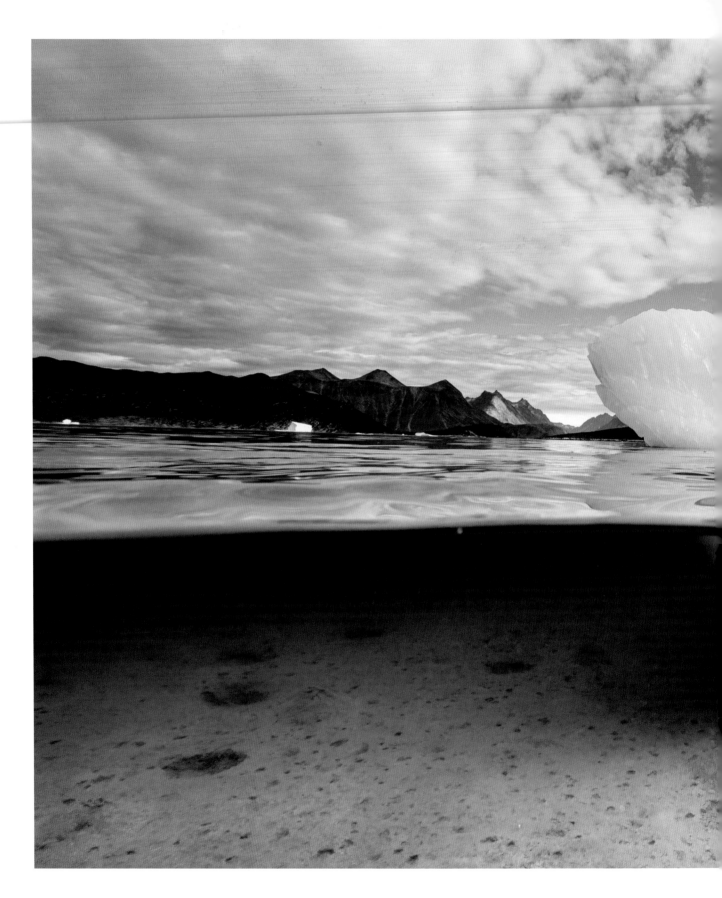

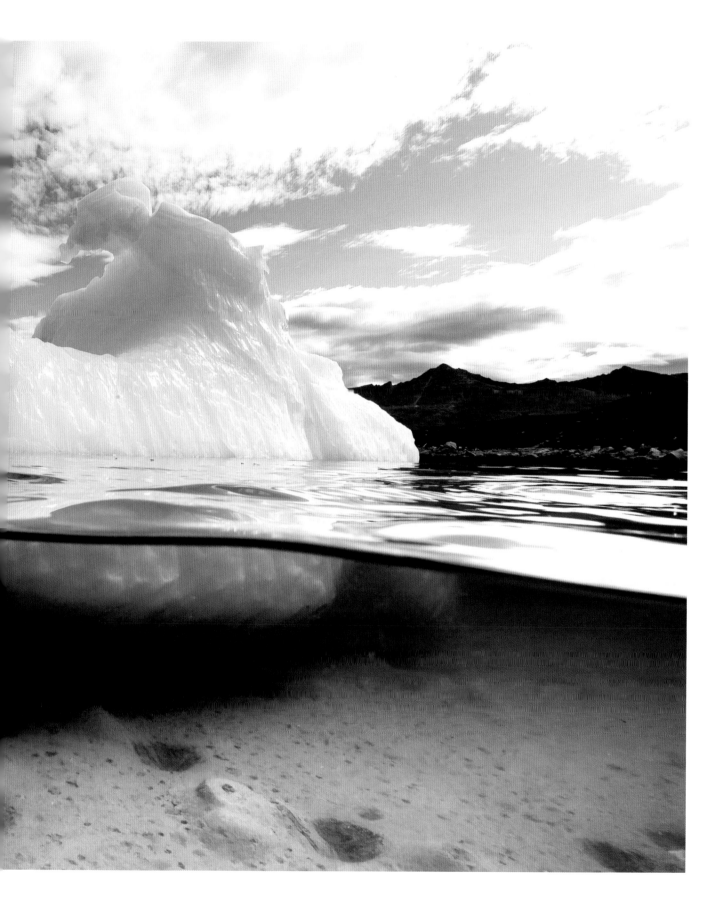

an island in the Pacific Ocean that sits less than a metre above sea level.

The Arctic has been warming twice as fast as the rest of the planet over the last half century and is expected to continue to warm faster than the global average. Extreme heat events have increased here since the 1970s and minimum temperatures have increased at three times the global rate. In 2021, rain fell on Greenland's ice sheet summit for the first time. When we were there filming, warm air was carried up over Greenland and remained there, which meant shorts and T-shirts for our crew but, for the ice cap, one of its most widespread melting episodes (a year of melting on such a large scale that it was matched by only three other years in the last century, all of which have occurred since the 1990s). Rain was so unexpected at this site that they didn't even have the correct gauges to measure the rainfall.

The story begins with age-old ice: a frozen reservoir of ancient freshwater, Greenland's ice sheet twists and ruptures through the rugged landscape as it moves into its glacial form. At sea level, cracking and crumbling into the fjord waters of Prince Christian Sound, ice debris meets saltwater for the first time after a glacial calving event. Now detached and mobile, an iceberg moves towards open ocean. In the town of Narsaq, ice everywhere shifts to liquid form as temperatures soar to 18 degrees Celcius above average in a three-day heatwave. A constant stream of tiny droplets falls from the tip of a super-berg. And finally, the new normal: glacial retreat means that ice no longer meets the sea, a new ecosystem begins to take shape, coloured by the striking aqua of glacial sedimentation.

Now detached and mobile, an iceberg
moves towards the open ocean.

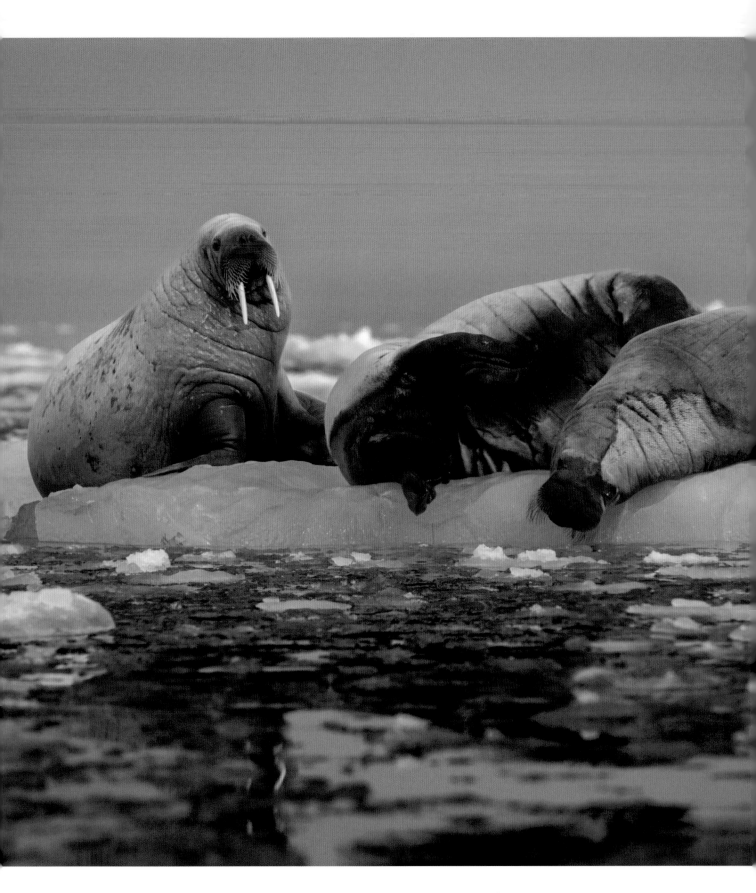

A group of female walruses (*Odobenus rosmarus*) rests on an ice floe in Kvitøya, Svalbard. They can lie for hours on the ice, digesting their meals or nursing young.

Arctic Survivors

SVALBARD, NORWEGIAN ARCTIC

JULIE CHANDELIER

Svalbard stands as the fastest-warming place on our planet, heating six times faster than the global average. The resulting loss of sea ice is turning some of the world's most resilient creatures into some of the most fragile, and time is running out.

In the summer of 2022, I spent several weeks in the high Norwegian Arctic of Svalbard, exploring the wider archipelago by sea and reaching even the remote easternmost island of Kvitøya. I witnessed incredible landscapes and had amazing encounters with some of the most exciting species on the planet, but the experience carried a bittersweet undertone. A battle for survival is happening for some of the Arctic's iconic wildlife, particularly the walrus populations and polar bears that call Svalbard home.

In Svalbard, it has been shown that there's been approximately a 3–5 degree Celsius (37–41 degree Fahrenheit) average temperature increase since the 1970s. As a result, the sea ice on which polar bears and walruses depend is rapidly diminishing. Some scientists believe the Arctic could be entirely ice-free in the summer months by the 2030s. Walruses rely on this ice as a platform for resting, breeding and accessing vital food sources. When mothers give birth they will usually seek a private ice float to do so. Their calves are instantly able to swim but mothers will then seek shelter among other walruses in order to keep foraging – they can't leave their calves alone on the ice while

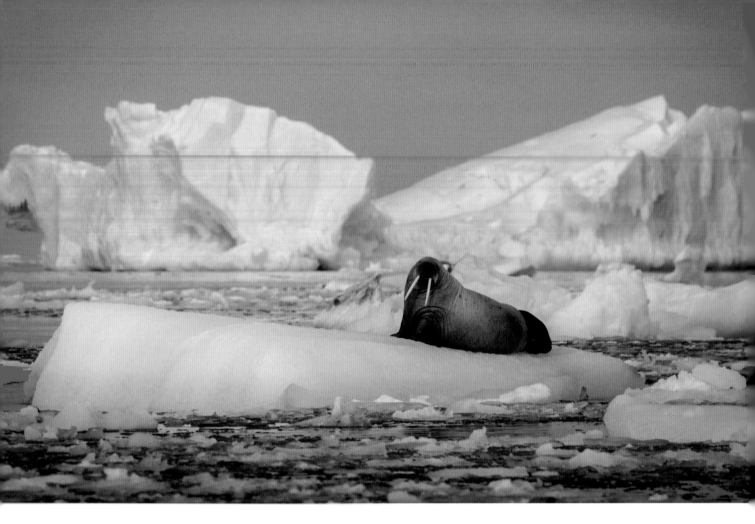

feeding, due to potential predation. The retreat of sea ice and ice floes means less space for them, forcing them to seek refuge on crowded shores, resulting in increased competition and potential conflicts.

I also spent some time on the pack ice above 80-degree latitude, in polar bear territory. These powerful animals are symbols of our climate crisis and the fragility of Arctic ecosystems. Once masters of the vast frozen expanse, they are now forced to adapt to a shifting environment. Polar bears depend on sea ice to hunt seals, their main food source. While they are proficient swimmers, their hunting is most efficient on solid ground. With the rising temperatures and the disappearance of the majority of the sea ice, their hunting territory is reducing and they are having to swim longer distances and hunt from the water instead. It is becoming increasingly difficult for them to feed. Nowadays, more bears are exploring built-up areas in search of food and are now eating reindeer, not their usual prey. They have also adapted, making bird eggs a bigger part of their diet. These adaptations offer only temporary

solutions, however, with new food sources lacking the long-term sustenance these bears need. Spending less time overall on sea ice and more time on land leads to longer periods of fasting, weight loss and a reduced number of offspring.

My experiences in Svalbard left an indelible impact on me, underscoring the urgency of addressing our environmental crisis and safeguarding these fragile ecosystems. Some of the most resilient species in the world are becoming some of the most fragile, due to global warming. Their struggle serves as a powerful reminder of the urgent need for us to address climate change and protect the wonders of the Arctic before they vanish.

ABOVE: This female walrus just finished nursing her calf away from the rest of her group.

OPPOSITE: A female polar bear (*Ursus maritimus*) stands still on the pack ice at 80 degrees North.

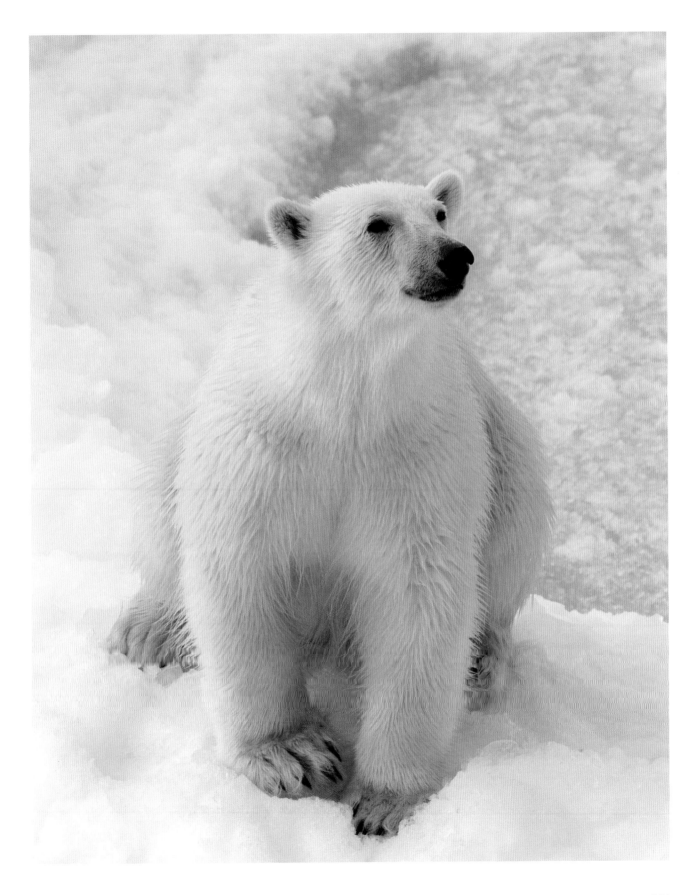

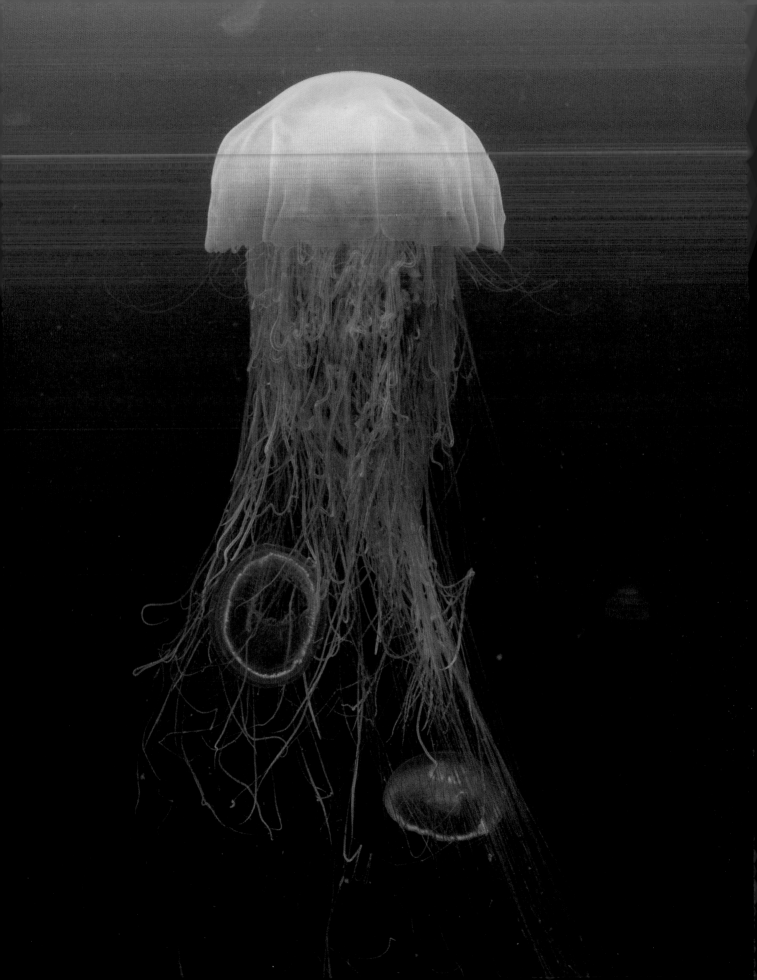

Alaska's Wild Ocean

PRINCE WILLIAM SOUND, ALASKA

SHANE GROSS

An eye-witness account highlights the rich marine life of this remote region, where aggregations of jellyfish give us a glimpse of one possible future for the oceans.

A silver lightning bolt flashed past me at the edge of visibility, just a few metres away. I squinted just in case it would help me see through the murky Alaskan seawater. It didn't, but soon emerged one of the most amazing animals in the ocean: a ten-foot salmon shark (*Lamna ditropis*). The large male shark swam towards me confidently and quickly, then turned on a dime and left. His grace and agility were humbling as I bobbed like a cork in my drysuit filled with air in the freezing water. Few people have heard of salmon sharks, let alone seen them in the wild. My gratitude for such encounters cannot be overstated.

Salmon shark populations have, unsurprisingly, been decimated in the last fifteen years. There is no law protecting them in Alaska, as the last scientific census took place before they became famous trophies for game fishermen. Stories and footage of hundreds of salmon sharks leaping from the ocean with salmon in their mouths are now things of the past.

Salmon sharks aren't the only reason I wanted to visit the fjords of Alaska's Prince William Sound. Massive aggregations of moon jellies (*Aurelia aurita*) make their way there each autumn to gorge on salmon eggs. The lion's mane jellyfish (*Cyanea capillata*) hunts the moon jellies.

A lion's mane jellyfish (*Cyanea capillata*) eats moon jellies (*Aurelia aurita*) in Prince William Sound.

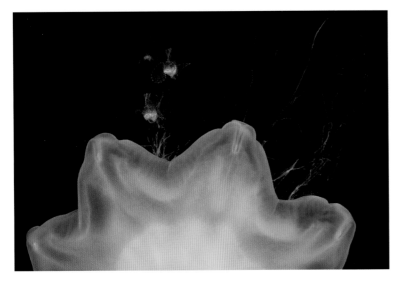

LEFT, TOP TO BOTTOM: A sculpin hides in the tentacles of a lion's mane jellyfish; a scuba diver swims through a dense smack of moon jellies; sculpins not only hide in the stinging tentacles of jellies, they also eat them.

ABOVE: A sculpin hitches a ride on a moon jelly.

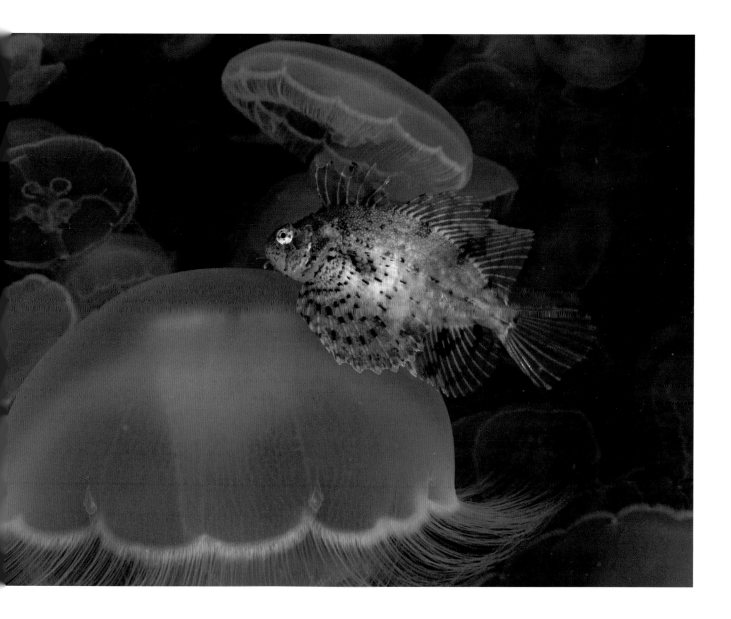

The lion's mane jellies are like floating hotels. Fish immune to their stinging cells will hide among the tentacles for protection, and some fish will find out the tentacles.

There were moments when the smack of moon jellies was so thick, so much, that I couldn't see my dive buddy just a few feet away. They would bounce off me in slow motion. Luckily, moon jellies don't sting, but I had to take care to avoid the long tentacles of the lion's mane jellies, which can stretch to over 30 metres (100 feet) from the bell and punch a powerful sting.

Jellyfish are predicted to be one of the few 'winners' in the changes brought by climate change. A warmer, more acidic ocean may lead to an ocean dominated by jellies and not much else. Are these massive aggregations of jellies a sign of things to come? Scientists aren't sure, but I for one hope we can undo the changes that mean we'll never have to find out.

About the authors

Matt Porteous

Matt Porteous is renowned for his environmental portraits and celebrated photography of the royal family. His unique talent lies in his natural ability to gravitate towards compelling narratives, seamlessly weaving them into visually captivating masterpieces. Whether he's capturing intimate moments or grand adventures, Matt has a knack for delving deep into the raw emotions that lie beneath the surface. Driven by a profound reverence for our planet and its waters, he places a strong emphasis on stories that carry a purpose, transcending individual experiences. Through his transformative energy and authentic gaze, Matt's evocative photographs come to life, leaving a lasting impact on viewers worldwide. Matt's deep-rooted passion for the ocean, combined with his expertise in photography and storytelling, drove him to establish OCL. Matt recognized the urgent need to raise awareness about the critical issues facing our oceans and believed that stories had the power to inspire change.

Tamsin Raine

Tamsin Raine is a lifelong ocean lover who has spent most of her life on or close to the sea. Inspired by her deep connection with the ocean from a young age, she embarked on a journey to communicate her passion to a wider audience. Working for advertising and marketing agencies, Tamsin managed national campaigns for leading brands. However, she soon realized the missing link was her profound love for the sea. Tamsin believes in bridging the gap between culture, science and communication through creative practices. Her mission extends beyond personal passion; she aspires to unite a global community of like-minded individuals and empower them to ensure their stories span across oceans. She envisions a world where the emotional bond between humanity and the sea is celebrated and leveraged for the betterment of our planet. Through her creativity and unwavering dedication, Tamsin is committed to fostering collaboration, raising awareness and inspiring meaningful change in the realms of sustainable development, heritage preservation and ocean stewardship.

Matt and Tamsin founded OCL with the aim to create a platform where a global community could come together to share the untold stories of the ocean. They wanted to shed light on the beauty and fragility of the marine world, while also addressing the pressing environmental challenges it faced. Through photography and storytelling, the duo sought to foster a deeper connection between humanity and the ocean, and to create a sense of responsibility for its preservation. In founding OCL, Matt and Tamsin imagined a world where people from all walks of life could be inspired to become stewards of the ocean, working collectively to protect this invaluable ecosystem.

List of contributors

Ali Ageel @aliageel1 (photographs, pages 98–101)

Janik Alheit @janikalheit (photograph, page 63l)

Jono Allen @jonoallenphotography (photographs, pages 106–109)

Arzucan Askin @arzu_askin (text, pages 106–109)

Grace Bailey @gracebaileyphotos (pages 36–9)

Nadine Bauer @cinnadine (pages 22–5)

Leo Bellis-Jones @leo_underwater (text, pages 202–5; photographs, pages 202, 204)

Daniela Beltran @danielabeltranb (photographs, pages 19, 20, 21t)

Desmond Bowden (photograph, page 122)

Building Coral www.buildingcoral.com (text, pages 182–5)

Carissa Cabrera @carissaandclimate (text, pages 216–19)

Arthur Cauliez @arthur_cauliez (pages 64–7)

Julie Chandelier @julie_chandelier (pages 228–31)

Maxime Cheminade @maxime_underwater (pages 102–105)

Sung Hua Cheng @azure27014 (pages 78–81)

Jay Clue @jayclue (pages 164–9)

Jasmine Corbett @jasminecorbettphotography (pages 148–51)

Fernanda Cortina @fernanda_cortina (pages 198–201)

Catherine Cushenan @catsharks (pages 30–35)

Marcus De La Haye @marcusdelahayephotography (pages 144–7)

Rowan Dear @rdearphotography (pages 82–5)

Callum Evans @callumevans_photography (pages 12, 26–9)

Javi García @javigl (pages 14–17)

Diego Leandro Genna @vagabondiving (pages 132–5)

Adrienne Gittus @soulwaterproductions (pages 178–81)

Roushanna Gray @veldandsea (text, pages 60–63; photographs, pages 60, 63tr, 63br)

Shane Gross @shanegrossphoto (pages 72–5, 232–5; photographs, pages 48, 216–19)

Andrea Kozlovic @makingwavesphoto (pages 86–9)

Georgia Laffoley @oceancommitment (pages 94–7)

Stephen Larder @slards (pages 190–93)

Yara Laufer @yaralaufer (pages 160–63)

Nasheed Lonu @lonubreak (text, pages 114–19)

Noemi Merz @noeunderwater (pages 120–23)

Rick Miskiv @rick.miskiv (pages 154–9)

Wendy Mitchell @wendys.underwater.world (pages 136–9)

Òscar Montferrer @oscarmontferrer (pages 68–71)

Corey Nevels @coreyray__ (pages 56–9)

Pier Nirandara @piersgreatperhaps (pages 52–5, as first published on ROADBOOK.com)

Will Nolan @willnolanphoto (pages 90–93)

Oceans Alive Trust @oceans_alive_kenya (text, pages 124–7)

Meaghan Ogilvie @meaghan_ogilvie (pages 174–7)

Alex Oelofse @alex.in.transit (photograph, page 62)

Matt Porteous @mattporteous (photographs, pages 10, 50–51, 76, 114–19, 120)

Miloš Prelević @prelevic.milos (pages 128–31)

Tamsin Raine @oceanculturelife (text, pages 48–51)
Alexander Roeterink @alexanderroeterink (photograph, page 205)
Michele Roux @michele_roux (pages 206–209)
Claudia Schmitt @thejetlagged (pages 44–7)
Karyle Soto @karyle_leiana (pages 194–7)
Madeline St Clair @mads_ocean (pages 222–7; photographs, pages 182, 185, 220)
Mia Stawinski @miastawinski (pages 140–43; photographs, pages 8, 184)
Kaushiik Subramaniam @kaushman (pages 110–13, 186–9)
Mika van der Gun @mikavdgun (text, pages 18–21; photograph, page 18)
Carla Virgos @carlavirgos (text, pages 98–101)
Phillip Vu @philllipv (pages 2, 152, 210–15)
Liam Webb @liamswebb (pages 40–43)
Kelsey Williamson @kelseywilliamson (pages 9, 170–73)

A version of Pier Nirandara's story 'Diving through History' (pages 52–55, text and image © Pier Nirandara 2022) was first published on Roadbook.com

Further Reading

The organisations and media outlets listed below are useful and reputable sources for more information on the stories featured in this book.

BBC Earth https://www.bbcearth.com/

Coral Reef Alliance https://coral.org/en/

Greenpeace https://www.greenpeace.org.uk/

Marine Conservation Institute https://marine-conservation.org/

Marine Megafauna Foundation https://marinemegafauna.org/

Mission Blue https://missionblue.org/

National Geographic https://www.nationalgeographic.com/

NOAA (National Oceanic and Atmospheric Administration) https://www.noaa.gov/

Oceana https://oceana.org/

Ocean Conservancy https://oceanconservancy.org/

Oceanographic https://oceanographicmagazine.com/

Only One https://only.one/

PADI AWARE Foundation https://www.padi.com/aware

Sea Shepherd Conservation Society https://seashepherd.org/

The Nature Conservancy https://www.nature.org/en-us/

WWF (World Wildlife Fund) https://support.wwf.org.uk/

Index

Acknowledgements

The Ocean Speaks is a tribute to the incredible community of dedicated and passionate ocean storytellers who have made it possible. They are the heart and soul of this project, tirelessly combining deep love for the ocean with their unique skill sets to give a resounding voice to our planet's greatest treasure.

A special note of gratitude goes to Darby Bonner, whose unwavering dedication, patience, grace and determination played a pivotal role in bringing this book to life. Darby, you are the glue that held it all together, and your commitment to our cause is truly inspiring.

We would also like to express our heartfelt appreciation to all the individuals who have supported our charity's cause. From the very beginning, you believed in our mission to protect and preserve the ocean, and you have found creative ways to contribute by whatever means possible. Your support has been instrumental in making a positive impact on our community and the world's oceans.

To our families and friends, who support our passion despite the demanding hours we dedicate, your patience, understanding and unwavering encouragement mean the world to us. Your support fuels our determination and keeps the fire of our love for the ocean burning bright.

To every storyteller, supporter and believer in the power of the ocean, we extend our deepest thanks. Your passion and commitment have been the driving force behind this endeavour, and it is through your collective efforts that we can continue to make waves of change for the betterment of our ocean and the planet.

With gratitude,
Tamsin & Matt

Quarto

First published in 2024 by White Lion Publishing, an imprint of The Quarto Group.
One Triptych Place, London,
SE1 9SH United Kingdom
T (0)20 7700 6700 / www.Quarto.com

'A Message of Hope' and chapter opener text © 2024 Tamsin Raine
Foreword © 2024 Nicole Stott
Illustrations © 2024 Stefán Yngvi Pétursson
Text and image © 2024, as listed on page 236–7
Cover design by Grade Design
Design © 2024 Quarto

Front cover: Diving into the heart of the ocean – a curious seal chases a mesmerising bait ball in the crystal-clear waters of Magdalena Bay, Mexico. Courtesy Matt Porteous (see also pp. 10, 50–51, 76, 114–19, 120).
Back cover: A curious juvenile whale shark approaches a diver in Roca Partida, part of the UNESCO World Heritage National Park Revillagigedo Archipelago, Mexico. Courtesy Fernanda Cortina (see also pp. 198–201).
Frontispiece: An unforgettable moment with a playful humpback whale in French Polynesia. Courtesy Phillip Vu (see also pp. 210–15).

ISBN 978-0-7112-8893-5
Ebook ISBN 978-0-7112-8895-9

10 9 8 7 6 5 4 3 2 1

Design by Ginny Zeal
Curated by Matt Porteous & Tamsin Raine
Assistant: Darby Bonner
Project Manager: Faye Robson
Commissioning Editor: Andrew Roff
Publisher: Jessica Axe
Production Controller: Rohana Yusof

Printed in China

FSC MIX
Paper | Supporting responsible forestry
FSC® C016973